MW01407957

THE SEARCH FOR BOND

THE SEARCH FOR
BOND

HOW THE 007 ROLE WAS WON AND LOST

ROBERT SELLERS

The History Press

Cover illustrations from istockphoto.com

First published 2024

The History Press
97 St George's Place, Cheltenham,
Gloucestershire, GL50 3QB
www.thehistorypress.co.uk

© Robert Sellers, 2024

The right of Robert Sellers to be identified as the Author of this work has been asserted in accordance with the Copyright, Designs and Patents Act 1988.

All rights reserved. No part of this book may be reprinted or reproduced or utilised in any form or by any electronic, mechanical or other means, now known or hereafter invented, including photocopying and recording, or in any information storage or retrieval system, without the permission in writing from the Publishers.

British Library Cataloguing in Publication Data.
A catalogue record for this book is available from the British Library.

ISBN 978 1 80399 658 5

Typesetting and origination by The History Press
Printed and bound in Great Britain by TJ Books Limited, Padstow, Cornwall.

Trees for Life

Contents

Preface 7

1	Before Connery	9
2	Connery	21
3	Replacing the Irreplaceable	49
4	Return of the King	71
5	The Saintly Bond	89
6	The Shakespearean Bond	121
7	Born to Be Bond	151
8	The Blonde Bond Bombshell	171

Notes 205
Bibliography 217
Index 219

Preface

This book began life sometime around 2007 and a good portion of the interviews I conducted come from around that period. Sadly, many of the people I spoke with have since passed away.

While researching this book, I began to sound out potential publishers. Not for the first time, and surely not the last, my idea met with a wall of indifference. So much so that I abandoned the project, left it on a memory stick and proceeded to work on other things.

Imagine my surprise when many years later I was able to interest a publisher into releasing the book. I took out the old manuscript, dusted it down, carried out new interviews and new research, and here we are. My thanks therefore go to Mark Beynon of The History Press.

I'd also like to thank the following people who contributed to and agreed to be interviewed for this book, past and present.

Vic Armstrong (2011 interview), George Baker (2007 interview), Robert S. Baker (2006 interview), Caroline Besson, Michael Billington (2005 interview), Honor Blackman (1997 interview), Tony Bonner, Eric Braeden, Michael Craig (2007 interview), Neil Dickson, Sir Ranulph Fiennes (2007 interview), Cyril Frankel (2011 interview), Fabien Frankel, Maria Gavin, Lewis Gilbert (2006 interview), Marcus Gilbert (2007 interview), John Glen (2006 interview), Julian Glover (2007 interview), Roger Green (2007 interview), Mark Greenstreet, Guy Hamilton (2007 interview), Robin Hawdon (2021 interview), Bob Holness (2008 interview), Paul Hough, John James (2007 interview), Michael Jayston (2007 interview), Christopher LeClaire, Christopher Lee (2005 interview),

Dyson Lovell (2007 interview), Glenn McCrory, Michael McStay (2007 interview), Tom Mankiewicz (2007 interview), Guy Masterson (2007 interview), Sir Roger Moore (2001 interview), Sam Neill (2007 interview), Simon Oates (2008 interview), Ian Ogilvy (2007 interview), Adrian Paul (2007 interview), Ronald Payne (2011 interview), David Robb (2008 interview), John Ronane (2008 interview), David Rossi, Philip Saville (2011 interview), Roger Barton Smith (2007 interview), Peter Snow (2007 interview), Ewan Stewart, Gary Stretch, Oliver Tobias (2008 interview), Rikki Lee Travolta (2007 interview), Giles Watling (2007 interview), Colin Wells.

1

Before Connery

The search for an actor to play James Bond did not start with the journey that ultimately led to the monumental casting of Sean Connery in 1962, but a full three years before, in 1959, when 007 looked like making his cinematic debut in a film directed by Alfred Hitchcock; though Ian Fleming had his fingers heavily crossed on that one. After years of hawking his books around film studios in England and Hollywood, with no takers, Fleming teamed up with a young maverick Irish filmmaker called Kevin McClory and together they formulated a plot line that saw Bond take on nuclear terrorism.

It was during Fleming's meetings with Paul Dehn, an early candidate to write the screenplay, that the subject of who to cast as Bond first arose. In a letter dated 11 August 1959 to his friend Ivar Bryce, Fleming announced, 'Both Dehn and I think that Richard Burton would be by far the best James Bond!' It's a fascinating suggestion, and undeniably the first recorded statement by Fleming about who should play his hero. Years later Fleming would champion David Niven as Bond, a very traditional English actor and a million miles away from the wild Celtic image and brooding manner of Burton. And what a Bond a pre-*Cleopatra*/pre-Elizabeth Taylor Burton would have been, before vats of vodka and a heady dose of disillusionment frayed his edges beyond repair.

According to Burton's brother, Graham Jenkins, the Welsh actor was a fan of the Bond books, numbering them amongst his favourite pulp reading along with Agatha Christie. Guy Masterson, a theatrical producer and director, and Burton's great-nephew, recalls that the

acting legend once confided in him about his decision to turn the Bond role down:

> At the time he was doing *Camelot* on stage and enjoying great stardom because of it. My uncle told me that Ian Fleming had approached him, asking him to play Bond. But back then Bond was a new concept – nobody had any idea it would be as big as it became. My uncle told me that he thought it was going to be just another movie.[1]

No matter how big Bond became, Burton never admitted to family or friends that he regretted missing out on the role. 'Had Burton played Bond,' says Masterson, 'I think he would have been absolutely fantastic.'[2]

Burton's rejection of Bond was probably just as well: the Welsh star was far too much of a free spirit to get tied down with a film series for any length of time. Ironically, in 1965, at the height of Bondmania, Burton scored one of his biggest successes with his Oscar-nominated role in *The Spy Who Came in from the Cold*, playing a cynical, worn-out MI6 agent who was the antithesis of 007. The potential casting of Burton as Bond also throws up a myriad of repercussions; cinema history might have been very different. Burton would almost certainly have missed his role as Marc Antony in 1963's *Cleopatra*, during which he fell in love with Elizabeth Taylor. One of the great showbiz couples of all time would never have been. And, of course, Sean Connery would have lost his opportunity for international stardom.

The casting of Richard Burton was an inspired idea and showed far greater insight into what kind of actor any potential Bond film required to connect with world audiences than did a previous screen incarnation of the character. Back in 1954, Fleming sold the screen rights to his first novel *Casino Royale* for a paltry $1,000 to the American TV network CBS and it was broadcast as part of their *Climax!* anthology series that October. Due to budgetary restraints and a script that was being altered right up to showtime, much of the nuance and scope of Fleming's novel was missing. Worse, the character of Bond was reduced to an American private detective rather than the suave gentleman spy readers knew. At one point in the proceedings, he is addressed as 'Card Sense Jimmy Bond'.

Cast in the role of Bond was Barry Nelson, a popular enough TV and screen star. He had recently finished starring as a globetrotting

businessman involved in international intrigue in *The Hunter*, a half-hour series that ran on CBS from 1952–54, and was currently appearing in the CBS sitcom *My Favorite Husband*. He was whacked, and had taken a short holiday to Jamaica, telling his agent he did not want to be disturbed.

No sooner did he land than his agent called saying that CBS desperately wanted him for *Casino Royale*. Nelson scrambled to get an immediate flight back to America to attend rehearsals the next day. He later confessed that the only reason for taking the job was a chance to act opposite Peter Lorre, who was playing Le Chiffre. 'I was really having my doubts, but when they told me Peter Lorre was the villain that was the clincher.'[3]

Arriving to play the role, Nelson had not the first clue what he was being asked to do. 'At that time, no one had ever heard of James Bond. I was scratching my head wondering how to play it. I hadn't read the book or anything like that because it wasn't well known.'[4] Far from carrying out even basic research, the most pressing prospect for Nelson was the fact that the 50-minute production was going out live. Where some people developed a nervous facial twitch, Nelson had a full body spasm. 'It was sheer fear. Peter Lorre saw me shaking and said, "Straighten up, Barry, so I can kill you."'[5]

Casino Royale made little impact on audiences or critics; Susan King of the *Los Angeles Times* called Nelson's portrayal of 007 'sexless and glum'. Nelson was later to reveal that CBS had an option on further Bond stories but didn't pick it up. What a relief, since a 007 TV series might have reduced the appetite for any potential studio to back a film franchise. It also meant no more Barry Nelson as James Bond; he went on with his career, largely appearing on Broadway along with a few film appearances in things like *Airport* (1970) and *The Shining* (1980), as the man who interviews Jack Nicholson's Jack Torrance for the job of the off-season caretaker of the Overlook Hotel.

When the Bond films struck gold in the 1960s, Nelson never regretted what some people might have viewed as a lost opportunity. 'I always thought Connery was the ideal Bond. What I did is just a curio.'[6]

Nelson wasn't the only actor to play James Bond before Connery. There was a TV presenter who became a cult figure in the 1980s with the quiz show *Blockbusters*; his name was Holness, Bob Holness. Born in South Africa in 1928, Holness was six months old when his family came

to live in England. In 1953, when he was 25, the whole family moved back to South Africa, and he began to find work in the theatre in Durban:

> In 1955 I started a career in radio and was in a repertory company that did a multitude of different productions from soaps to the classics. And it was with the South African Broadcasting Corporation that I was offered the chance to play 007 in a live radio adaptation of *Moonraker* in 1958, I think.[7]

Like Barry Nelson before him, Holness hadn't even heard of James Bond, let alone read a Fleming novel. Even so, the broadcast was a great success. 'But when enquiries were made about the possibility of doing another adaptation we were told that there were plans to turn a novel into a film and they wanted to see how that went. The rest, as they say, is history.'[8]

As for playing Bond on the big screen: 'it never even occurred to me,' admitted Holness. 'When my children were younger, I would take them to the cinema to see the latest Bond release, but we all agree that after Sean Connery it was never really the same. Having said that, I think Daniel Craig was extremely impressive, so maybe I've now changed my mind.'[9]

The failure of the CBS production of *Casino Royale* did not do much to endear the Bond novels to prospective film backers. However, in 1955, Hollywood actor John Payne purchased the film rights to Fleming's third Bond novel, *Moonraker*, with the intention of starring as 007 himself. Born in 1912 in Virginia, Payne was a contract player with 20th Century Fox during the 1940s and early '50s, starring in a string of forgettable musicals and film noir crime stories. His most notable appearances were in *Miracle on 34th Street* (1947) and controversial drama *The Razor's Edge* (1946) in which he co-starred with Tyrone Power, an actor whose dark matinee idol looks he somewhat resembled.

By the time *Moonraker* was published in the early part of 1955, Payne was disheartened by most of the poorly conceived scripts he was getting and very much aware that his career needed a boost. Fleming's novel offered him something better and very different. 'It was an agent at the William Morris Agency in Beverly Hills who first alerted him to the thrillers of Ian Fleming,' reveals Ronald Payne, the actor's distant cousin:

John was very receptive and enthusiastic and immediately went about seeking the option rights to *Moonraker* with hopes of doing a series of films. Fleming's hard living and dangerous super spy appealed to Payne, who wanted his film to be absolutely faithful to Fleming's novel. Payne liked the speed of Fleming's rollercoaster plot.[10]

For director, Payne sought out his friend Delbert Mann, then a hot property having just directed Ernest Borgnine's Oscar-winning performance in the drama *Marty*. It was thanks to several conversations with Delbert Mann in the 1970s that Ronald Payne came to learn so much about his cousin's Bond film plans. John Payne had already dissected the novel's plot and characters and made copious notes on how James Bond was to be portrayed on the screen, which he shared with Mann. Impressed with the work Payne had done, the director only had one major concern. While he personally thought Payne was physically right for James Bond, he could not look past the fact that Bond was British. His suggestion was that Payne produce the film and they bring in David Niven as 007. This idea was endorsed by actor/director Dick Powell, who was also interested in the enterprise. Payne personally liked and admired Niven but saw the *Moonraker* project as vitally important in helping relaunch his by then flagging career. 'He loved the book and saw himself as Bond,' states Ronald Payne. 'He would not budge on this.'[11]

If, then, Payne insisted on playing Bond, Mann suggested the character be changed to an American FBI agent or perhaps a former OSS (Office of Strategic Services) agent, and that the book's British location be moved to either New York, Washington or San Francisco. Payne was vehemently against these ideas. 'He wanted to remain completely faithful to Ian Fleming,' Ronald Payne recalls Mann telling him:

And shoot the picture in Technicolor and CinemaScope in London with a fully British cast and crew. He placed all emphasis on his fidelity to Fleming, whom I don't think he ever met. He was obsessed with the creation of a certain noir element in the writing of the script and the big slam bang conclusion when Bond saves London and the girl from total annihilation.[12]

Payne's choice to write the script was Ben Hecht.

John Payne also had a clear mind when it came to casting. The Irish-born actress Maureen O'Hara, who made many films for John Ford and her friend John Wayne, including the classic *The Quiet Man* (1952), was at the top of his short list to portray Gala Brand. For baddie Hugo Drax, Payne looked no further than Basil Rathbone, with instructions for the former Sherlock Holmes actor to play the villain as 'cunning, dangerous and quite mad'.[13] In one newly devised scene, an obvious nod to Rathbone's Robin Hood/swashbuckling days, Bond and Drax were to engage in an elaborate duel, 'slicing at each other with fencing swords', according to Mann.[14] This would have predated Bond's sword-fight with Gustav Graves in *Die Another Day* (2002) by almost forty years. As for the famous card game scene at the Blades Club, Payne told Mann that he thought it might be fun to get some of his Hollywood pals to play a few cameos. The camera would pan around the gaming table and the audience would spot several famous faces. Payne envisioned a 'walk-on' role for Tyrone Power, who was to accidentally bump into Bond at the club. Payne also wanted Peter Lorre to play a former Nazi psychiatrist and Drax henchman. After the card game, Lorre tails Bond's ally and friend, to be played by Cesar Romero, and knifes him to death in a dark Mayfair alleyway.

As to how the film would look visually, Payne took inspiration in the bold, almost pulp magazine-like, covers of the British Pan paperbacks, as Mann recalled:

> He wanted that heightened sense of death defying, last minute, live or die suspense. He loved the Bond covers created for the Pan editions and kept repeatedly showing them to me and asking if I could reproduce them in the framing of the film in terms of lighting and cutting. Seeing them only once, I knew exactly how he wanted his Bond film to look and be perceived.[15]

Mann recalled two set pieces that Payne was particularly excited about putting on the screen. One involved the lorry carrying rolls of heavy newsprint that are dropped in front of Bond's Bentley and take him off the road; 'white knuckle stuff,' says Ronald Payne.[16] Another was Bond's dramatic rescue of Gala Brand from being roasted alive from the flames

of the Moonraker rocket as it's fired on London. 'He wanted the audience to be practically screaming in their seats to get out of there before it was too late,' Mann recalled to Ronald Payne. 'And he wanted the audience to feel the heat of the exhausts and see the sweat on Bond's face.'[17]

By this stage Mann believed that had the film been made it would have been a success:

> It didn't really matter to me, at this point, if John Payne's James Bond was British or American. The story as he envisioned it was so gripping and exciting no one would have cared. John Payne's James Bond would have been a hero like none other of that era. In many ways he was on the same track creatively later followed by Broccoli and Saltzman.[18]

And ahead of the curve, too, regarding Bond's cinematic potential.

Keen on possibly making a series of 007 films, Payne ultimately dropped the *Moonraker* option, for which he paid $1,000 a month, once he learned that the rights to the other Bond books would not be available to him.

Where others had failed to get Bond off the ground, Irish filmmaker Kevin McClory was convinced he could make a go of it. Top of his list to direct was Alfred Hitchcock; Fleming being impressed by the master of suspense's recent thriller *North by Northwest* (1959) starring Cary Grant. If Hitchcock were to countenance coming on board, it was made quite plain that the decision as to who played Bond would be taken by the director and no one else – and Hitchcock's choice was James Stewart. Hitchcock was currently in search of a vehicle for Stewart, one of his favourite actors, whom he'd cast already in four of his movies, notably *Rear Window* (1954) and *Vertigo* (1958). How did Fleming react to Hitch's suggestion of a man famous for playing cowboys being his suave secret agent? Surprisingly philosophically according to this letter, dated 7 October 1959, to his friend Ivar Bryce. 'Of course James Stewart is the toppest of stars and personally I wouldn't at all mind him as Bond if he can slightly anglicise his accent. If we got him and Hitchcock we really would be off to the races. Cross all your fingers.' Perhaps Fleming was so desperate to see one of his novels made into a film that he was prepared to compromise totally. Bryce, far more sensibly, was heavily against the casting. 'I shudder at lackadaisical Stewart portraying dynamic Bond,' he immediately wrote back to Fleming.

Interestingly, at the same time, a 90-minute television adaptation of *From Russia with Love* was in development in America, with James Mason already cast as Bond. If that proved a hit, Mason would become the man most identified in the public's mind as 007. 'So, if the worst comes to the worst, we might have to settle for him,' Fleming wrote Bryce on 11 August 1959, sounding not entirely won over by the idea. Mason was, after all, more famous as a silky villain (Captain Nemo in Disney's *20,000 Leagues Under the Sea* (1954) for example) than a heroic leading male. Indeed, in 1979 he was first choice to play Hugo Drax in *Moonraker*, a role that ultimately went to Michael Lonsdale. In the end, though, the *From Russia with Love* TV drama never happened. But Fleming did later change his mind about James Mason, according to the author's cousin Christopher Lee. 'I know who Ian thought was the best person to play Bond – James Mason, who would have been marvellous. He had all the right qualities. I don't think anyone has ever succeeded in putting Ian Fleming's James Bond up on the screen. The closest in my opinion is Pierce Brosnan.'[19]

McClory, at this point, favoured Trevor Howard to play Bond in their proposed film and met the actor at least twice to discuss it, in July and October 1959. Fleming disagreed, saying that Howard, in his mid-forties, was too old and suggested instead Peter Finch. McClory had to tell Fleming that Finch was in fact only a couple of years younger than Howard. Fleming wrote back saying that he would be happier if the part could be given to a young unknown actor, with established stars playing the other roles.

As production loomed ever closer, Trevor Howard was still being talked about as a possible Bond. Then two new fascinating names entered the frame: Dirk Bogarde and Richard Harris. In 1959, Bogarde was the top box office draw in Britain, so not surprisingly was very much in demand. 'Dirk Bogarde is probably committed for our dates of location,' production manager Leigh Aman wrote to McClory that November. 'He might, however, be free. His fee is £30,000.' In the 1960s Bogarde was to appear in a couple of spy films designed to cash in on the success of the Sean Connery Bonds, *Hot Enough for June* (1964) and *Modesty Blaise* (1966). In 1975 he played a particularly cold and brutal intelligence agent alongside Timothy Dalton in the spy thriller *Permission*

to Kill. As for Harris, then just embarking upon what was to become a highly successful film career, he was interviewed personally by McClory. One can only imagine what those two very different actors would have made of the Bond role.

Meanwhile, in New York, McClory had dinner with the Swedish boxer Ingemar Johansson, then the world heavyweight champion. 'He is looking for an acting career,' McClory wrote to Bryce. 'And, my golly, he would make a wonderful James Bond. Unfortunately, I don't think we can do anything about his Swedish accent – if only we could dub the voice.'[20]

Even Fleming's agent, Lawrence Evans, got in on the act. But his suggestion was sheer lunacy. He advocated that a man be found whose real name was James Bond and he be groomed for the part. Then, so Evans' logic went, wherever he went in the world he would be known and addressed as James Bond. 'I think this is an impossible but amusing idea,' said Fleming. 'But I do think the idea of creating our own James Bond from an unknown and to sign him up for ten years and have a very valuable human property on our hands to act in Bond television series etc, is an excellent one.'[21] Not long after Evans' absurd suggestion, three letters applying for the role of James Bond arrived, sent by real James Bonds!

Incredibly, McClory's London production office was overwhelmed by letters from ex-soldiers and out of work actors asking for an audition to prove that they were the only person in the world capable of playing Bond. Wives, too, sent letters describing the various attributes of their husbands and why they should be cast in the role. Best of all, McClory's secretary was sent one such letter and contacted her boss about it saying, 'A Mr. Arthur Tarry (accountant) telephoned. Will you be wanting him for James Bond?'[22]

Fleming too was pestered with potential Bond wannabes who sent their photographs to him. One in particular was interesting enough for him to pass it on to McClory, with a proviso. 'His acting record seems good, but of course he may be only four feet six inches with a cockney accent and quite out of the question.'[23]

As pre-production continued, news about the proposed James Bond film began appearing in the showbiz and gossip pages of the tabloid press and for the first time speculation amongst the general public began about

who should play the famous spy. People wrote to newspapers with their own candidates, names like Patrick McGoohan, Michael Craig, Richard Todd, Peter O'Toole and George Baker, plus Hollywood idols William Holden, James Garner and Montgomery Clift. Bizarrely even Donald Sinden and Peter Cushing were mentioned as possible 007s.

The *Daily Express* quickly got in on the act and encouraged readers to send in their choices. One who did was a young film journalist by the name of Tony Crawley. On 15 June 1959 he wrote, 'The Kevin McClory search for a screen James Bond makes good copy. This could be the first time the public have cast a cine-hero. But who should it be?' Crawley's candidate was an excellent one. 'He's Welsh. He's popular. He is all but an international star. He's tough. And he's proved his romantic worth. He's Stanley Baker.' Crawley wasn't alone in suggesting Baker for the part.

By this stage McClory had hired noted screenwriter Jack Whittingham to fashion his and Fleming's story ideas into a workable screenplay. In early 1960, Fleming personally took this screenplay to the New York offices of his agent MCA. The response was highly positive. According to an internal MCA memo from their film division it was: 'An excellent first draft screenplay out of which may be produced an excellent commercial motion picture.'[24] With respect to casting, the memo read: 'Mr. Fleming mentioned David Niven. Another thought would be to set it up with 20th Century Fox and attempt to obtain the services of Stephen Boyd. Along this same line of thinking the combination of Peter Finch and Warner Bros. would also make sense.'[25]

Alas that was about as far as the project went. Christened *Thunderball*, Fleming took Whittingham's screenplay and without his or McClory's permission used the basis of it for his next James Bond novel, not even bothering to change the title. Both McClory and Whittingham sued Fleming for plagiarism and won, with McClory ending up with the film rights to the story. But to all intents and purposes he could do little with them; his thunder had been stolen by two producers, the American Albert R. Broccoli, and the Canadian Harry Saltzman. Both men were based in London and in the spring of 1961 struck up a partnership destined to become the most successful in entertainment history. They shared the same dream as McClory, that of bringing James Bond to

the screen. The only difference was – they succeeded in doing it. Taking out an option on Fleming's novels they scoured Hollywood for potential backers but were met with indifference everywhere. Luckily Broccoli had a personal contact at United Artists and on 20 June 1961, just days before their option on the Fleming novels expired, a deal was struck. At last, a Bond movie was on its way.

2

Connery

The question of who would play the part of James Bond in *Dr. No*, the film Broccoli and Saltzman had chosen to launch their series, became the male equivalent of the search for Scarlett O'Hara. As early as 1958 Broccoli had been toying with the idea of making Bond films and even went so far as to offer the role to Peter Lawford. This London-born actor certainly had the background and personality to play Bond. The son of a First World War hero, Lawford was an MGM contract player in the 1940s and married four times, once to the sister of John F. Kennedy, making him brother-in-law to the President of the United States. He was also a notorious womaniser and reportedly had romances with Lana Turner, Judy Garland, Grace Kelly, Ava Gardner, Nancy Reagan, Elizabeth Taylor and Marilyn Monroe. Most famous of all Lawford was part of Frank Sinatra's notorious Rat Pack, along with Dean Martin, Joey Bishop and Sammy Davis Jr, appearing on stage and film with them, most notably in *Ocean's Eleven* (1960).

Lawford would have made a pretty decent 007. He was familiar to American audiences and combined David Niven-like English charm with a mild toughness. But the prospect of playing a spy just did not appeal to him back in 1958. It was a missed opportunity that remained one of Lawford's deepest regrets; although there is no record as to whether or not Broccoli went back to Lawford to offer him the *Dr. No* gig. Towards the end of his life Lawford sank into drug and alcohol dependency, spending more time in the Betty Ford clinic than film studios, and died in 1984. In 1962 Lawford was among the cavalcade of stars in the epic

war drama *The Longest Day*, the film Sean Connery made just before embarking upon his 007 career.

Because of the impact he'd made as John Drake in the British TV spy series *Danger Man*, which began in 1960, Patrick McGoohan was one of the first actors approached by the producers to play 007 in *Dr. No*. Only he turned Broccoli and Saltzman down flat no less than three times, according to McGoohan himself, and never regretted the decision. 'Patrick actually would've made a wonderful Bond,' says John Glen, an editor on *Danger Man*, and someone who would become the 007 series' most prolific director. 'Pat was asked but said no thank you. He had a thing about kissing on screen and had some hang-ups about the Bond character. I thought he was a wonderful actor.'[1]

A self-styled puritan, McGoohan stamped his own personality on the *Danger Man* series, never allowing his character, for instance, to become romantically involved with his leading ladies or to use a gun unless necessary. The licentious and violent behaviour of the Bond character was therefore pure anathema to him. Unlike Drake, who McGoohan tried to base in some kind of reality, Bond was too much of a cartoon strip fantasy. 'I thought there was too much emphasis on sex and violence,' McGoohan explained a few years later. 'It has an insidious and powerful influence on children. Would you like your son to grow up like James Bond? Since I hold these views strongly as an individual and parent, I didn't see how I could contribute to the very things to which I objected.'[2]

This puritanical stance was also the reason why McGoohan turned down the chance to star in *The Saint* when offered it by his TV boss Lew Grade. Amazing to think, isn't it, that over a twelve-month period McGoohan had the chance to play both James Bond and Simon Templar. The man who eventually landed the role of Leslie Charteris' playboy adventurer, Roger Moore, was another early Bond candidate, although his involvement in *The Saint* TV series immediately ruled him out and he was never interviewed. When Moore finally landed the Bond role in 1972, Broccoli told him that he had indeed been on their short list.

For a long time, Broccoli visualised Cary Grant as Bond, and it's not difficult to understand why. Born in Bristol in 1904, Grant had made a career for himself in Hollywood as the ideal, smooth English gentleman, with just a hint of cruelty and darkness. The two men were actually very close friends; Grant had been best man at Broccoli's

wedding in 1959. Terence Young, who had been hired to direct *Dr. No*, made the claim that he went over to Hollywood to meet with the superstar. According to Young, Grant agreed to the prospect of doing one picture but was not prepared to sign up for any potential series. More likely Grant realised himself that he was too old (he was already in his late fifties), especially if there was going to be a series, so despite being intrigued by the prospect, and being a fan of the Fleming books, he declined. Broccoli's wife, Dana, was to admit years later, 'Cubby would have loved to have Cary play Bond.'[3]

Rod Taylor was another suave and handsome Hollywood actor considered, then most famous for his role in the 1960 film version of H.G. Wells' *The Time Machine*. Born in Australia in 1930, Taylor came to Hollywood in the 1950s, and his virile, matinee idol looks assisted him in scoring numerous film roles. Broccoli, in particular, wanted Taylor to screen test for Bond but the actor declined. 'I thought it was beneath me,' he confessed years later. 'I didn't think Bond would be successful in the movies. That was one of the greatest mistakes of my career! Every time a new Bond picture became a smash hit, I tore out my hair. Cubby and I laughed about it ever since.'[4] Feeling left out, Taylor jumped on the Bond-wagon later in the 1960s, playing novelist John Gardner's secret agent Boysie Oakes in *The Liquidator* (1965) alongside future Bond girl Jill St John.

Two other 'name' choices were Stanley Baker and Steve Reeves. According to Stanley Baker's widow, Lady Ellen, the Welsh star refused the Bond producers' overtures. 'Stanley was offered a three-film, five-year deal by Cubby Broccoli to do Bond – Stanley didn't want to be tied down. He never regretted it. He thought Sean Connery the perfect choice.'[5] At the time, Baker was Britain's premier tough guy actor thanks to roles in films like *Hell Is a City* (1959) and *The Criminal* (1960). Like fellow Welshman and friend Richard Burton, Baker's screen presence was gritty and combustible, possessing an aura of dark, even menacing, power. You can quite easily visualise Baker cracking skulls with Robert Shaw aboard the Orient Express in *From Russia with Love* (1963).

In 1963 Baker produced and starred in the film for which he will always be known, a film incidentally that might well have never seen daylight had he played Bond: *Zulu*. Baker remained a popular star until his tragic early death in 1976 of cancer at the age of 48.

Steve Reeves was an ex-bodybuilder. In his early twenties he was holder of the Mr America title (1947) and then went on to win Mr Universe twice in 1948 and 1950. Born in Glasgow, Montana, in 1926, he was talent spotted by a casting agent and began making 'sword and sandal' pictures in Italy playing muscular biblical heroes like Hercules and Goliath. At one point he was the highest paid actor in Europe.

There were always rumours surrounding whether Steve Reeves was ever approached about the Bond role. According to Christopher LeClaire, who wrote Reeves' authorised biography and lived and worked for a time on his ranch, the offer was a genuine one. How Christopher got to meet Reeves is an interesting tale. In the early 1990s Christopher was in his early twenties and at college in Boston. With an interest in lifting weights, he read all the muscle magazines but could never identify with the sport because too many participants either took steroids or were behemoth hulks like Schwarzenegger. Then he started reading up on Steve Reeves, who he remembered from watching his films on TV as a kid. 'The guy had an inspiring physique. He didn't seem like a Schwarzenegger; he was much more aesthetic.'[6]

Christopher began to read and research more into Reeves and saw what a fascinating life story he had. When he couldn't find a biography on him, he decided to write one himself. The problem was Reeves was someone who protected his privacy and was somewhat reclusive. Now in his mid-sixties, he had turned his back on Hollywood and showbiz and was living on a ranch raising horses out in the California desert. Christopher tracked his number down. 'I called and within two rings I heard the deep baritone voice and I said, "I'm looking for Mr Steve Reeves," and he said, "This is he." And I broached the idea of a book to him over the phone.'[7]

Reeves was somewhat indifferent to the proposal but asked Christopher to call again in a few weeks' time. Christopher did and they talked some more. After several more phone chats, Reeves finally agreed that Christopher could come over to the ranch when he would have one hour to make his pitch. Christopher flew from Boston to San Diego and rented a Hertz car to drive to the ranch. When the hour was up both men had reached a tacit agreement. Then Christopher decided to go for broke:

I was walking out, then I thought, I've got to strike while the iron's hot. I turned round and said, 'If I'm going to write a life story about you, I think I'm going to have to move out to California.' He looked at me and he said, 'Well, I'll tell you what, my ranch hand has got to go back to Mexico, if you want there's a job here on the ranch. There's some living quarters in the stables, and we'll give you three square meals a day and $75 a week.'[8]

When the 1993 spring semester ended at college, Christopher came down to California, something he repeated the following summer. It was gruelling work, cleaning stalls, ploughing fields. And in exchange Reeves submitted to interviews. 'And so many of the best interviews with Steve were when I was working out in the fields with him or we were driving to get hay or grain for the animals.'[9]

Inevitably the subject of Bond came up:

We talked about the directors he had worked with, like Sergio Leone, and Steve brought up the name of Terence Young and that he was given the role of Bond in *Dr. No*. And he would say it so casually. He told me that his agent ran it by him. I think at the time he was living in Switzerland. So he was offered the role. He liked the role. And he was offered $50,000. And at the time Steve was one of the biggest box office draws in the world and the highest paid actor in Europe. He was making $250,000 per film. And this being the first Bond film, there was nothing behind it, it was just a script and a character. Obviously, he was familiar with what Bond was based on. And Steve said, 'They only offered me less than a quarter of what I was already making.' And so, he turned it down. He said to me, 'How was I supposed to know the film would take off the way that it did and make the millions that it was going to make.'[10]

Christopher got the sense that turning down Bond was one of the biggest regrets of Reeves' career:

He loved the role and the whole premise. 'Why wouldn't I want to do that,' he said. 'I always played the good guy, why wouldn't I have

wanted Bond.' But Steve was so financially savvy. He always reverted back to the money. He said again, 'They didn't want to pay me the kind of money I was making.'[11]

One of the reasons the Bond producers went for Reeves was that he was an in-demand star, and a top box office draw, especially in the European markets, and internationally, though ironically that elevated position led to Reeves pricing himself out of the job. He also looked physically good and would obviously be able to handle the action and fights. He was an American, of course, but this didn't appear to be an issue. One must also remember that at this time Reeves was getting so many offers and so many scripts that to him the Bond job was just that, another offer. Of course, the producers ended up casting another ex-bodybuilder and Mr Universe contestant in Sean Connery.

According to Christopher, the subject of Bond came up a few times over the course of their many conversations:

And whenever Steve brought it up it was the fact that it could have been a number one role for him, and who knows what it could have really done for him, and I really felt that it stung him. 'It was a great storyline,' he told me. 'I really liked it and I would very much have liked to have played Bond, but the money just wasn't there.' I remember once when we were driving in his Jaguar, he turned to me and said, 'Look here, driving in a sports car. I would have made a great Bond, wouldn't I.'[12]

A popular British actor on the producers' list was Michael Craig, then a Rank contract player. Born in India in 1929 to an English father on military duty, Craig spent much of his adolescence in Canada, where he acquired a slight accent. This may have been what Broccoli and Saltzman saw in him, a debonair leading man not plagued with a clipped British accent but an American-type drawl that would play well on both sides of the Atlantic. Craig left school for the merchant navy at 16, but finally returned to England and the lure of the theatre. Film extra work and small speaking roles eventually led to his discovery by Rank and a series of starring roles in popular movies like *Campbell's Kingdom* (1957) and *Doctor in Love* (1960), taking over from Dirk Bogarde as St Swithin's

newest doctor hunk in the perennial comedy series, and the Ray Harryhausen adventure *Mysterious Island* (1961).

With his Rank contract expiring, Craig was being wooed by Hollywood, so Broccoli and Saltzman were determined to pounce. They contacted Craig's agent about setting up a meeting. 'At the time,' Craig explains:

> Saltzman and Broccoli were more or less joke figures in the film business in England, responsible for some real pot boiling stinkers and notoriously bad payers. No one knew quite how they had managed to get the rights to the 007 franchise, but everyone expected them to really screw up if their past record was anything to go by.[13]

This is a mildly unfair comment by Craig, especially regarding Saltzman who helped start Woodfall Films, with filmmaker Tony Richardson and writer John Osborne. Together they produced social realism films, dubbed 'kitchen sink dramas', such as *Look Back in Anger* (1959), *The Entertainer* (1960) starring Laurence Olivier and *Saturday Night and Sunday Morning* (1960), which made a star of Albert Finney. Craig is probably referring to Broccoli's track record. Prior to Bond, Broccoli made a slew of pictures with Irving Allen for their production company Warwick Films, most of which were the 'pot-boilers' Craig referred to, most notably *The Black Knight* (1954), a critically lampooned medieval drama with Alan Ladd. However, out of the many bad films they made, *The Cockleshell Heroes* (1955) and *The Trials of Oscar Wilde* (1960), their last picture together, were of merit.

Craig recalls that the money on offer to play Bond was £5,000:

> I think, not great even then, and they'd want an option for further films at a slightly higher fee. My agent and I agreed that it wasn't much of a proposition and I turned down the interview. I later found out that a number of actors of my age and experience had likewise turned it down. I'm not remotely suggesting that I'd have been offered the part, or that I'd have been any good in it, I'm just saying how it was for me. Connery was terrific, no one could have been better.[14]

One man who gave a possible offer to play Bond some serious thought was Ian Hendry. Born in 1931 in Ipswich, Hendry's ambition was always

to be an actor and he attended London's Central School of Speech and Drama, landing on the same course as future M, Judi Dench. It was the impact he made in the lead role of Dr David Keel in the first series of *The Avengers* in 1961, alongside Patrick Macnee's John Steed, that must have alerted the producers to his talent.

Hendry had by now left *The Avengers* to pursue a career in the cinema and it was his desire not to be tied down to a series of films that informed his decision to turn down Bond, something he came to deeply regret later. There is another story that Hendry was invited to do a screen test but arrived for it drunk (the actor had alcohol issues his entire adult life) and was rejected as a result.

In a newspaper article Hendry talked about how his portrayal of Bond would have been a very different proposition. 'Bond is supposed to be a man you would pass in a crowd, but you can't help but notice the characters created by Connery and Roger Moore. I would have been the bloke you *do* pass in the crowd – until you see the steel in his eyes.' Not conventionally handsome or particularly debonair, Hendry guessed that this might have hindered his portrayal. 'My type of character wouldn't have been so successful. People like big glamorous men. But my face has never been glamorous and my character would have been very down to earth.'

Hendry went on to have a modest film career – highlights included a role opposite Sean Connery in *The Hill* (1965), Roman Polanski's *Repulsion* (1965), *Get Carter* (1971) and *Theatre of Blood* (1973). He also appeared in numerous TV series, twice alongside Roger Moore in *The Saint* and *The Persuaders!* Sadly, work dried up as the 1970s went on and Hendry died in 1984 at the tragically early age of 53.

As for Hendry's former *Avengers* co-star, Patrick Macnee, he has several Bond connections. Back in his early acting days, Macnee worked in Canada and became great pals with Christopher Plummer. During the Bond search, Plummer advised Macnee to have a go. 'He thought I'd be ideal for it, and if it had been five years earlier, I might have been interested. I looked a bit like a weed, and you have to have the right build for Bond, because it's wish-fulfilment for everyone.'[15] Macnee, of course, later played an amusing role in 1985's *A View to a Kill*.

Given the limited budget of *Dr. No* (just under a million dollars), it's debatable whether Broccoli and Saltzman could ever have afforded a major star like Cary Grant, or, as we have seen, persuaded an already

established star like Stanley Baker or Michael Craig to commit to a film series. And so they turned their sights instead upon either a complete unknown or an actor yet to make it big; in that way audiences would automatically accept him as Bond and the producers could also control and put that actor under a long-term contract.

Pretty high on that list was Richard Johnson, who at one time was Terence Young's preferred choice. Johnson was born in London in 1927, trained at the Royal Academy of Dramatic Art and performed in John Gielgud's repertory company. After National Service in the navy, Johnson played in the West End and nurtured a growing reputation as a Shakespearean actor. Making small appearances in films, he was spotted by Hollywood and put under contract to MGM. His Hollywood debut was the war drama *Never So Few* (1959), which saw him co-starring with Frank Sinatra and a young Steve McQueen.

Undoubtedly it was Johnson's debonair and handsome looks, and considerable acting ability, that made Terence Young insist Broccoli and Saltzman meet him, which they did. And Johnson turned them down. 'I was under contract to MGM anyway, so that gave me a reasonable excuse to say no, because they told me I'd have to be under exclusive contract to them for seven years.'[16] Johnson didn't much fancy the prospect of playing the same part for that amount of time. 'Eventually they offered it to Sean, who was completely wrong for the part. But in getting the wrong man they got the right man, because it turned the thing on its head and he made it funny. And that's what propelled it to success.'[17]

Ironically, Johnson did get a chance at playing secret agents when he appeared as the revamped Bulldog Drummond in a couple of 007-inspired romps, *Deadlier than the Male* (1966) and *Some Girls Do* (1969). These two films give a pretty good indication of how Johnson would have gone about playing Bond.

Another Bond potential was William Franklyn, who may have been on Broccoli and Saltzman's list because of his role in the then popular television series *Top Secret* as Peter Dallas, a British agent fighting crime in Buenos Aires. 'So, I had a bit of mileage under my belt as a smooth spy type,' he said. Born in London in 1925, Franklyn served in the Parachute Regiment during the war, then soon after being demobilised appeared in repertory theatre. Small roles on television and film followed, including *Above Us the Waves* (1955) and *Quatermass 2* (1957).

The actor did once reveal that he was amongst the final short list of six actors drawn up by the Bond producers, but never got to carry a Walther PPK. Not long after losing out on Bond, Franklyn got the job that earned him his place in TV history, lending his distinctive vocal tones to advertise Schweppes Tonic Water in a host of commercials, whispering the words: 'Schhh! You know who.' In an early one, he even sported a dinner jacket, James Bond-style. Franklyn also appeared as a spymaster in the Morecambe and Wise 007 spoof *The Intelligence Men* (1965).

Someone else with quite a bit of experience was Patrick Allen, who had been playing military types in war films like *Dunkirk* (1958) and *I Was Monty's Double* (1958). He also took the lead role in the controversial Hammer drama *Never Take Sweets from a Stranger* (1960) and enjoyed a busy stage career, too. Tall, attractive and with a jutting jaw, on 12 July 1961 *Variety* reported that Allen was 'likely' to be cast as James Bond. In an interview with the Hammer fanzine *Little Shoppe of Horrors*, Allen revealed that he wasn't tested: 'Let's say I was given a brief look – along with who knows how many others. Somehow the producers came up with the right actor. I can't imagine anyone who could have been better than Sean Connery.'[18] Asked if he had any regrets about not getting the 007 job, Allen replied, 'Well, it might have been nice, but no. It's not easy handling all that comes with playing a role like that.'[19]

Allen continued to appear successfully on film and television, and thanks to a distinctive, authoritative voice later won a lot of commercial work as the voice-over for Barratt Homes and British Leyland, among many other ads. In the 1970s he narrated a series of government public information films intended to offer advice for survival in the event of a nuclear holocaust. Some of his lines were later sampled for the Frankie Goes to Hollywood hit 'Two Tribes'. Allen was also regularly employed doing voice-overs for British film trailers, including for most of the Roger Moore Bonds.

One actor who might have been expecting a call from Broccoli and Saltzman was George Baker. A few years before, Baker was having lunch with Robert Clark, head of Associated British Picture Corporation, where he was under contract, when who should walk into the restaurant but Ian Fleming. 'Ian came over to our table,' Baker recalled, 'and he said, "Now Robert, you've got to do these books and there's your Bond

sitting beside you." And Robert made the wonderful, classic remark, he said, "Ian, they're good books, but they'll never make films."'[20]

Best known for his role as Tiberius in the BBC drama *I, Claudius* and Inspector Wexford in fifty-two episodes of *The Ruth Rendell Mysteries*, Baker made his West End debut in 1953. He was spotted by future Bond director Guy Hamilton and offered a small role in his film *The Intruder* (1953), which was quickly followed by a part in *The Dambusters* (1954). The starring role in historical swashbuckler *The Moonraker* (1957) led to a sudden burst of fame, which included a stint on Broadway in a Noël Coward play and an affair with Brigitte Bardot – all of which should have been enough to rank him high on any list of potential Bonds. 'When Broccoli and Saltzman came on the scene,' Baker related, 'Ian Fleming actually rang me up and said, "Now George, I'm going to put you up again because this time you're going to get it." I was never even seen. I never got an interview. So, that was that. Broccoli and Saltzman had different ideas, I guess.'[21]

Baker, however, must have left some sort of impression on the producers since he was later cast as Sir Hilary Bray, head of the Royal College of Arms, in *On Her Majesty's Secret Service* (1969), and then as a naval bigwig in *The Spy Who Loved Me* (1977).

Who were Fleming's ideal Bond candidates at this time, besides George Baker? Much has been written about his preference for David Niven. Whether Niven would have been any good is debatable, however fine an actor he undoubtedly was. One can't judge it by his performance in the 1967 spoof *Casino Royale*, as that was played for laughs. Probably Niven was too refined, too gentlemanly to play a cold-blooded assassin, too old as well; he was already in his fifties by 1962.

In 2009, when the highly respected Irish-British actor Richard Todd died, many of his obituaries noted that he was a favoured choice of Fleming to play Bond. Indeed, that the actor had to rule himself out due to other work commitments. Todd had been a major star in the 1950s, playing heroic British figures like Robin Hood and *The Dambusters*' Guy Gibson, but by the early 1960s his box office lustre was fading. Todd certainly had the stiff upper lip qualities to play Bond, but his screen personality was perhaps too bland, too conservative, and he didn't have the vicious quality the role demanded. Famously, Todd was amongst the first British officers to land in Normandy on 6 June 1944, D-Day, as part

of Major John Howard's glider force that captured the strategic Pegasus Bridge. Todd would later play Howard in *The Longest Day* (1962). In a side note, Todd bought the rights to Fleming's non-Bond novel *The Diamond Smugglers*, and announced in 1964 his intention to both star in and produce a film version to be shot on location in South Africa. Despite working on the project for at least two years, it never transpired.

According to Sir John Morgan, Fleming's stepson-in-law, the author had another favourite, the little-known actor Edward Underdown. Educated at Eton College, Underdown was a jockey and steeplechase rider before making a career for himself in post-war British cinema playing supporting roles, notably in the Bogart cult classic *Beat the Devil* (1953) in which he was Jennifer Jones' prim dullard of a husband. Most of Underdown's work was in dismissive 'B' level fare as stuffy types or military men. Fleming's apparent enthusiasm for Underdown was clearly not shared by Broccoli and Saltzman who never took the actor seriously for the role. In any case, Underdown was already by then in his fifties. They did, however, later cast him as the Air Vice Marshal in *Thunderball* (1965).

Despite Saltzman's earlier pronouncement to the press that Bond was 'the acting plum of the decade', much head-scratching was going on over who would ultimately be perfect in the role. Drastic measures were called for. In July 1961 Patricia Lewis, the show-business editor of the *Daily Express*, announced, 'Harry Saltzman and Albert "Cubby" Broccoli are having trouble casting James Bond for their upcoming series of feature films.' That was an understatement. The search was getting so desperate that a helping hand was required, so Lewis announced a 'find James Bond' contest. 'Competitors must be aged between 28 and 35,' she wrote. 'Measure six foot in height; weigh about 12 stone, have blue eyes, dark hair, rugged features – particularly a determined chin – and an English accent.' Applicants were invited to send their CV, photographs and vital statistics to a production office in Soho Square. The finalists would be chosen to undergo screen tests in front of a judging panel that included Saltzman, Broccoli, Fleming and Patricia herself.

The winner was announced in late September as 28-year-old London fashion model Peter Anthony. 'He's often seen these days in tobacco adverts,' noted *Kinematograph Weekly*, 'laying flat on his back, a straw hat pushed over his eyes, smoking a cigarette.' In Patricia's column Broccoli noted a 'Greg Peck quality about him'.

Peter Anthony got into modelling purely by chance. He'd just come out of the merchant navy and was living in Carnaby Street when a friend who owned a small store in the area was looking for models for a clothing catalogue he ran. When that seemed to work out Anthony answered an ad in the magazine *Man About Town* asking for models. He sent a photo, did some tests and was hired. *Man About Town* was a man's magazine of the 1950s and '60s, very much the progenitor of today's men's style magazines. Over the next few years Anthony became one of its most in-demand models, and was photographed by the likes of David Bailey, Terence Donovan and Norman Parkinson. He also had a lot of success later in New York doing television commercials.

It was an actor friend that pushed Anthony to respond to the *Daily Express* competition. He sent some of his *Man About Town* photos in, shots of him behind the wheel of a snazzy sports car or posing in a sharp suit. They certainly made an impression and out of something like a thousand applicants he made the final six. Interestingly, another of the finalists was a stuntman called Bob Simmons. Anthony received a letter from Saltzman and Broccoli's film company, Eon Productions, asking him to report to The Dorchester hotel where he would be picked up and chauffeured to Twickenham Studios for a test. He was also sent a two-page script to perform. It was a scene taken from the *Dr. No* screenplay where Bond reports to M's office and is told that his Beretta is being replaced with a Walther PPK. He was loaned a costume and a film prop gun. Anthony then took part in a photo session with the five other candidates, then another one by himself. It all went extremely well. 'The producer Cubby Broccoli called me to say he wanted to see me,' Anthony recalled years later. 'He and Ian Fleming had no doubt. I had the physique and the build to play Bond.'[22]

Anthony must have been called into Eon's offices at South Audley Street because he told his long-time friend, David Rossi, what happened next:

> He remembered that he was sitting on the settee and there was Broccoli and Saltzman, and while one of them was sat in front of him chatting and asking questions, the other one was slowly walking round in circles eyeing him up from every angle, from the back and the side, checking him out as far as his profile goes.[23]

The final decision was that Peter Anthony was worth taking a punt on. 'He was very photogenic,' says Rossi, 'with the square jaw and what have you. And he had the voice as well, quite a deep voice.'[24] But obviously his acting was insufficient, so the producers came up with the idea of him taking acting lessons and going into repertory theatre to gain some experience. But Anthony had the good sense to realise that he wasn't an actor; besides he was doing very well financially out of his modelling career. 'They would have paid me £40 a week to learn how to act. I would have had to go to a theatre in the London suburbs. But I was getting £100 a day to be a model. So, I said "no" to the role. And I have never regretted it.'[25]

It would have been a gamble too, after all it was just the one film, nobody knew if it would be a success and lead on to a series. That would mean Anthony having to give up his lucrative modelling for a length of time. 'And once you're out of the modelling game it was difficult to get back in,' says Rossi.[26] That must have preyed on Anthony's mind. Other younger models would take his top spot while he was gallivanting around in rep. Plus he wasn't guaranteed the part at the end of it. This led to his decision to stay with the modelling. As a memento of the experience, Anthony always kept the letter Eon sent to him.

Broccoli felt much the same way too: while he considered Anthony an 'exciting find', his lack of acting experience was a major drawback and he thought he would be unable to cope with such a demanding part as Bond at the first attempt. As it was, Anthony didn't think it was such a big deal losing out on Bond. No one expected the films to be such a huge success, and because he wasn't really an actor anyway it didn't matter to him one way or the other.

He must have made a strong impression at that audition, however, and stayed in the mind of Broccoli, because sprinting ahead to 1971 and *Diamonds Are Forever* the producer contacted Peter Anthony again. 'He still looked the part,' confirms Rossi. 'Even into his 70s Peter looked very smart, he never let himself go, he used to be careful about what he ate.'[27] Then living in New York and working for a top modelling agency, Anthony was flown over to Los Angeles to meet with Broccoli, Saltzman and director Guy Hamilton. He was then asked to perform a screen test: the scene where Bond, posing as diamond smuggler Peter Franks, meets Tiffany Case in her apartment. They are interrupted by the real Franks

and Bond engages in a fierce fistfight. The test never led anywhere, and once again Anthony was beaten to the role by a returning Sean Connery.

Peter Anthony never did go into the acting game, staying in the modelling business until the late 1970s when he returned to the UK. He left New York because of the rise in crime and didn't want to bring up his children there. In London he opened a French restaurant in West Smithfield, which in its heyday in the 1980s was a hang-out for Fleet Street hacks and Westminster MPs. 'The menu was only in French and all the staff were French,' recalls Rossi. 'At the time you couldn't get a table there it was so popular.'[28] When it closed in 1991, Peter and his French wife, Katherine Pastrie, herself a top model in the 1960s, retired and moved to Antibes, the historic French coastal town.

According to David Rossi, Peter Anthony never had any regrets about losing out on Bond – twice – and rarely, if ever, really talked about it. 'He wasn't one of those guys who was flash about things. He was always quiet about it. And 100% he had no regrets about it. He enjoyed his modelling, travelled the world. The money was very good and he had a great time.'[29]

Peter Anthony passed away in 2023.

Back to that *Daily Express* competition and Patricia Lewis. In one of her articles, the writer revealed her own choice for the role of Bond. No doubt taking advantage of rumours currently circulating around both Wardour and Fleet Street she said, 'Who will get the part? My hunch is that it will go to Sean Connery.'

Terence Young first met Connery in 1957 when he directed the young and inexperienced actor in a piece of melodramatic rubbish called *Action of the Tiger*. 'He was a rough diamond, but already he had a sort of crude animal force, like a younger Burt Lancaster or Kirk Douglas,' remembered the director.[30] It wasn't only Young who spotted the raw charisma pouring off the Scotsman but the female star of the film Martine Carol. 'This boy should be playing the lead instead of Van Johnson,' she told Young one day on location. 'This man has big star quality.'[31] Hardly surprising, since Van Johnson had the sex appeal of a haddock.

Young knew *Action of the Tiger* was tosh, that he'd botched it. At the end of the shoot, Connery approached him asking, 'Sir, am I going to be a success?' Young didn't want to lie to the eager actor of whom he'd grown fond and answered, 'Not after this picture you're not, but keep

on swimming until I can get you a proper job and I'll make up for what I did this time.'[32] Young would indeed keep his promise.

Elsewhere other filmmakers, who would play a significant part in the success of the early Bond films, were being switched on to Connery. Editor Peter Hunt was currently working on a low budget comedy about two scroungers in the RAF called *On the Fiddle* (1961). Not much was expected of the movie produced by the Polish Benjamin Fisz, an associate of Saltzman; they later teamed up together to make *Battle of Britain* (1969). Even less was expected of the two leads, Alfred Lynch and Sean Connery. One evening Peter Hunt and Fisz were enjoying a meal at the Polish Club in London when they were joined at their table by Saltzman and his wife Jacqueline. It was during this meal that Hunt was offered the editing job on *Dr. No*. Inevitably the conversation turned to how Saltzman was getting on with the tests to find a suitable actor to play the part. 'What about that Sean Connery,' Fisz suddenly said. 'Don't you think he might make a good James Bond?'[33]

This was a statement that took Hunt completely by surprise, since Fisz had originally been dead set against casting Connery in *On the Fiddle* when its director Cyril Frankel first suggested him. 'He can't act,' Fisz had complained. 'He's just sitting around at the Pinewood canteen doing nothing and nobody will work with him.'[34] But Frankel wanted Connery, his brawn and earthy vulnerability would play well in the role of a dim but loyal soldier. 'Well, I've tested him,' Frankel told Fisz. 'And I know I can get a performance out of him.'[35] And so, reluctantly, Fisz agreed. Now here he was putting that same actor up for James Bond. Hunt agreed and said, 'Well, we could send a reel up for Harry or Harry can see whatever he likes of the film.' Saltzman was keen on the idea. 'Yes, can you send me up some film?'[36] Fisz and Hunt discussed which reels were the best ones featuring Connery and the next day shipped them over to the Bond office.

According to Cyril Frankel, Fisz turned up with Saltzman on the set of *On the Fiddle*, still filming at Shepperton Studios. 'And they said to me, "Do you think Sean could play James Bond?" And I said, "Standing on his head and reading a newspaper." And that's how Sean got the part.'[37]

Almost at the same time in Hollywood, Broccoli organised a screening at the Goldwyn Studios of a Walt Disney picture Connery made in 1959, a charming Irish fantasy called *Darby O'Gill and the Little People*.

Broccoli first encountered Connery when he and his former producing partner, Irving Allen, were making the dark comedy *How to Murder a Rich Uncle* (1957). Connery was one of two young actors that showed up at the producers' Mayfair office looking to play a small role in the film. Broccoli interviewed them one after the other before finally making his choice. It wasn't Connery; Broccoli selected the other actor instead, Michael Caine.

Something like six months later Broccoli was formally introduced to Connery at a London party given by Lana Turner, who was working with the young actor in the romantic potboiler *Another Time, Another Place* (1958). 'He was a handsome, personable guy, projecting a kind of animal virility,' Broccoli later wrote. 'He was tall, with a strong physical presence and there was just the right hint of threat behind that hard smile and faint Scottish burr.'[38] Broccoli never thought very much of the film when it came out, but Connery's potential must have registered with him, especially his 'easy, confident style in front of the cameras'.[39]

Darby O'Gill wasn't the ideal vehicle to show off Connery's potential as James Bond, playing as he did an innocent farm labourer, so an unsure Broccoli called up his wife Dana. 'Could you come down and look at this Disney leprechaun film? I don't know if this Sean Connery guy has any sex appeal.' Dana caught a cab and arrived at the screening room. The lights dimmed and the movie began, and it wasn't long before Connery appeared. 'I saw that face,' Dana was to recall. 'And the way he moved and talked and I said, "Cubby, he's fabulous." He was just perfect; he had such presence. I thought he was star material right there.'[40]

And so, a meeting with the actor was arranged at the same London office in South Audley Street where Connery had failed that earlier audition for Broccoli. Terence Young telephoned Connery urging him to wear a suit for the impending interview and not his usual casual street gear, but the actor insisted on arriving scruffily dressed in baggy, unpressed trousers, a nasty brown shirt, no tie, a lumber jacket and suede shoes. Young had never seen anyone come more deliberately to antagonise people. Associate producer Stanley Sopel thought Connery the most appallingly dressed man he had ever seen. 'He looked as though he'd just come in off the street to ask for the price of a cup of tea.'[41]

Throughout the meeting Connery behaved with bloody-minded arrogance, repeatedly pounding on the desk, swearing and making

demands. It was all an audacious act, for Connery didn't want to leave the impression of a starving actor desperate for work. 'I think that's what impressed us,' Broccoli remembered. 'The fact that he had balls.'[42]

Next, the thorny question of a screen test was broached. Connery shook his head. 'Sorry, but I'm not making tests. I'm well past that. Take it or leave it, but no test.'[43] Broccoli and Saltzman rose to their feet to thank him for coming and said they would be in touch. No sooner was he out of the room than they rushed to the window to watch him leave the building and cross the street. It was the way Connery moved that clinched it: for a big man he was light on his feet, 'like a big jungle cat', Saltzman observed. Broccoli said, 'He walked like he was Superman. The difference with this guy is the difference between a still photo and film. When he starts to move, he comes alive.'[44] The producers had found their Bond. Barring falling under a double-decker bus, Connery was it from that moment. 'We'd never seen a surer guy,' said Saltzman. 'Or a more arrogant son of a bitch!' added Broccoli.[45]

The fact that both producers were international (Broccoli American, Saltzman Canadian), and not English, undoubtedly affected their final choice for Bond; neither really wanted some cultivated actor with a RADA accent. Alert to the world market, they needed their Bond to be less Ian Fleming's old Etonian and more of a brawling street fighter. Hence Broccoli's belief that Connery's virile, aggressive masculinity was crucial, arguing against the role being played by 'some mincing poof'.[46] It was a view shared by Bond screenwriter Richard Maibaum:

> Sean was nothing like Fleming's concept of Bond. But the very fact that Sean was a rough, tough Scottish soccer player made him unlike the kind of English actors that Americans don't like. Sean was not the Cambridge/Whitehall type – he was a down to earth guy. The fact that we attributed to him such a high-style epicure was part of the joke.[47]

Backers United Artists were less than convinced. Refusing to test, Connery was tricked into undergoing a few filmed auditions with prospective leading ladies. This footage was sent to America and the studio response was blunt to say the least. A cable sent to Saltzman dated 23 August 1961 read: 'New York did not care for Connery feels we can

do better.' To their credit Broccoli and Saltzman stood by their man, intending to go ahead with Connery or not at all.

In his memoirs, film executive David Picker recalls how things unfolded stateside. At the time, Picker was assistant to United Artists president Arthur Krim. Names had been filtering across the Atlantic about who was going to play Bond; McGoohan's name was mentioned, so too Robert Shaw. Then Picker got a call from Saltzman saying he was coming to New York with some footage and photographs of their choice for Bond, Sean Connery. The clips Saltzman played were from *Darby O'Gill* and *Another Time, Another Place*, in which Connery was given an 'introducing' credit. Picker was unsure about the accent but thought he was attractive. 'I was neither over or underwhelmed. I asked Harry if he was the best he could find, and his answer was, "He's the richest man in the poor house." "If he's the best you can find, then let's go with him." It was as simple as that.'[48]

The producers were a little anxious about telling Fleming that they'd found his dashing hero in the guise of a former Scottish milkman. On finally hearing the news, Fleming wrote to his friend Ivar Bryce: 'Saltzman thinks he has found an absolute corker, a 30-year-old Shakespearean actor, ex-navy boxing champion and even, he says, intelligent.'[49] A meeting between Connery and Fleming was arranged at the author's cramped business office near Pall Mall. Sir John Morgan, Fleming's stepson-in-law, was also present. 'Afterwards Ian said to me, "That couldn't be further from my idea of James Bond. Everything was wrong, the face, the accent, the hair." It was a thousand miles away from his idea of James Bond.'[50]

They talked and, in the end, Connery guessed Fleming regarded him as a compromise choice. Saltzman, however, knew Fleming was far from sold on the idea. 'I was looking for Commander James Bond, not an overgrown stuntman,' was one derisory comment supposedly made by the author. Fleming feared that the working-class Connery didn't have the sophisticated persona to play Bond. His mind was to be swayed by a female companion over lunch one day at the Savoy. At Fleming's table was Connery, Ivar Bryce and Bryce's cousin, Janet, who had recently married the 3rd Marquess of Milford Haven. After lunch she pronounced Connery as having 'IT' and that seemed good enough for Fleming.

When the producers finally presented the Bond offer to Connery, it was much like asking a boy who is crazy about cars if he'd like a Ferrari as a present. Connery sensed that, if done right, *Dr. No* would be the first of many Bond films; it was a great opportunity and because of that it gave him pause. Connery was wary of long-term commitments, having been burned once before. Back in the late 1950s Connery was under contract to 20th Century Fox, where he was repeatedly loaned out to make films at other studios; that taught the actor a valuable lesson, what it felt like to be owned. Connery was adamant that would never happen again: 'Contracts choke you and I wanted to be free.'[51]

Broccoli and Saltzman had fanciful notions about maybe turning out two Bond films a year. After much consideration they scaled that back to just the one, but declaring that Connery had to make five 007 films over a period of five years. The original contract also stipulated that Connery's non-Bond films be produced under the aegis of Broccoli and Saltzman. This smacked of ownership, it would virtually make Connery a slave to the Bond Company Eon, and the actor quite rightly wanted nothing to do with it. The producers hastily rubbed that part of the contract out and Connery was free to find projects elsewhere, providing they did not clash with his Bond commitments.

For days Connery pondered the offer and talked it over with his fiancée, the actress Diane Cilento, whose opinion he valued. Connery had only read a couple of the Fleming books and gave Diane a few to look over. Cursorily reading through them she found Fleming's Bond 'relentlessly awful unless he was given a sublime sense of humour'.[52] It was Cilento's advice that if Connery was to accept the role, he should insist that the script have more humour in it to take 'the unpleasant edge off the character'.[53] As it happened, Terence Young agreed to give the film another dimension by injecting humour, but at the same time to play it absolutely straight and serious. To make the fantasy as believable as possible.

On 3 November 1961 it was announced in the movie trade papers, with surprisingly little fanfare, that Connery had secured the role of James Bond. In the later climate of multimillion dollar deals it's striking to note that Connery's fee for *Dr. No* was a modest £6,000.

Colleagues found it all terribly amusing that Connery had landed the role of 007. 'It was a bit of a joke around town that I was chosen.'[54]

One day Saltzman bumped into the playwright John Osborne, his old producing partner at Woodfall Films. Saltzman told Osborne of his plans to make a Bond film. 'And who do you think I've got as James Bond?'

Osborne scarcely knew the books but gamely played along. 'I don't know, Harry. James Mason.'

Saltzman stared back. 'Hell, no.'

Osborne had another try. 'David Niven.'

'For Christ's sake,' screamed Saltzman, before pausing for effect. 'Sean Connery!'

Osborne looked incredulous. 'Harry, he's a bloody Scotsman! He can hardly read.'[55]

There was nothing much in Fleming's English public school Bond that connected with Connery. The actor's friend, the director John Boorman, claimed that it was probably only Connery who could have taken the character by the throat and shaken some sense into it. That it was the disparity between the man and the role that made it so compelling. Here was a Scot from humble origins playing a product of the English establishment. What made Connery's Bond so appealing worldwide was that he was able to imbue the character with a cool classlessness that tapped into the energy of the emerging new decade, and arrived at the same time as other working-class actors like Albert Finney, Michael Caine and Peter O'Toole. If the Bond films had been made any time in the 1950s undoubtedly someone of the ilk of David Niven would have played him. Now it was perfectly reasonable, indeed it made creative and commercial sense, to hire a working-class actor to play what was essentially a servant of the state, a British hero.

Connery came from as working class a background as it was possible to imagine. Born in 1930, he grew up in Fountainbridge, a deprived and rough area of Edinburgh, where his father worked in a local factory and his mother was a cleaner. Fountainbridge was the kind of place that bred people to work all their life in physical labour. Connery began work young, at the age of 9, delivering milk at the crack of dawn. By his fourteenth birthday he was done with school, leaving with no qualifications. He took on a succession of dead-end jobs, lifeguard at the local swimming pool, road digger, coffin polisher, and working in the machine room of the *Edinburgh Evening News*. There was also a stint in the navy, which didn't last long as he was invalided out with ulcers.

For a while Connery was an artist's model and had begun body-building at a local sports club. With some friends he came down to London to compete in the 1953 Mr Universe contest. This led to a job in the chorus line of the stage musical *South Pacific* when word went out that the producers were looking for muscular types to play the sailors. Then on a record-breaking run at London's Drury Lane, Connery remained with the show when it went on a year-long UK national tour. By the end it was his ambition to become an actor. He managed to land extra and walk-on roles in theatre, TV and film before his big break in 1957 when he played the lead in a BBC play, *Requiem for a Heavyweight*. Out of that came his contract with 20th Century Fox.

For a while it looked like Connery was heading in the right direction, with featured roles in a Tarzan picture, a film for Disney and starring opposite Hollywood goddess Lana Turner. But as the 1960s began he had lost momentum and looked as far away from stardom as ever, appearing in what amounted to British 'B' films, like the modest London gangster drama *The Frightened City* (1961). Ironically it was on the small screen where Connery was still doing his best work, as Hotspur in *An Age of Kings* (1960), the BBC's epic serialisation of Shakespeare's history plays; playing Alexander the Great in the BBC's 1961 adaptation of Terence Rattigan's play *Adventure Story*; and starring opposite Claire Bloom in another BBC stage adaptation, this time Tolstoy's *Anna Karenina*. Within days of *Anna Karenina*'s broadcast Connery was announced as James Bond. He had even been flown over to Canada to play the lead in a television production of *Macbeth*.

Broccoli and Saltzman took a giant leap of faith casting Connery, and they gave the task of transforming him into Bond to Terence Young. The director began by taking Connery to his own tailor and shirtmaker and making him go out in this new, unfamiliar wardrobe. 'Because Sean's idea of a good evening out would be to go out in a lumber jacket.'[56] Young even made Connery sleep in one of his new suits to get the feel of it. He also took Connery to fine restaurants in Mayfair and taught him how to order wine; they visited gaming clubs too, learning the basics of casino etiquette. Connery's hair and eyebrows were also trimmed. It was a total transformation; a feat of which Henry Higgins would have been proud. And Connery, like a sponge, absorbed it all.

Above all, Connery had the wonderful advantage of spending time with Fleming himself, something denied to every subsequent actor in the role. Together they discussed Bond the man and the world he operated in. Over time Fleming grew enormously fond of Connery and the feeling was reciprocated with genuine warmth. Fleming even bestowed on Bond Scottish heritage. 'That's all a tribute to Sean,' said 007 screenwriter Tom Mankiewicz.[57]

Shortly before *Dr. No* opened in British cinemas, the journalist Ken Ferguson, for *Photoplay* magazine, visited Ian Fleming at his London office to talk about the impending debut of his literary creation. 'This chap, Sean Connery, is damn good,' said the author. 'When I first met him, I thought he was a bit on the large side and rugged. But he looks and moves very well indeed, which, of course, is important. Intelligent sort of chap, too. I think he makes a very good James Bond.'[58]

Fleming talked to Ferguson about the exhaustive search that everyone undertook to find the right actor, which at some point included the likes of Cary Grant, James Mason and David Niven. 'But after long chats with the producers we decided to go for a fresh face. Mr Connery is certainly not new, but his face isn't as identified as those of Grant, Mason, Niven and so on. It was a gamble, but I think it has paid off extremely well.'[59]

Today the casting of Connery is seen as a stroke of genius, but his debut performance in *Dr. No* drew a mixed bag of notices. The critic of *The Spectator* ridiculed him as nothing more than a superannuated Rank starlet, while the *Monthly Film Bulletin* saw him as a 'disappointingly wooden and boorish Bond'. The *News of the World* felt he fitted Fleming's hero 'like a Savile Row suit'. And *Time* magazine suggested Connery 'moves with tensile grace that excitingly suggests the violence that is bottled in Bond'. Ultimately it was the public who decided and *Dr. No* was a global smash hit.

What Connery brought to the Bond role that few other actors were capable of was sheer animal sexuality and raw masculine power. With Connery there was always a hint of the beast lurking beneath the tuxedo. Audiences believed that here was a man who would kill without hesitation. Connery once revealed that the secret to playing Bond was that the actor inhabiting the role must be dangerous. 'If there isn't a sense of threat, you can't be cool.'[60]

The actor also brought a great deal of physicality to the role. As a former bodybuilder, Connery looked formidable on screen, the embodiment of Broccoli's edict that Bond be a ballsy, two-fisted spy. The teachings of Yat Malmgren were especially of help here. Malmgren was a Swedish ballet dancer and acting teacher who had opened his own school in London. With Diane Cilento, Connery attended his movement classes for a period of three years. As a young drama student, Pierce Brosnan also studied under him. The graceful way Connery moved as Bond was then part natural, part learned. 'One of the chief qualities, I think, that made Sean such a big star in those early Bonds, was his movement,' said Philip Saville, who directed Connery in one of his early television plays. 'His hand movement, his agility, he was an altogether organic man. It's a very important quality if you're making action movies. Steve McQueen had it, he had that natural sense of forward movement and all his body coordinated. Connery had it, too, in spades.'[61]

With *Dr. No* raking in the money, Saltzman and Broccoli hurried their next film, *From Russia with Love*, into production, and it proved even more successful. The producers were on a crest of a wave and readying the third 007 opus *Goldfinger* (1964) when an Irishman threatened to gatecrash the party.

After successfully suing Ian Fleming for plagiarism over his novel *Thunderball*, Kevin McClory was now the proud owner of the film rights, and following the huge success of the first two Eon-produced Bond films intended to bring out a renegade 007 feature. With press reports suggesting it was ready to go before cameras in March 1964, the same month as *Goldfinger*, two names were mentioned as potential Bonds: Laurence Harvey and Rod Taylor. Harvey seemed the favourite and in January revealed to the press that he had been asked and was considering the offer. 'I think the script is marvellous and I would be delighted to portray Bond.'

With his clipped speech and refined manner, this very 'English' appearing actor was born in Lithuania and educated in South Africa. Coming to Britain in 1946 to enrol at the Royal Academy of Dramatic Art, he languished for several years in a series of second features until his Oscar-nominated performance as the ruthless social climber Joe Lampton in *Room at the Top* (1958) brought him fame. Big roles followed,

opposite John Wayne in *The Alamo* (1960) and as the brainwashed assassin in John Frankenheimer's *The Manchurian Candidate* (1962). So, Harvey was pretty much at the top of his game when McClory approached him about Bond.

The press had a field day with the prospect of competing 007 movies. 'Stand by for the battle of the Bonds' was one headline. Never before had two independent producers prepared to film two different movies at the same time each featuring the same hero. But the big question everybody was asking was – would the public accept another actor as Bond, now that Connery had so completely made the part his own?

Harvey and Taylor were soon out of the running, with McClory declaring that while his Bond would not be played by an American actor, he would be personified by a 'big animal type actor'. He also told reporters that he wanted to cast his Bond from the very top acting drawer, likely candidates now being Peter O'Toole and Richard Burton. 'Or alternatively to do an offbeat Bond with Peter Sellers.' This was a bizarre suggestion from McClory, but it found resonance somewhere as three years later Sellers would indeed be cast as the lead in Bond spoof *Casino Royale*.

Influenced perhaps by Fleming's suggestion years before that Richard Burton would be his ideal Bond, McClory approached the hellraising Welsh superstar. In late February he flew to Toronto where Burton had opened in a pre-Broadway run of *Hamlet*. Burton was reportedly 'very amused' with the idea of playing the super spy and more than curious about the very large pay packet. 'Richard would be absolutely fantastic as James Bond,' McClory told reporters. 'He IS James Bond.' McClory felt the Welshman was much closer to Fleming's original image than Connery.

A few days later, on 21 February, McClory revealed that after four days of talks with Burton, they were 'mutually agreed on all points'. The start date of *Thunderball* had now shifted from March to June when Burton's schedule was free. 'Everything appears right for him to step into the part,' a confident McClory told the press. 'Only the contract has to be signed.'

By the time Connery started work on *Goldfinger* he was hitting his stride as Bond. 'Sean was much more accomplished than in *Dr. No*,'

revealed the film's director Guy Hamilton. 'There is a big difference in the performances. He was becoming more assured in front of the camera; his personality was breaking through.'[62] At the same time the actor's fears of being typecast as Bond were starting to grow, and so the notion of someone else tackling 007 was an appealing one. 'Although I think they'd be crazy to do it,' he said. 'There was talk of Burton doing one, and I said he must be out of his mind. It would be like putting his head on a chopping block. Whatever he did he couldn't make the films more successful than they are.'[63]

Connery was right. McClory had lost the opportunity to put out a successful Bond film first. Broccoli and Saltzman had by now established a formula in the public's mind. Things like the opening gun barrel, the theme music, Connery, would all be missing from McClory's production. The only real chance he had was to join ranks with the producers he threatened to rival.

Broccoli and Saltzman felt much the same way, that a rival Bond production at this early stage would harm their own series. And so, by mutual consent, the two opposing forces joined together. In September 1964 Broccoli flew to Dublin where he and McClory met at the airport and a deal was struck. *Thunderball* became a co-production and the world never saw Richard Burton as James Bond, despite it nearly happening twice.

By this stage, however, things were not at all happy in the Bond camp, with Connery's relationship with the producers strained to near breaking point. Connery also found it increasingly difficult to live in a world where the public expected him to be Bond and only Bond. To some extent he no longer existed as an actor, or a person. In the eyes of millions, he was James Bond. As his wife Diane Cilento summed it up, 'A genuine international male icon was born and suddenly, Sean wasn't Sean anymore. He was James Bond, 007.'[64]

Perhaps his resentment might have been softened if the producers had taken the advice of Terence Young and cut the actor in on more of the huge profits the series was raking in, essentially making him a partner. 'In future make it Cubby and Harry and Sean,' urged the director. 'He'll stay with you because he's a Scotsman. He likes the sound of gold coins clinking together. He likes that lovely soft rustle of paper. He'll stay with you if he's a partner, but not if you use him as a hired employee.'[65]

Bond had made Connery a star, yes, and he was well paid for it too, but he always felt he was due more. Take the merchandise, for instance, most of which bore his image and raked in untold millions round the world, and yet he never received a single penny.

The producers did not take Young's advice and after the 1965 release of *Thunderball* Connery started dropping hints that his next Bond would be his last. 'The sooner it's finished, the happier I'll be,' he told one reporter, no doubt with a pissed-off expression on his face. The producers hit back. Broccoli could sometimes be heard to complain, 'We'll get a new Bond. They got new Tarzans, didn't they?'[66]

Over at United Artists, executives were getting jumpy, especially over the expensive publicity blitz that would be required to sell a new Bond to the public. 'There might be a lot of initial interest in a new Bond,' said United Artists' David Picker. 'But if he didn't go over, 007 would be in trouble.'[67]

Contractually obligated to do two more Bond films, *You Only Live Twice* and then *On Her Majesty's Secret Service*, the producers attempted to ease the tension with their star by dropping the requirement for the second film, confident Connery could be wooed back after he had cooled off for a while. Connery, though, had made up his mind. It wasn't just his fear of becoming typecast, or the money, but the fact that the Bond shooting schedules had got progressively longer, making it difficult to fit in other work. He could do, say, two films in the time devoted to bringing just one Bond to the screen.

Before cameras rolled on *You Only Live Twice* (1967), Connery made an announcement many had been predicting: this was indeed to be his final Bond. The 007 image, he said, had turned into a Frankenstein's monster and his relationship with the producers had irredeemably broken down. In Tokyo, Broccoli was interviewed by journalist Alan Whicker about the future of a Connery-less Bond series. 'It won't be the last one under any circumstances. If Sean doesn't want to do it, and he has a right not to do it, this won't stop us from making another Bond that audiences out there want to see.'

Lewis Gilbert, riding high on the success of *Alfie* (1966), had been given the directorial reins on the new Bond and remembered trying to talk Connery out of quitting the series, putting a quite logical argument to him:

> I was against him leaving and I used to say to him, 'Sean, you are taking a risk, because in a sense you are typecast now. You're in an incredible situation here, because when you're Bond you can do what the greatest actors in the world can't do. If you say to United Artists, I'll do the next Bond film, but I want to play Oedipus Rex or I want to do Hamlet, they'd say, Ok Sean, here's the money.' But he wouldn't listen. His mind was made up.[68]

Yes, Connery admitted to reporters, Bond had been good to him, probably more so than any movie character in history. 'But I've done my bit. I'm out.' At the film's royal premiere in London, when confronted by the Queen with the question 'Is this really your last James Bond film?' Connery bowed his head demurely and answered, 'I'm afraid so, Maam.'[69]

Connery's impact on the Bond role was such that future actors not only had to tussle with the myth of the character, but also the image of Connery himself. He is, and always will be, the yardstick. Honor Blackman, the screen's classic Pussy Galore, once confessed to me that she lost all interest in the Bond movies after Connery left. 'Sean was so special,' she said, 'and so right in the part.'[70]

Connery's performance had just the right mix of humour, cruelty and sexual power. At the actor's lifetime achievement award at the American Film Institute in 2006, Steven Spielberg paid tribute to his performance as James Bond and how it 'captured lightning in a bottle'. Certainly, for him as a 16-year-old watching *Dr. No* for the first time at his local drive-in, it made an impression. 'Every entrance a tour de force. Every turn of his head a suggestion of danger. And then every glance never without that twinkle of dry Scottish humour.' Connery's portrayal of Bond was truly a cinematic landmark that was to influence countless future screen action heroes. The problem now was, how do you follow that?

3

Replacing the Irreplaceable

Saltzman and Broccoli were determined that Connery's departure would not mean the end of the 007 franchise, as some commentators were predicting. The producers tried to convince the press, and maybe themselves too, that the Bond character was bigger than any single actor's interpretation of it. Still, they faced a daunting task; would the public accept a James Bond that wasn't Sean Connery?

In July 1967, as *You Only Live Twice* was packing out cinemas around the UK, Saltzman told the *Daily Mail*, 'The guy who gets this part will take off. Cubby and I made Sean a millionaire. I don't think any actor has got as rich as he has in recent years. Believe me; playing Bond is better than winning the pools.'

Yet, nervous at the notion of blooding a new actor, the filmmakers initially came up with the bizarre notion of Bond undergoing plastic surgery in the new film to render him unrecognisable to his enemies, and conveniently introduce their new star. Fortunately, they saw sense and this was ditched. It was screenwriter Richard Maibaum who called out the lunacy of the plastic surgery plot device at a script conference, asking why they didn't just have the new Bond say 'I'm not like the other guy' and get on with it. Hence Maibaum's line at the opening of *On Her Majesty's Secret Service*, when after rescuing a girl from kidnappers, only for her to run out on him, Bond turns to camera and says, 'This never happened to the other fella,' as the titles roll. As Maibaum explained, 'It said, look, you know it's not the same James Bond, so we're not going

to kid you or do anything corny to excuse it. You'll just have to accept that this just isn't the same fellow.'[1]

Speaking some forty-six years later, Sam Mendes, who directed two of the Daniel Craig Bond films, *Skyfall* (2012) and *Spectre* (2015), thought that line a terrible miscalculation, especially for a new actor taking over the role:

> Poor old George Lazenby, they gave this poor guy a poison chalice. They asked him to turn to the camera, look into it and say, 'This wouldn't have happened to the other guy.' To me, that was a complete misjudgement on the behalf of the filmmakers. Disaster. He looked into the camera and talked about another actor, playing the role. What chance could he possibly have, from that moment on, after basically apologizing for being himself? Talk about cutting someone off at the knees before they've even started. That was not a good idea.[2]

Connery's resignation from the Bond films came at a momentous time. The 1960s were drawing to a close and the state of cinema was very different to that of 1962 when *Dr. No* burst onto the screen. Society too had vastly altered; this was the era of counterculture, drugs and the civil rights movement, and the producers wondered how much of this social change should be reflected in the new James Bond. A new actor meant a new start. And so, a big meeting took place to discuss what direction to take. Should Bond reflect these changing times, even down to having an actor with long hair? While we were never going to get a paisley-shirted, weed-toting Bond going 'Groovy Blofeld, groovy', there was potential to reinvent the character. In the end, however, everyone reached the conclusion that they didn't want change; what they wanted was another Sean Connery. 'Fine,' said Peter Hunt, the man charged with directing the new 007 movie. 'I agree with that because at least now we've got some idea of what we're looking for.'[3]

In late 1967 the search for a new Bond began in earnest, principally to find an unknown who would have no associations with any other well-known role. Acting agencies and provincial repertory companies were trawled for suitable talent, 'testing the people who had that sort of sexual quality that Sean had', according to Hunt.[4] Saltzman, too, identified sex appeal as a major factor: 'I look for tremendous virility in

an actor, a sexual animal magnetism that makes men identify with my star and women want to kiss him.'[5]

The press quickly got in on the act. *Showtime*, a popular British movie magazine, invited its readers to vote for who they wanted to fill Connery's shoes. The results in their October 1967 issue make for interesting reading today. Tied in third place was Richard Johnson, then appearing in cinemas as the updated and very Bond-like Bulldog Drummond, and Patrick McGoohan, receiving less support than the magazine's editor had expected. There was another tie for second place with Gene Barry, then a big hit in the American TV police drama series *Burke's Law*, and a certain Roger Moore.

But the clear winner was – Oliver Reed. 'He's dark, handsome and very masculine,' was one view. Speaking to the magazine from the set of the film musical *Oliver!*, Reed thanked his supporters and commented:

> Ironical, really, to be considered old enough to play Bond. I was too young before. When Harry Saltzman started his 007 search, I was 22. He had me in mind for some time; spent ages trying methods of making me look older! Now I gather Ian Hendry is the best bet for the new Bond; he's a very good actor and would be great, if he wants to do it. But I think they'll go for a lesser known actor; and as Sean is so much a part of Bond, the new man will obviously be very Connery-ish; tall, tough and cruel-looking.

Candidates that didn't make the top three in *Showtime*'s poll are also worthy of note and included Terence Cooper, who had just played '007' fairly straight in the otherwise wacky *Casino Royale*, and Connery's brother Neil, whose Italian spy spoof, *Operation Kid Brother*, had yet to open in the UK (as *O.K. Connery*). 'He's Sean's exact double,' wrote one rather disillusioned reader. 'The public wouldn't know the difference.'

Many *Showtime* readers voted for their favourite TV stars, which accounts for the inclusion of names like Robert Hardy (then in the BBC's globetrotting oil drama *The Troubleshooters*), Adam Adamant himself Gerald Harper, Patrick Macnee and *Man from UNCLE*'s David McCallum. Surprisingly no one voted for Robert Vaughn. Some American actors, however, did receive the vote, including Robert Stack, Clint Eastwood, then making a name for himself in spaghetti

westerns, and a young Lee Majors, who 'strips well', according to one Manchester reader.

Already established film stars also made an appearance in *Showtime*'s poll; names like Michael Caine, James Coburn, Paul Newman and Stanley Baker. But, as with all polls and votes, there was the odd bizarre choice: can you believe Harry H. Corbett of *Steptoe and Son* fame, and singer Frankie Vaughan? 'Why not?' said one reader. 'He's a good actor.'

Whether influenced or not by the *Showtime* poll, Oliver Reed was seriously considered to take over from Connery, and it's fun to visualise just what he could have done with the role. Alas, Reed missed out because of his hell-raising reputation. Years later Broccoli outlined the reason why he finally decided not to take the gamble on Oliver Reed as 007. 'With Reed we would have had a far greater problem to destroy his image and remould him as James Bond. We just didn't have the time or money to do that.'[6]

In a press interview, Saltzman suggested that Roger Moore would make a great Bond, but that he was too well known as The Saint. Even so, the actor did have discussions with the producers about taking over from Connery. At the time, though, he was still committed to playing Simon Templar on television. So, it looked like the best option was to cast an unknown. 'And finding good, undiscovered actors of 30 is not too easy,' admitted Saltzman.[7]

Not easy, indeed. To get an idea of just how wide the producers were casting their net, or perhaps an example of how desperate they were, amongst the people approached was a television journalist for ITN's *News at Ten* called Peter Snow. Perhaps it was his trouble-shooting television persona as a roving reporter, covering everything from bank raids in London to war zones in the Middle East, that prompted Eon to contact him. Later, of course, Snow became something of a TV legend with his swingometer during BBC general election broadcasts. 'I was rung up by a production company,' Snow recalls:

> And they said, 'Would you be kind enough to come round in connection with the James Bond series.' I went round to this house in the middle of Mayfair, it was a modest little house, and there was a small grill on the door. I knocked on the door and I saw a little slot opening and these eyes stared out at me and started looking me up and down. I

saw a definite sense of the eyes dropping when they saw how tall I was. I am six foot five. So, the eye let me in and said, 'Do sit down. We are considering from a wide range of people who should be James Bond. But to be perfectly honest, from the moment I saw how tall you were outside I realized that you were probably not going to qualify.' And I said, 'Oh, I'm very disappointed to hear that.' We had a very pleasant chat and then I went off and that was it.[8]

This was far from being a proper audition, or even an interview:

I wasn't asked how well I could act; I was simply looked at by this guy. Now, I am unusually tall, so that may have squashed my chances I'm afraid. I was delighted to be contacted, it seemed to be a great compliment and I would have been very sorely tempted to do it if I had been asked. But I'm very glad that I wasn't asked because I would have missed out on a lifetime of journalism. Then I suppose I could have tried to get back into it again, or maybe have been made offers of other film parts, but I think once you do James Bond, you're lucky not to get typecast. But my whole life would have been different. I'm sure I would have had a whale of a time, but alas it never transpired.[9]

Even more improbable as Agent 007 was Lord Lucan, who was to famously disappear from his home in London in November 1974 after his children's nanny was found murdered. He was never seen again. No actor to be sure, but the aristocrat's background was exemplary. The 7th Earl of Lucan, he was born in 1934, educated at Eton and served in the Coldstream Guards. He was also an inveterate gambler, playboy and man about town. He even owned a soft-top Aston Martin.

Broccoli knew Lucan, but only as an acquaintance, probably on nodding terms as they frequented many of the same gambling clubs in Mayfair. In Sally Moore's 1987 book on Lord Lucan, Broccoli saw him as the very image of Commander Bond, 'He had it all – the looks, the breeding, the pride', and seriously wanted to test him for the role. All Lucan is reported to have said regarding the offer was – 'Good heavens!'

Lucan may have been put off acting after a disastrous screen test for the famous Italian director Vittorio De Sica. In 1966 Lucan was asked to fly to Paris to audition for the small role of a British diplomat in the film

Woman Times Seven. But he froze in front of the cameras and could barely get his lines out. He didn't get the part. However, in his 2003 biography of Lucan, Duncan MacLaughlin claims that it was the lord himself who took the initiative regarding a Bond screen test. 'But Broccoli saw the results, decided the blue-blooded wannabe was "too wooden," and the test came to nothing.'

It was around this time that a young actor entered the scene who would become almost *the* perennial Bond candidate, linked to the role for the next fifteen or so years – Michael Billington. Born in 1941 in Blackburn, Billington began his career in theatre in a couple of West End musicals, even enjoying a stint in cabaret with Danny La Rue, before appearing in small roles on television, including an episode of *The Prisoner*. Billington's involvement in Bond began when Bud Ornstein, then European head of production at United Artists, saw him in late-night theatre and asked the actor to meet with him at the United Artists offices. He told Billington that he would get some photographs done and show them to Saltzman. Surprisingly, Billington wasn't sure about having his name put forward for Bond. 'For me the power of Connery's impact in the role was formidable. I really didn't want to be a quasi-Bond. Even though I think I could have played the character well I feared I would always seem second best.'[10] Billington wasn't stupid though, and realised that any publicity about his name linked to the 007 role would do his career prospects no harm whatsoever.

A few weeks later Billington was called in to meet with Peter Hunt about playing Bond in *On Her Majesty's Secret Service*, even though he'd already heard news from the industry grapevine that a George Lazenby was under contract. 'And when I saw a photograph of Lazenby I thought he had the perfect look for the role, so subsequently I put the possibility of my playing Bond completely out of my mind.'[11] Bond, though, was far from finished with Billington.

Another young English actor who believes he came as close as anyone to playing 007 was Patrick Mower. Born in Oxford in 1940, Mower was RADA trained and since the mid-1960s had appeared spasmodically in TV shows like *Dixon of Dock Green* and *The Avengers*. Then in 1967 he landed his own TV series, the supernatural drama *Haunted*, and played a decent role in the cult Hammer horror film *The Devil Rides Out* (1968) with Christopher Lee. In his autobiography, Mower recalled

that his close brush with 007 began when his agent rang to say that Harry Saltzman wanted to see him. Michael Caine had left the Harry Palmer film series but Saltzman wanted to turn another Len Deighton novel into a movie. Mower turned up at Eon's office, whose reception room was decked out with top name actors. Determined to play it cool, when he was called Mower walked tall into the producers' office. There was Saltzman seated at his desk and not too far from him was Broccoli. The two men looked at Mower intently. Suddenly Saltzman blurted out, 'What's your body like?' A strange question Mower thought, but answered, 'I've never had any complaints. Everything's in the right place.' The interview continued for some thirty minutes. At the end Saltzman said, 'We'll call you in again when we have a director.'

A few days later Mower's phone rang; it was Saltzman, they now had a director and could he come and see them tomorrow. Arriving, Mower sensed that both producers were very pleased to see him. It turned out they hadn't decided on a director yet for the Len Deighton project, which puzzled Mower and he asked what the point was of him coming in. 'This is for something else,' Broccoli said and explained their search for an actor to replace Connery as Bond. 'Who are you thinking of?' Mower asked, in all innocence. The producers didn't reply but just stared back at him. Eventually the penny dropped. 'You're thinking of me.' They nodded. 'But Sean is a man, I'm a boy,' said Mower, almost apologetically. 'You're a man Patrick,' Saltzman replied. 'Believe us. We think you've got it.'

For the next few weeks Mower had several meetings at Eon with Saltzman and Broccoli but believes that it was his own conceit and sense of humour that robbed him of the role. He'd go around the office humming the Bond theme and announcing, 'The name's Mower ... Patrick Mower.' Then when his agent rang to say that they were holding a screen test at Pinewood, it transpired there were going to be ten other actors attending as well. Mower thought it was just him. Crushed, and unable to face the test, he stayed at home, in floods of tears. 'I'd had a part of a lifetime in the palm of my hand, and I had let it slip out. No! I had thrown it away.'

Someone else who later revealed that he pretty much scuppered his chances of being 007 was Terence Stamp. By the close of the 1960s, Stamp had established himself as one of Britain's biggest movie stars, so

it was odd that he even countenanced the idea of playing Bond; he didn't need the role. Although as he later admitted, 'Like most English actors, I'd have loved to be 007 because I really know how to wear a suit.'[12]

It was Harry Saltzman that took Stamp out for dinner at the White Elephant restaurant in Curzon Street, a famous hang-out for the rich and famous. 'We're looking for the new 007,' said the producer. 'You're really fit and really English.'

Stamp was slightly taken aback but thought it was a great idea. He only had one misgiving. 'The fact is,' he explained to Saltzman:

> Sean has made the role his own. The public will have trouble accepting anyone else. But in one of the books, it starts with him disguised as a Japanese warrior. If we could do that one, I could start the movie in complete Japanese make-up. By the time it came off they are used to me a little bit. I would love to do it like that.

Saltzman was not impressed. 'I think my ideas about it put the frighteners on Harry. I didn't get a second call from him.'[13]

Several other English actors were mentioned in dispatches. These included Ian Richardson, who became best known for his role as the Machiavellian Tory politician Francis Urquhart in the BBC's 1990 drama *House of Cards*. Also, Peter Hunt was to recall looking at Ian Ogilvy. Anthony Valentine was possibly looked at, having impressed as the ruthless agent Toby Meres in the then popular ITV spy series *Callan*, opposite Edward Woodward, a series that was ahead of its time in its cynical view of espionage.

The film and television director Paul Annett once mentioned that Tom Adams, who he knew and worked with, 'was always auditioning for James Bond, but never got it!'[14] Adams was very much in the Connery mould and had a reasonable career, appearing in the war classic *The Great Escape* (1963) and on television in the 1960s soap opera *Emergency Ward 10* and '70s BBC serial *The Onedin Line*. In the 1960s he played a rather low-rent imitation James Bond named Charles Vine in three films, beginning with *Licensed to Kill* (1965), *Where the Bullets Fly* (1966) and *Somebody's Stolen Our Russian Spy* (1967), which went unreleased for ten years. One imagines the Bond producers treated this trilogy with

the contempt it deserved, thus scuppering any chance Adams may have had to play Bond.

One young English actor who tried to put his name forward for Bond and failed was Peter Purves. Back in 1965 Purves won his first big TV role, playing stranded space pilot Steven Taylor, one of the early time-travelling companions in *Doctor Who*, then played by William Hartnell. He was in the show for forty-four episodes, spread over two years. In 1966 he was told that his contract was not being renewed. After that he scrambled around for roles:

> One of the very few parts I managed to get in the following months was that of a character who was strangled to death before the opening titles had even started rolling. Things got worse shortly afterwards when Sean Connery announced he was no longer playing James Bond, and I auditioned unsuccessfully for the role, at which point I was dumped by my agent.[15]

Things perked up the very next morning when his former agent phoned with an offer to be a presenter on the children's programme *Blue Peter* at the BBC. 'It wasn't proper acting, but it was better than nothing.'[16] Purves joined the show in November 1967 and became a beloved fixture on British television screens, remaining with *Blue Peter* until 1978.

If you can't visualise Peter Purves as James Bond then you'll have even greater difficulty with the perennially grinning singer and actor Jess Conrad. Born in Brixton, South London, Conrad began his career as an actor in rep and a film extra before being spotted by a music producer and signing to Decca Records where he enjoyed several chart hits. By the late 1960s his chart career was over, but he had begun to make appearances on film and television. Hearing about the Bond auditions Conrad began to dream of playing the super-agent and even had some photographs of himself taken in a suitable Bond pose holding a gun. 'I thought I looked rather wonderful. I did look very Bond-ish. I could have been nurtured, I'm sure.'[17]

Conrad managed to wrangle an audition and came up with a plan. Thinking of the many film stars with blue eyes, he purchased, at great expense, a pair of blue contact lenses. They were non-prescription so the vision out of them was lousy. Conrad turned up at South Audley

Street for his meeting. The casting director was delighted to see Conrad because Broccoli had a spare moment and could see him straight away. Conrad recalled:

> I ran up the stairs and I knocked on the door. I could imagine Cubby Broccoli with the big cigar, and he went, come in. I thought, I won't go in now because running up the stairs I'm just a little bit out of breath. And Bond wouldn't be out of breath. So, I relaxed, thinking, Jessie boy, this is my big break. I'm just about to go in and I forgot my eyes. By now Cubby's waiting for the door to open and James Bond to walk in. I get my eyes out, I put one eye in and it falls out onto the carpet. I pick it up and put it back in. But it's got a bit of carpet in it so now the tears are in one eye and I'm fiddling about. I finally put the other eye in and walk in. I flicked my cuffs like James Bond does and I said, 'My name's Conrad, Jess Conrad.' And I gave him the full blast of my white teeth. And I heard a voice say –'I'm over here.' I couldn't see where he was.[18]

Needless to say, Conrad did not get the part.

For the first time, the Bond producers cast their net over to America and an actor who had become a household name playing a very different kind of action hero – Batman. Adam West scored as the caped crusader in a hugely popular TV series but had recently heard the news that the show was going to be cancelled after three seasons. Invited to the UK on business, West and his agent, Lew Sherrell, were taken out to dinner by Broccoli. During the evening Broccoli asked West if he was interested in playing 007. 'Lew nearly spat out his tea when a firm offer was made,' said West. 'And I'll have to admit, I was tempted.'[19] However, there was one big problem as West saw it: he wasn't British. Sure, West believed he could handle the accent, but sensed that the press and fans would get on his back because of his nationality. 'In my heart, I felt that Bond should definitely be played by an Englishman, and I said so. Cubby respected my stand, and I still think I did the right thing.'[20] Indeed, West felt somewhat vindicated following the less than positive response to Australian George Lazenby's sole stab at the role. 'He was much better than his detractors gave him credit for, but anyone would have looked bad following Connery.'[21]

West at least had the model looks and physique, along with a decent tongue-in-cheek humour, to play Bond, which is something you can't say about the dancer and actor Dick Van Dyke. However, on the Kevin Pollak chat show in 2013 the veteran entertainer stunned his host with the claim that he was, for a very brief moment, up for Bond:

> While I was doing *Chitty Chitty Bang Bang*, Sean Connery had spoken about leaving the Bond pictures and Cubby Broccoli [who was the producer on the film] called me in and asked me if I wanted to be Bond. I said, 'Have you heard my English accent?' [alluding to his much-ridiculed take on a cockney chimney sweep in *Mary Poppins*] and Cubby said, 'Oh that's right – forget it.'

Now, was Van Dyke pulling Pollak's leg or, as he claimed, did it really happened?

Meanwhile, a Canadian by the name of Daniel Pilon had caught the eye of Harry Saltzman. Pilon, just 27, had done a bit of modelling and had just made his first picture, *Le Viol d'une jeune fille douce* (1968), a Canadian satirical drama directed by Gilles Carle. At the time he was working at a world's fair, Expo 67, in Quebec where he was responsible for looking after the VIP guests:

> Saltzman wanted to meet me. The next day, he called me back to thank me and invited me to join his guests for a private meal. It was during this meal that he asked me what I would do after the Expo. I told him that I wanted to go back to my studies but that first, I would take a month of vacation to visit Europe.[22]

During his European break Pilon met Saltzman in London and was put under contract. Saltzman gave him a small role in a film he was producing, the Michael Caine war drama *Play Dirty* (1969). 'What Saltzman saw in me was the role of James Bond. He told me that one day. But Cubby Broccoli did not share his opinion.'[23] Broccoli felt that Pilon was too young to succeed Sean Connery. Pilon continued to act in film and on television, mainly in soap operas, including a small recurring role in several episodes of *Dallas*. He died in 2018 at the age of 77.

After several months of interviewing and testing something like 100 candidates, according to Peter Hunt's estimation (400 according to one press report), a short list of five possible contenders was drawn up. First, there was Robert Campbell, of which next to nothing is known. The Dutch-born Hans De Vries was largely a bit part player appearing in a couple of action TV series like *The Saint* and *Randall and Hopkirk (Deceased)*. He also played a Cyberman in the classic *Doctor Who* story 'Tomb of the Cybermen' in 1967. Interestingly he appeared as a control room technician in *You Only Live Twice* and then had a small role in the first film Sean Connery made after leaving Bond, the western *Shalako* (1968). Anthony Rogers was a Scottish actor who moved to America in the mid-1960s and appeared in small roles in Howard Hawk's *Red Line 7000* (1965), *Camelot* (1967) and as a doctor in the John Wayne western *El Dorado* (1967).

By far the most well known of the group was John Richardson, who had attended the *Thunderball* premiere with his girlfriend, Bond girl Martine Beswick. Classically handsome, Richardson was born in Worthing in 1934 and appeared in minor roles in films such as Mario Bava's *Black Sunday* (1960). In the mid-1960s Richardson seemed destined for stardom when he was cast as the male lead opposite Ursula Andress in the Hammer epic *She* (1965) and then as a grunting caveman who falls in love with Raquel Welch in *One Million Years B.C.* (1966).

Richardson was in Rome making the thriller *Candidate for a Killing* (1969) when the call came through that the Bond producers wanted to have a look at him. 'I was given a day's leave, flew from Italy to London and was put up in the Dorchester hotel in one of the top rooms. I was whisked off to Pinewood at 5am, did the scenes, bang, bang, bang, and was back on the plane to Italy that evening.'[24]

His meeting with Broccoli and Saltzman was just as brief. 'I was rushed off to their office and hardly had any time at all with them.'[25] Richardson never heard from either of them again. Peter Hunt did find Richardson handsome enough but lacking that special quality. Richardson himself didn't think he fitted the role anyway. 'I wasn't the right age or the right look. The guy who got it looked a bit rougher and tougher than me and was much better suited to the role. I was more like Roger Moore.'[26]

After losing out on Bond, Richardson's career failed to maintain momentum and eventually petered out after some forgettable continental movies. Richardson retired from acting in the 1990s, going on to become a noteworthy photographer. He passed away in 2021.

The name of the fifth contender, although at the time as undistinguished as most of the others, proved highly significant – George Lazenby. Born in 1939 in Canberra, Australia, Lazenby was rebellious as a youth and left home at the age of 15. After a short stint in the army, he took up mechanics before switching from mending cars to selling them, a job that took him all over Australia. In 1964, Lazenby moved to Britain and got a job as a car salesman at £10 a week. It wasn't much, but for the future James Bond it was a start.

By his own admission Lazenby was a bit of a slob in those days; he sported long hair, was overweight and wore drab clothes. Going on holiday with a girl, he decided to spruce himself up and on his return was spotted by fashion photographer Chard Jenkins, who came into Lazenby's West End car showroom one day and the Australian tried to flog him a Mercedes. Instead, Jenkins suggested he try out for male modelling. 'English male models were at the time pale and rather effeminate,' said Jenkins. 'George was rugged, tanned with a face that looked lived-in and very extrovert in that masculine, Aussie way.'[27] Within a year Lazenby had become one of the highest paid models in Europe selling petrol, cigarettes and cosmetics, and even made the break into television, appearing in a series of commercials as the 'Big Fry Man' who arrives at various exotic locations with a large box of chocolates.

When a friend set him up with a blind date one evening, Lazenby found himself in the company of agent Maggie Abbott. When Connery announced his Bond retirement Maggie remembered her date and tracked Lazenby down to a Paris hotel. 'You've got to come over to London,' she said over the phone. 'I think you're ideal for this role that they can't fill.'

Lazenby was tired and hardly in the mood. 'What's the role?' he asked.
'I can't tell you on the phone.'
'What's it paying?' said Lazenby.
'I can't tell you.'
'Right, I'm not coming,' said Lazenby and hung up.[28]

Sometime later Lazenby ran into a friend and heard that Maggie Abbott was searching everywhere for him, so he made an impromptu visit to her office. It was then that she told him the part was for James Bond. Lazenby wanted to know why she wanted him. 'Because you'd be perfect for it, because you're so bloody sure of yourself.'[29]

Maggie lost little time in calling Eon's casting director Dyson Lovell. An actor himself, Lovell had trained at RADA, appeared at the Old Vic and played supporting roles in films such as Franco Zeffirelli's 1968 version of *Romeo and Juliet*. Later a film producer, Lovell had been given the nightmare task of finding a replacement for Connery. When he was first asked to do the job, Lovell arrived at Pinewood to see Broccoli and was shown into a reception room. He sat there for several minutes. 'Then Cubby came out of his office and took one look at me and said, "No, no, no, no. No blondes for Bond." And I said, "You don't understand, I'm not here about playing James Bond, I'm here about casting James Bond."'[30]

Lovell was installed in his own office at South Audley Street and set about his task:

> We'd explored the Roger Moore route, that didn't work out. I was very keen on Tim Dalton and met him, but he said – no I'm far too young for it. So one went through this agonising search to find a Bond and we'd had no luck at all and then, and I don't want to be held responsible for this, an agent called Maggie Abbott called me up and said, 'There's this guy that you should meet, he's not an actor, but he looks really good, you should really meet him.'[31]

Dyson Lovell had already put together a list of male models that he thought deserved some consideration. At the time most of the successful male models working in Britain were Australians. One in particular had caught his attention, Gary Myers, who would shoot to fame later in the year as the first ever 'Milk Tray Man' in a series of classic TV ads in which he played a 007-type adventurer bracing numerous perils to deliver a box of chocolates to a mysterious lady. It's interesting to note how very similar Myers' life was to Lazenby's up until that time. Born in Perth in 1941, Myers was a physical training instructor for three of the six years in which he served in the Australian Army. After that, he decided to work his way around the world and confessed to being something of

a beach bum for a couple of years, just living off the land. Myers then made his way to Cannes working on a yacht as a crew member. He then took a boat to the Bahamas, and next arrived in London. During those years, he took any job that was going. Then he met up with a friend who suggested that his looks and physique would be ideal for modelling, so he found himself in commercials and later became interested in acting. After losing out on Bond, Myers won a small semi-recurring role in the cult sci-fi TV show *UFO*. Then in the mid-1980s, after a host of Milk Tray ads, he returned to his native Australia.

Lazenby thought that if he was going to see the Bond people he really ought to dress for the part. Truthfully, he didn't really have that far to go; he already owned Bond's watch, a Rolex, and wore one of Connery's old Bond suits, sold to him by a Savile Row tailor after the star failed to collect it. Then he went to a barber at The Dorchester Hotel frequented by Connery to demand that his hair be cut like the star. As luck would have it in the chair behind him was Broccoli himself. The producer didn't know Lazenby from a tin of beans but when the Australian left he turned to his barber and said, 'That guy would make a very good James Bond, but he's probably a successful businessman and wouldn't be interested.'[32] Little did Cubby realise.

Lovell agreed to meet Lazenby at Eon's office and was quite struck by him:

> He looked very good when he arrived. I talked to him and then I phoned Harry and said, 'Listen, there's this guy in my office, he looks good. I don't know if he can act, but I don't want to send him away without somebody seeing him because he does look the part.' So, Harry met him.[33]

For that crucial first interview Lazenby had one big advantage over some of the other actors going for the role who probably would have entered that room thinking of Connery. But Lazenby wasn't an actor. What he was, as Maggie Abbott had clearly recognised, was arrogant, and he had nothing to lose. What he didn't know was that Cubby and Harry had been watching him cross the road out of the first floor of their building. 'They were impressed,' recalled Maggie Abbott. 'He hadn't even come to the office yet.'[34]

Lazenby made up a bunch of lies and a false acting CV to impress the producers. Later when he met Peter Hunt, Lazenby decided to come clean and admit he'd never acted a day in his life. Hunt stared back at him. 'What! And you say you can't act. You've fooled two of the most ruthless men I've ever met in my life. Stick to your story and I'll make you the next James Bond.'[35] Inevitably the truth got out and Saltzman especially was not best pleased. 'Get him out of here,' he raged. 'He's a clothes peg. We'll be the laughing stock of the industry if we hire a male model.'[36]

Extensive tests on Lazenby and his four competitors began in April 1968, with Peter Hunt and stuntman George Leech presiding. Leech, who had previously worked as an assistant to the 007 series' stunt and fight arranger Bob Simmons, was in control of the action on the new film. Simmons had made himself unavailable, having taken a job on Connery's western *Shalako*. Two scenes from the script were chosen for the audition piece: Bond's hotel love scene with Tracy and a brutal fight with her bodyguard. A set was specially constructed and Russian wrestler Yuri Borienko hired as the heavy; doing so well that he eventually won a role in the movie, as Blofeld's henchman Grunther.

When it was Lazenby's turn to do the fight he got caught up in the moment and let fly with a massive punch, accidentally breaking Borienko's nose. It was partly over-enthusiasm and partly naïvety, the fact that Lazenby just wasn't used to carrying out stunt fighting.

Once the test was over (Leech later admitted that the fight turned out better than the one in the finished film), it was Hunt's job to edit it all together into a ten-minute showreel that was, as Leech recalls, 'tremendous'. In Hunt's view, Lazenby had the right look to be Bond. And the physical side of him was excellent. The acting side of it, however, was a gamble. But he felt confident that he could make him James Bond.

Lazenby's test footage was sent to United Artists' New York office accompanied with a 'top recommendation' from Broccoli and Saltzman. Once again, United Artists' top brass didn't share Eon's faith in their choice of Bond and company head honcho David Picker flew to London to begin negotiations to lure Connery back. The talks failed, and Picker ultimately accepted the choice. 'He looked good. His experience as a male model gave him style, and if the producers felt he was the best shot, who were we to argue with the success they had created.'[37]

The testing continued. And as the other actors fell by the wayside Lazenby started to believe that he could be James Bond, comforted by the knowledge that Peter Hunt was on his side. All this time, Lazenby was holed up in a suite at The Dorchester Hotel, paid for by Eon. Here, so Lazenby has claimed, a female escort was sent to his room to prove his masculinity.

Finally, it was agreed to go with Lazenby. For Broccoli, the Australian had the 'masculinity' for the role. What was true was that many of those interviewed and tested were better actors, but few, if any, had the same sexual assurance of Connery. For Lazenby it came naturally. Jill St John, when she was making *Diamonds Are Forever*, recalled Broccoli telling her that when Connery left the Eon office after his Bond interview, every secretary wanted to know who he was. 'And Cubby said the only other time it happened again was when George Lazenby walked into the office.'[38]

Others didn't agree with the choice, like Bob Simmons. 'Who's George Lazenby?' he asked. 'I couldn't see a chocolate box carrier as James Bond.'[39]

Someone else not wholly convinced by the decision was the man who first set the wheels in motion at Eon, Dyson Lovell. 'The minute George was cast I was kind of alarmed. So, I thought we'd better surround him with some really strong people, hence the reason why we got Diana Rigg and Telly Savalas. I must say, I'd hate to be credited with casting George Lazenby!'[40]

On Monday 7 October 1968 Lazenby was introduced to the press as the new James Bond during a reception held at The Dorchester hotel. It was daunting for a guy not used to the pitfalls of showbiz. Lazenby was now public property; Fleet Street was already reporting that the producers had bought up all Lazenby's advertising material intended for future publication. They didn't want 007 promoting deodorants. He'd been medically examined for a million-dollar insurance policy too, and ceased working for a Mayfair model agency, acquiring a theatrical agent instead.

Because Lazenby had never performed or spoken in front of a camera before in his life, the producers enrolled him in an extensive course of acting lessons. To eradicate his strong Australian accent ('I talked like a lad from the bush'), he was sent to elocution classes. The producers also

provided an acting coach on set throughout the shoot. Lazenby ignored them, preferring to do things his way and gaining inspiration instead from Fleming's novel.

More than anyone else, it was Peter Hunt that championed Lazenby. With Lazenby in the role he saw a chance to revert to the concept implicit in Fleming's novels, of a young man with an inherent sexual assurance, which was the predominant thought in the director's mind throughout the search for the new 007. His aim was to make people forget all about Sean Connery once they saw George Lazenby.

That was the problem, though: Lazenby was too much in the Connery mould, and therefore not sufficiently different enough to avoid comparison. It probably didn't help that the producers made him watch all of the Connery Bonds for days on end. 'They used to sit me in a little screening room and I would watch them over and over until I fell asleep.'[41]

Lazenby himself always believed that he was chosen because he was the closest to the Bond persona already established by Connery. It was going to be difficult enough trying to convince the public; Lazenby even had trouble convincing staff at Pinewood Studios that he was Bond. When he turned up for his first day's work at the studio the man on the gate wouldn't let him in. He didn't know who he was! When Lazenby told him he was the new James Bond, he didn't believe him. It took a phone call to establish Lazenby's identity and he was allowed in.

Initially against casting the Australian, United Artists now wanted Lazenby to commit to making five Bond pictures, but he was reluctant to sign on the dotted line. In the end Broccoli and Saltzman started shooting *On Her Majesty's Secret Service* with their leading man only signing a letter of intent. It was an incredible situation and one that would later prove disastrous.

It's impossible now to imagine the pressure and tasks Lazenby faced as the new 007.

He was, however, surprisingly self-assured about it all. As a Bond fan himself he had illusions that he could play it better than anybody else. But these were tough shoes to fill. He was following an actor who had become one of the icons of the decade thanks to playing Bond, and someone who was still totally identified with the role. To some extent Lazenby was on a losing wicket from the start. Modern audiences have

become familiar with a new actor taking over as Bond, but this was the first time it had happened. Plus, he was doing so with no acting experience whatsoever, and had not made a single film in his life. People often forget that *On Her Majesty's Secret Service* wasn't just Lazenby's Bond debut; it was his debut movie full stop.

Not long after winning the role Lazenby bumped into Diane Cilento at a party and was introduced to her with, 'Hey Diane, you should be interested in this guy. You're Australian, he's Australian, and he's the new James Bond.' She gave Lazenby a couple of looks, said, 'I feel sorry for you' and walked away.[42]

Looking at it now, the casting of Lazenby was an extraordinary situation. No wonder he flipped and, in his own words, 'became hot-headed, greedy and big headed'.[43] Many of the problems he created himself, but in truth he was totally unprepared for what happened. 'I didn't know what I was doing and nobody told me. I was just plucked from the world of advertising and thrust into the role of a superstar. Overnight I became a class A celebrity. I felt very insecure.'[44] Neither did he have the acting experience to fall back on; he had no understanding of how to build and sustain a character and a performance. In the end he thought his best chance was just to try to play Bond the way Connery did. He was hired as a Connery clone so he thought he might as well act like one.

One would have thought Lazenby might have received guidance from Peter Hunt, but unfortunately that wasn't to be. According to a Q/A session with Bond historian Steven Jay Rubin at the American Cinematheque in June 2011, Lazenby revealed, 'Peter Hunt was an amazing character. But I had a little falling out on the first day of filming and he never spoke to me the whole nine months.'

As it was Hunt had his hands full with the challenges posed by the logistical nightmare of shooting in the Swiss Alps, where weather conditions played havoc with the schedule. In hindsight, maybe Broccoli and Saltzman made a mistake giving Hunt, a former editor, this film to direct, his first, when a more experienced director was needed to handle Lazenby's debut. Saying that, Hunt did end up directing a Bond classic.

By January 1969 Lazenby had been shooting for nearly three months without signing his contract, causing Saltzman and Broccoli mounting concern. Hunt recalled that the producers would often come down to

the set and take Lazenby into his caravan for a discussion. Lazenby was offered a new incentive to sign on the dotted line. 'Harry, not Cubby, was offering me money under the counter to sign the goddamn contract, and then United Artists offered me any picture that they owned, which we could do in between each Bond movie.'[45] It sounds like the dream deal, so why didn't Lazenby sign? Enter Ronan O'Rahilly, an Irish businessman producer and boss of the pirate radio station Radio Caroline, under whose influence Lazenby had fallen hook, line and sinker. Unbelievably, O'Rahilly advised Lazenby not to sign the contract, convincing him that the Bonds were old hat, finished and that the hippy generation was in, with films like *Easy Rider* taking over. In a sense O'Rahilly was right to be cautious. Hollywood was changing with emerging directors like Francis Ford Coppola and Martin Scorsese ready to sweep out the old brigade and lay waste to the tired, formulaic studio pictures of recent years. In such heady times the Bond character was in danger of becoming an anachronism, fatal for the actor playing the role. But O'Rahilly had crucially underestimated Bond's staying power.

Lazenby's own ego came into the equation too. He thought Bond would put him on the showbiz map and that afterwards he'd be able to strut into Hollywood and get any job he wanted, or make films in Europe that paid better than his 007 contract ever could. The truth of the matter is that Lazenby was genuinely torn between signing the contract and heeding O'Rahilly's advice.

On Her Majesty's Secret Service was still only halfway through its shooting schedule when Lazenby announced this was to be his first and his final Bond. People were dumbfounded; how could he be so arrogant and so stupid as to turn his back on Bond and a five-picture deal? Lazenby informed the producers that he would fulfil his promotional obligations, and then he was out of it.

As audiences went to see *On Her Majesty's Secret Service* that Christmas of 1969, they already knew Lazenby was gone, so reaction was mixed. The film itself was well received critically, Lazenby less so. 'Back to the chocolate, George,' said the *Daily Mirror*'s Donald Zec. And this from the *Guardian*'s Derek Malcolm: 'Mr Lazenby looks like a clothes peg and acts as if he's just come out of Burton's short on credit. It is reported that he would just as soon go back to lorry driving and indeed, I share

his sentiments exactly.' And from *Variety*, 'Lazenby is pleasant, capable, and attractive in the role, but he suffers in the inevitable comparison with Connery. He doesn't have the latter's physique, voice and saturnine, virile looks.' And this from the *San Francisco Examiner*, saying what many Bond fans have argued ever since: 'Might have been the best Bond if not for the bland Lazenby.'

Ever loyal, Broccoli hit back. 'I don't agree with the press. They should have given him an A for effort. It's true he's not Olivier, but Olivier could not play Bond in any circumstances.'[46] Some reviewers did applaud Lazenby's debut. 'He could pass for the other fellow's twin on the shady side of the casino,' said Alexander Walker in the *Evening Standard*. While F. Maurice Speed in *What's On in London* commented, 'Does one miss Sean? Frankly I didn't. Handsome newcomer George Lazenby looks like 007 probably should, and performs with a sort of casual unawareness of acting that gives the part a nice new look.'

When asked by the press if Lazenby would be Bond in the next instalment, Broccoli replied. 'It's a question of relationships. I find it incredible that a plum role can't be respected.'[47] Saltzman was a bit more forthright when he spoke to a journalist from the *Daily Sketch*:

> I think that the man who plays Bond is not the most important thing in the films. We've discovered that since Sean left us. We have not even started looking for a man to play Bond yet. But you can take it as sure that it will not be George Lazenby.

In the end *On Her Majesty's Secret Service* performed only moderately in America, earning $22.8 million, well down from previous Bonds, although it was the number one film in Britain for 1970. However, Lazenby's plan to conquer Hollywood using Bond as his springboard never materialised; he didn't even get to first base. People assumed he'd been dumped as Bond and producers, having read a lot of negative things about his attitude, were reluctant to hire him. Consequently, Lazenby's post-Bond film career was almost non-existent; he earnt more from his business and real estate dealings.

Lazenby was always philosophical about his Bond escapade, but has spoken with regret that he didn't sign that lucrative deal, that it was bad

business advice and he listened to the wrong people. Maybe things would have been different if he had done another one or two. Undoubtedly, he would have grown into the role and made a very creditable Bond. It isn't very hard to visualise him in *Diamonds Are Forever* or *Live and Let Die*. But it was not to be.

When pressed about Lazenby in 1970, Connery was to say, 'My feeling about the Lazenby picture was – if he kept his mouth shut, he might have come out a lot better. Because I thought for somebody who had no previous acting experience, he did quite a good job.'[48]

As for the man instrumental in casting Lazenby, Dyson Lovell believes the actor was on thin ice right from the start:

> The problem with Lazenby was that Sean had made such an impact in the role that whoever came in next was going to be clobbered. Years later I did a mini series of Cleopatra and the problem of casting Cleopatra was horrendous because no respectable actress would touch it after Elizabeth Taylor, and the others didn't want to fall into her shadow. So, it was a really difficult job that Lazenby had.[49]

4

Return of the King

With Lazenby gone, the producers tried to shrug off the fact that they had to go back to square one and find another Bond by blasting that there were fourteen Tarzans! This still didn't stop United Artists optimistically mailing Lazenby a cheque for his appearance in *Diamonds Are Forever*. He sent it back. There are other claims that Lazenby's services as 007 were dispensed with because he was asking for too much money.

One of the first names to come up this time, as in 1961, was Roger Moore, but he was already committed to *The Persuaders* TV show. Of course, the return of Connery was what the bosses at United Artists really wanted, but Broccoli and Saltzman were hesitant, in Dana Broccoli's words, 'to beg a reluctant actor to act'. And so the search was on to find Bond number three, a search that quickly began to resemble the mad, blind scramble that ended up with Lazenby's casting. The most unqualified of people were approached. How else can you explain the producers' thought patterns behind the potential marquee legend 'Michael Gambon is James Bond'? Undoubtedly a great actor, Gambon went on to be knighted by the Queen for services to the industry, and won millions of fans when he played Professor Dumbledore in the *Harry Potter* films, but Bond he never was. Indeed, when Gambon himself heard the news that he was being considered he was rendered dumbstruck.

At the time Gambon was enjoying his first real break in *The Borderers*, a BBC period drama about the lives of a family of Scots living on the borders with England in the 1500s. Gambon swashbuckled away as the

tough head of one of the clans and, much to his surprise, had become something of an action hero. It was this series that brought him to the attention of the Bond producers and he was requested to see Cubby Broccoli in his Mayfair office, not knowing what the meeting was about. He was given a smoked salmon sandwich and a glass of champagne. Then Broccoli announced, 'We're looking for a new James Bond.'

Gambon was so flabbergasted he burst out laughing. 'James Bond, me? But I'm bald.'

'So was Sean; we'll get around it,' said Broccoli.

'But my teeth are like a horse's.'

'We'll take you to Harley Street,' Broccoli replied.

'But I've got tits like a woman.'

'We'll use ice-packs before the love scenes,' said Broccoli. 'Just like we did with Sean.'[1]

Gambon was encouraged and believed the interview went well, but upon leaving the room noticed a parade of other actors waiting to audition outside. He never heard anything more.

Just as bizarrely, an ex-soldier was very seriously considered, someone who was just about to begin the extraordinary life of adventure that one day would see him acknowledged as the greatest living explorer by the *Guinness Book of World Records* – his name, Sir Ranulph Fiennes. Certainly, Fiennes had the perfect pedigree to play Bond. He was born in Windsor in 1944 to a well-to-do family and educated at Eton before joining the British Army where he served for eight years, including a stint in the SAS. That was until he was thrown out for inappropriate use of explosives. He also served in the Sultan's Armed Forces in Oman fighting Marxist terrorists. All this must have seemed manna from heaven to the Bond producers and perhaps it made some kind of sense recruiting from the armed forces, Bond having been a Commander in the Royal Navy and Fleming himself serving during the war in military intelligence. Still, the offer came out of the blue. 'I was in Scotland at the time,' Fiennes recalls:

> I'd got married that year and having hardly any money we were living in a cottage with no electricity, it was literally in the middle of nowhere. One day a postman arrived and said that the William Morris agency

was on the lookout for a new James Bond. I don't know if this is true, but this is what I heard, Mr Lazenby had asked for a certain amount of money for doing a second Bond film and the producers had decided that the answer was to get some actor who wasn't so keen on being paid too much but who did Bondy type things. They had asked around and someone had told them that I might answer that description.[2]

The offer arrived at a propitious moment. Fiennes had heard on the grapevine that someone with military experience was being sought to lead an expedition to the Headless Valley in Canada. Desperate to land the job, Fiennes needed to get to London to see the people in charge at the Military of Defence. 'But I literally couldn't afford the British Rail ticket from Inverness. So, this Bond interview was a real stroke of luck. I assumed that I would immediately be turned down, but would get my job with the Ministry of Defence, having had a free ticket to London and accommodation.'[3]

Things didn't quite work out that way. Far from being dismissed Fiennes found himself placed as one of the favourites:

There were various types of screen tests and as they went on, I was constantly being surprised about getting through to the next one. I knew that once they saw me, they would realise that it was absurd, but then when they kept on asking me back to the next stage of screen testing, I began to start getting stupid thoughts that perhaps the world had gone mad and I actually would be Bond.[4]

Fiennes had seen the previous Bond movies and read all the Fleming books so knew quite a bit about the subject:

Finally, I made it to the last group and the last group were vetted by Broccoli himself. I went in to see him. He had a big cigar. And he took one look at me and the phrase that he said in front of me, never mind what he might have said after I left the room, was, 'Your hands are too big and you've got a face like a farmer.' He didn't mince his words at all. And obviously I didn't get the role. But I ended up with the job I was after, to lead the Headless Valley expedition.[5]

While these tests were going on, Fiennes was secretly sneaking off to the Ministry of Defence and meeting with the army PR office that oversaw the expedition:

> And there were rather fewer contenders for that than there were for Bond. But I wasn't the only contender, so I put in a plan as to how I would do it and ended up organising and leading that particular expedition, which was my first big expedition. So, I'm obviously very grateful for that whole Bond experience happening because it worked out very well for me.[6]

Who knows whether Fiennes' remarkable life of exploring would have been different, or indeed happened at all, if the Bond producers hadn't paid for his ticket down to London.

Another bizarre casting choice was – wait for it – singer and heart-throb Engelbert Humperdinck, famous for his power ballads 'Release Me' and 'The Last Waltz'. Born in India in 1936, the son of a British engineer and the youngest boy in a family of ten children, Humperdinck moved to England at the age of 10. By the early 1950s he was performing in nightclubs but had to wait until the mid-1960s before finding international chart success. I contacted Humperdinck's agent to see if indeed the stories were true that the singer was approached to play Bond and received this reply: 'I checked with Engelbert, and although there was some low-level discussion about him testing for Bond, it never went any further than that. As such, there is really nothing to talk about for your book. Thanks for asking though.' Short and sweet, but definitely a confirmation. But can you see Engelbert Humperdinck driving a moon buggy or vaulting over a police car in a speedboat? No, neither can I.

Nor for that matter Tom Jones. But in 2010 the Welsh superstar surprised many by revealing that he was once linked to the Bond role:

> When I was young, I would have liked to be James Bond, and at one time it was discussed. I think it came from Cubby Broccoli, and he said when my name was put forward, 'Tom Jones is so recognisable as Tom Jones – he's become this singer with a big character. So, for him to do James Bond, would people accept him as being James Bond?

Could they get past him being Tom Jones?' And so apparently that was what the problem was.

While it never came to anything, Sir Tom said that to be even linked with the part was 'definitely a big compliment'.[7]

This story came up again two years later when Jones spoke to the *Radio Times* and was asked about his regrets. 'The only thing I regret is that I'd like to have had a pop at acting when I was younger. My name was up for James Bond at one time, but Cubby Broccoli apparently said I was too well known for people to believe it.'

Sir Tom did not specify which years he would have been considered, although it seems likely to have been either the late 1960s or early '70s. Sir Tom already had a connection with the Bond films, of course, having recorded the *Thunderball* theme song in 1965.

In perhaps an admission that they were having trouble finding a suitable replacement for Lazenby in any of the British actors they'd interviewed so far, the producers started looking further afield, in particular at a New Zealander called Roger Green. Then in his early thirties, Green had no formal drama training and had been a sheep-farmer and rugby player back home before arriving in 'swinging' 1960s London. He appeared in the small role of Duncan in the 1970 epic *Waterloo*, with another future Bond might-have-been Ian Ogilvy, and followed that up with an arty BBC 2 television play in which Green appeared naked:

> Nobody told me I was to be fully nude. But, as they say, if the cause is worthy go with the flow. The irony of it was that the play was broadcast at the exact same time as Miss World on BBC 1. Fortunately, very few people watched the first full frontal male nude on British television. Perhaps Broccoli and Saltzman did! [8]

By then Green's agent had decided his client would make a jolly good Bond and persuaded him to have a photograph taken. When this was sent to Eon's casting director, Green was asked to come and meet Broccoli. 'I proceeded to try to impress him with my acting ability by embellishing my very small acting CV,' Green remembers:

I was well relieved when Broccoli said, 'We are not so concerned with your acting ability; we're more interested in how athletic you are?' This was music to my ears as I had just completed a successful rugby career where I had achieved near All Black status at an early age and had played for the Junior All Blacks against the touring British Lions in 1959. I told Broccoli of this and the meeting ended with Broccoli saying, 'I want you to meet my partner Harry Saltzman,' and promptly made an appointment for me.[9]

Green's meeting with Saltzman was held around his boardroom table with director Guy Hamilton and others present. 'They asked me if I felt I could do this role. Of course, I said yes. They then handed me the script of the forthcoming screen test to be held at Pinewood Studios at 6am on the date nominated. I was asked to have a haircut with their favourite barber.'[10]

Green only had a few days to organise himself. He called his girlfriend and together they rehearsed the scene, while another friend introduced him to a stuntman who gave tips about how to perform in a staged fight in front of cameras. Finally, the day of the test arrived and Green turned up at Pinewood in a suit and tie. The actress Imogen Hassall, who had appeared in numerous action TV series such as *The Avengers* and *The Persuaders*, had been hired to play the role of the new Bond girl Tiffany Case. Bond stuntman Bob Simmons was the bad guy. Green guessed that his audition was merely one of several planned that morning. 'The finished screen test itself lasts all of 10 minutes,' says Green.[11] It begins with Bond in Tiffany's apartment pouring himself a drink and lighting a cigarette. Dialogue takes place between them when there is a knock at the door. Tiffany asks Bond to 'see who that is'. Bond opens the door; the visitor introduces himself and proceeds to swing at Bond. A fight ensues, ending with the intruder dead on the floor, after several karate chops from Bond.

After the first take Green asked Guy Hamilton if he wanted to go again. 'No, we've enough in the can,' he said. Green said:

This surprised me but upon seeing the take I was not surprised as it stood up well. The audition ended with Guy Hamilton saying, 'I want

to tell you, you have a great chance of getting this part, we will get back in touch with your agent.' Need I say it! For this sheep farmer on extended holiday in the UK this was certainly an event to cause me to walk on air for the next three months.[12]

After that Green was regularly informed by his agent that other contenders for the role were being 'let go' one by one. Then eventually he read in the press that Connery was returning.

> And I was at last let go! My agent said that Hamilton, Broccoli, and Saltzman had wished me to play the role but United Artists had said, 'Not another unknown Antipodean actor, please!' I'd been quite confident about getting the job, but was realistic enough to realize the odds were great. After all I was not a trained actor, nor had I sought the role in the first place. But I had always felt I could make a good job of it if invited.[13]

Still, Green has an amazing souvenir of his 007 close encounter: a personal 16mm copy of his screen test that was given to him by Eon. Green eventually went back to live in New Zealand, running the family land company and hoping to set up a drug and alcohol treatment centre, having suffered from his own addiction for which he was successfully treated:

> On a final note, I could never understand what the Bond producers saw in me as I understand drama school and lots of training and experience were required before one succeeded in this cut throat business. Still, who was I to complain. I did not lie to them and as a New Zealand sheep farmer foot loose in the drawing rooms of Belgravia I had a ball.[14]

Another actor who thought he had a real chance of landing Bond, and was led to believe that he was on the producers' short list, was Michael McStay. This appeared to be confirmed when an official-looking telegram arrived at his house one morning announcing: 'The next James Bond is ex-policeman Michael McStay.' The ex-policeman was a reference to an ITV television series he'd made in the 1960s called *No Hiding*

Place in which he played Det. Sgt Perryman. 'Then the phone rang,' recalls McStay. 'It was Fleet Street on the end of the line, they heard I was up for Bond and wanted to send some photographers round to my house. They duly arrived and asked me to pose in various situations.'[15] The shots included McStay and his wife in their garden and kitchen and then an impressive solo image of McStay sitting with a vodka bottle and glass in the foreground. Obviously, the reporters were hoping that if McStay were suddenly announced as Bond, they'd have the scoop and the first pictures of him.

It was all rather bizarre, and unfortunately short-lived, for that same evening McStay and his wife attended a party where one of the guests was television director Steve Previn, brother of the composer André Previn. 'I eventually drifted over to join his party,' says McStay:

And everyone was busy talking about this total crap that the press was running about a new James Bond. And Previn said, 'They've already cast Connery.' And someone replied, 'But Sean Connery's not doing anymore.' And Previn said, 'Yes he is, they've persuaded him to do one more and they've offered him Scotland to do it.' And that was the one more that Connery did. And after that they got Roger Moore. So that was it for me.[16]

Born in 1933 in East London, McStay appeared in episodes of *Dixon of Dock Green* and *Crossroads* before landing his big break in 1964 when he joined the cast of hit police drama series *No Hiding Place*. He stayed on that show for two and a half years and became a well-known face. This was an experience McStay wasn't altogether comfortable with and one of the reasons why he never regretted losing out on Bond:

Your life changes totally when you play Bond, so I don't think I would have wanted it. Doing a top television show for so long stripped away a lot of privacy. I remember leaving the studios one day for a lunchtime drink with a mate and it had been rumored that the Beatles were going to appear on *Ready, Steady Go* that night and there were a hundred kids gathered outside. An hour later when we came back there were a thousand kids there. And I said, 'That's what I want, that kind of fame.' And the chap I was with said, 'No, the Beatles can never,

ever do what you have just done, go down to the local pub and have a beer.' There's a lot of truth in that.[17]

Another hurdle for McStay in playing Bond would have been the character's trademark humour. 'I could never handle those deadpan one-liners which Sean Connery did so wonderfully, and poor old Lazenby couldn't handle at all. It's very hard to just throw those lines away.'[18]

Throughout the 1970s and beyond McStay continued to work in television, appearing in a *Persuaders* episode, *Doctor Who* and *The Inspector Lynley Mysteries*. However, had he been asked to play Bond, how would McStay have gone about it? 'I've played a lot of policemen and a lot of villains and somewhere between those two there is James Bond. But those one-liners would have still worried me a great deal.'[19]

Another television actor seriously considered to replace Lazenby was Simon Oates, best known at the time for his portrayal of Dr John Ridge in the cult BBC sci-fi series *Doomwatch*. Born in Canning Town, East London, Oates worked in theatrical rep during the 1950s before many guest appearances in TV shows like *Man in a Suitcase* and *Department S*:

> My agent told me that the Bond producers were interested in me so I went up to Pinewood to do the test and got a round of applause afterwards from the crew who said, 'Well, that should be you, son, you're all right.' So, I thought, that seemed to have gone all right. But then I didn't hear anything back from them, so it never happened for me. But, you know, life goes on.[20]

Exactly what the test entailed Oates couldn't remember save that there was a lot of physical stuff involved. Most likely it was the same scenario that Roger Green underwent. 'This was ok because years before I'd been a boxing champion so I was pretty fit, I could handle all that.'[21]

After losing out on Bond, Oates did get to play one of fiction's other great spies, John Steed himself, in a 1971 stage adaptation of *The Avengers* with Sue Lloyd and Kate O'Mara. Oates can also boast of close connections with some of the Bond actors. He was friends with Roger Moore, worked with a pre-007 Pierce Brosnan in an episode of *Remington Steele* and performed on stage with Sean Connery in the biblical play *Judith*. Negative reviews cut short the West End run of *Judith* at the close of

1961 but not before Terence Young had witnessed Connery's impressive performance, which may have played a part in the actor winning the Bond role. 'I wouldn't be surprised,' said Oates, 'because he was fantastic in it.'[22]

As for his own close shave with 007, Oates had no regrets:

It would have been nice to have played Bond, but then you look at Lazenby and where's he? Of course, it would have been a success if I'd played it my dear. But playing Bond would have totally changed my life, maybe for the best, maybe for the worst. I'm more than happy with the way my career and life went. So, I really have no regrets about it. Basically, had I played Bond I wouldn't have met my wife, and for me that's more important than playing Bond.[23]

Another British actor with a distinguished track record of television appearances and film work was John Ronane. Born in 1933 he played guest roles in such cult shows as *The Saint*, *The Avengers* and *The Persuaders*, as well as more distinguished fare such as the 1970 BBC television mini-series *The Six Wives of Henry VIII* and its 1971 follow-up, *Elizabeth R*, in which he played Thomas Seymour opposite Glenda Jackson's Queen. He was also a member of the Royal Shakespeare Company.

At the time Ronane shared the same agent as Sean Connery, Richard Hatton, and it was he who told the actor unexpectedly one day that Saltzman and Broccoli had asked to see him. 'I thought myself a most unlikely British naval commander,' Ronane confessed, but went to see the producers anyway at their office. 'They were both charming but didn't indicate any apparent understanding of the way an actor approaches a part; hence, I suppose, why the Bond role was subsequently played by some of the worst actors ever to carry British Equity cards, in my opinion.'[24]

The interview, in the end, never amounted to anything. Had the role been offered to him, though, Ronane would have taken it:

But I would have sought, probably vainly, Ian Fleming's character; i.e. a man living on the edge and by his wits – not without any concept of fear, and most likely to die before reaching fifty! By this I think I mean that fear, to a greater or lesser extent, should play its part in all life,

that 'derring do' without fear seems stupid and looks embarrassing. Witness some of the Bonds to which we've been subjected.[25]

The real revelation for Ronane was when Harry Saltzman told him that he had been on his short list to play Harry Palmer in *The Ipcress File* (1965), a role that, of course, went to Michael Caine. 'I would have dearly loved to have played that character much more than Bond,' said Ronane. 'But I've no regrets whatsoever. I've had a blast! Hollywood bit, Emmy nomination; a life of making a living as an actor. What more could I want?'[26]

Someone Broccoli was keen on was Eric Braeden, who had recently played the lead in the sci-fi thriller *Colossus: The Forbin Project* (1970), about a malicious supercomputer. Braeden recalls:

Cubby Broccoli had seen that film and approached my agency and wanted to have lunch with me, and he said, 'Would you be interested in playing James Bond?' I said, 'Umm.' We talked a bit further and then Broccoli asked, 'Do you still have a British passport?' And I said, 'I have a German passport.' And the iron curtain came down. He apologized afterwards profusely to my agency but he said, 'Obviously we can't have a German play James Bond.' And I understood that completely. There would have been an uprising in the UK. So that idea was dropped and that was as far as it went. They were very interested, I found out afterwards.[27]

It is odd that Broccoli didn't do his homework on the actor. Braeden says there is a very logical reason for that. 'Back then, Hollywood film producers never looked at television, and had Broccoli looked at television before he would have realized that I played a Nazi/Rommel figure in a very successful television series in America called *The Rat Patrol*.'[28] This 1960s action series was about the Second World War missions of an Allied commando patrol squad in North Africa and Braeden was credited under his real name of Hans Gudegast:

I changed my name because Lew Wasserman, who ran Universal, insisted that no one would star in an American picture with a German name. After *The Rat Patrol* I did a film in Spain called *100 Rifles* (1969) with Jim Brown, Burt Reynolds and Raquel Welch and during that

film Universal called and told me to come and do a screen test to play the lead in *Colossus: The Forbin Project*. And Lew Wasserman said, 'we love him but we want him to change his name.' And I first said, 'fuck it, I will not do that.' But then eventually my wife talked me into it.'[29]

Despite Broccoli's error of not realising Braeden was German, it's not difficult to see what must have impressed him about the actor. He was a similar type in a way to Connery in that he was smooth and laid-back in his acting style, and was very athletic, having done a lot of sports. 'There's a kind of visceral feeling that you get from Connery that he can take care of himself,' says Braeden. 'Well, so can I. And I had played a lot of bad guys on television so I certainly knew how to pull a gun and look threatening.'[30]

And if that offer to play Bond had remained on the table, would Braeden have accepted?

Would I have considered it, yes, I probably would have. Although at that time I was very enamoured of Ingmar Bergman films and Fellini films and I thought, James Bond, umm. Also, who could possibly be better than Sean Connery, and as far as I'm concerned, he was the only one. Then I met both Sean and Roger Moore at some celebrity tennis tournaments in Monte Carlo, and they were both charming, but we didn't talk about Bond.'[31]

Braeden continued to work successfully in film and television and today is best known for his role as Victor Newman on the CBS soap opera *The Young and the Restless* for which he won an Emmy award in 1998.

Despite the Antipodean Lazenby, and the almost German Braeden, it was a sort of unwritten rule that Bond should be played by a British actor. Director Guy Hamilton was certainly of that opinion, that is until one night sitting in a hotel room in America, he caught a late-night TV chat show and was knocked out by one of the guests. His name was Burt Reynolds, a stuntman turned TV and sometime film actor. Hamilton thought he was terrific, combining all the qualities they were looking for, he moved beautifully and had a nice sense of humour. Hamilton insisted the producers meet him, but the idea fell flat with United Artists. 'They said he was just a stuntman. Broccoli's objection

was that it had to be an Englishman. And I said, in nine-tenths of the world Bond speaks Chinese, German, French. I really think Reynolds would have made a marvellous Bond. But in the end Cubby was probably right.'[32]

Despite Broccoli's reticence over Burt Reynolds, he and Saltzman did end up interviewing several American candidates. 'There are some marvellous actors in the United States,' associate producer Stanley Sopel recalled. 'But there's no James Bond.'[33] Well, it turned out that there was.

His name was John Gavin, a 40-year-old former naval intelligence officer. As Guy Hamilton remembered it, Dana Broccoli was one of his strongest advocates. According to Maria, Gavin's daughter, the actor was a friend of the Broccolis: 'I know that my dad was friendly or acquainted with the Broccolis, with Cubby and Dana. Years later, I recall going to a New Year's Eve party at the Broccoli's house.'[34]

After finding no suitable candidate to play Bond, was it simply a case of Broccoli knowing Gavin – knowing that he could trust and work with him; that, as an experienced and good actor, he could do a job; and that he looked the part, thanks to his dark matinee idol looks? 'He did have that look,' says Maria Gavin. 'And the sort of charisma that a Bond should have. He did have that swagger.'[35] You can quite easily visualise Gavin in a tuxedo going into a casino to play baccarat, and in the next moment getting into a fight with a henchman. The actor was well built and capable of looking convincing in scenes of physical action.

Of course, and this is something Gavin had no control over, he was American, and so would have become the first actor from America to play Bond. 'I don't know if he would have tried to do the accent,' says Maria. 'But I know that he was friends with a very famous voice coach, this man was known as the Henry Higgins of Hollywood. But my father didn't have a very strong American accent so he could have toned it down or tried a British accent.'[36]

Born in 1931 in Los Angeles, Gavin graduated with honours from Stanford University, majoring in Latin American economic history. 'When he was at university, he used to joke that he didn't know where the drama department was,' Maria recalls. 'He wasn't into acting then. He only got interested in acting after he was in the navy.'[37]

When he came out of the navy, Gavin was offered a screen test by Universal who snapped him up, put him under contract and hyped him

as the next Rock Hudson. Handsome and debonair Gavin made his film debut in 1956 and his first major lead was opposite Lana Turner in the classic weepy *Imitation of Life* (1959). On a roll in 1960, he played Janet Leigh's lover in Alfred Hitchcock's *Psycho* and then Julius Caesar in *Spartacus*, directed by Stanley Kubrick, with whom Gavin became good friends.

By the time the Bond producers came calling, Gavin was still appearing in the odd big movie, such as *Thoroughly Modern Millie* (1967), an amusing pastiche of the 1920s starring Julie Andrews; Gavin played Millie's self-absorbed boss. But mostly he worked in television and in Europe, where he made, for example, a French/Italian 007 spoof called *OSS 117 – Double Agent* (1968); also known as *OSS 117 Murder for Sale* or *No Roses for OSS 117*. Watch that and it may give you a fair idea of how he would have approached playing Bond. He shares some scenes with Luciana Paluzzi, SPECTRE's black widow assassin Fiona Volpe from *Thunderball*. And it is inconceivable that Broccoli and Saltzman would not have seen this film or at least known about it, as they kept a very close eye on their movie spy competitors.

And so, John Gavin accepted the job, signed a contract and was going to be James Bond in *Diamonds Are Forever*.

Nervous about the introduction of another new Bond, especially after the less than stunning box office returns for *On Her Majesty's Secret Service*, United Artists were convinced there was only one actor who could guarantee a smash – Connery. United Artists president David Picker called the producers to see how likely it was that this could be arranged, only to learn that the men's relationship with their former star was, essentially, 'non-existent and non-speaking'.[38]

Despite that, a meeting between the producers and United Artists top brass took place at Broccoli's home in Beverly Hills; Picker flew in from New York. The upshot was – let's try to make a deal with Connery. Stanley Sopel was chosen as the man most likely to succeed, given his close friendship with the actor. Flying into London Sopel arranged to meet Connery for lunch at The Dorchester hotel. Since quitting Bond, Connery had made the western *Shalako* and *The Molly Maguires* (1970), a historical film about immigrant miners in Pennsylvania in the late nineteenth century co-starring Richard Harris. Both did badly. Connery remained determined to develop his career in challenging ways, and a

return to 007 would be a step backwards, and perhaps an admission of failure. So, the answer to Sopel was – no. Sopel, however, did not leave the meeting empty-handed: Connery managed to sell him a second-hand Mercedes from a garage business he had an interest in.

Next, the producers roped in Ursula Andress, always Connery's favourite Bond girl, to act as some kind of mediator. The actress flew from Paris to London to present the offer and persuade him to accept. Still, he wouldn't budge.

Picker decided to tackle the star himself and flew to London in person with an unprecedented offer: a staggering basic fee of £1.25 million, 10 per cent cut of the gross and a penalty clause that if the film went over schedule Connery received $10,000 per additional week. Furthermore, Picker promised Connery that United Artists would financially back, to the tune of $1 million apiece, any two films of his choosing, to either star in or direct. One of those films turned out to be the gritty police drama *The Offence* (1972), for which Connery gave one of his best performances. The other project never materialised.

Surely this was a deal too good to refuse, and so it proved. Still, there was a lot of soul-searching and Connery took a week off by himself just to kick the idea around. In the end it served his purpose. In 1970 Connery joined forces with Scottish industrialist Sir Iain Stewart and racing driver Jackie Stewart to create the Scottish International Educational Trust, a charity that funded artistic individuals and worthwhile projects in Connery's homeland. To get the foundation in place and in sound financial order Connery donated his entire fee from *Diamonds Are Forever*.

In all the brouhaha about Connery's return, one man had been forgotten: the man who had already signed a contract to play 007. It was probably Broccoli, as Gavin's friend, who told him the bad news. According to Maria, though, Gavin already knew that his chance to play Bond was blown. 'My dad said that one day he got home and there was the newspaper there and it said that Sean Connery was getting divorced, and my dad just went, 'I'm never making that movie'. Because he knew that Connery would need some extra money to get through his divorce.'[39] As it was, Connery did indeed make *Diamonds Are Forever* for the money, but in the end, as we know, gave it to charity.

After losing the role Gavin took his family on a short break to San Diego. Maria recalls:

We spent a few days there and I just think he felt disappointed and was a bit down in the dumps. I was very young but I remember thinking he was a little down, a little grumpy. So, yes, it was a disappointment for my dad that he didn't get to do Bond. They did honour the contract, which was a pay or play contract. So he got paid and he got residuals.[40]

Maria thinks the residual payments continued for the rest of her father's life. Although, thanks to Hollywood creative accounting, they weren't very much at all.

Gavin continued to act, making his Broadway debut in 1973, and served on the board of the Screen Actors Guild, becoming Guild president for two years. Later in the decade Gavin was engaged in business activities, much of which took him to Mexico and other Latin American countries. This led to a move into politics and he was nominated to serve as American ambassador to Mexico by President Ronald Reagan from 1981 to 1986. 'His biggest joy was being the US ambassador to Mexico,' says Maria. 'It meant a lot to him because his mother was from Mexico.'[41]

The story of John Gavin is an interesting one. With the exception of Pierce Brosnan losing out to Timothy Dalton back in 1986, no one else has come closer to being James Bond than John Gavin. And curiously, when Brosnan first missed out on James Bond there was only one other man in the world who knew how it felt, and that was Gavin. Maria says:

Years later when Pierce Brosnan was going to be Bond and then he couldn't be, because the makers of his TV show *Remington Steele* wouldn't let him out of his contract, I remember my dad saying, 'They should have let him out. They should have let him do it. That wasn't right.' Obviously, he could relate to what Pierce was feeling and going through, of having had the role and then it being taken away from him.[42]

With Connery back, the producers did everything to make the shooting of *Diamonds Are Forever* as pleasurable a return as possible, including providing a luxury suite at the best hotel in Las Vegas and arranging for him to play golf at conveniently located courses. 'If this was to be

his last Bond film,' Broccoli said, 'then we wanted to part as friends.'[43] Connery reciprocated by being the ultimate professional and enjoyed his time working on the picture. He was gratified too that it turned out a huge hit. 'I was in theatres many times,' said the film's screenwriter Tom Mankiewicz, 'when in the beginning of the picture he said, "My name is Bond, James Bond," audiences cheered because he was back.'[44]

With *Diamonds Are Forever* a worldwide smash Saltzman and Broccoli were determined to lure Connery back for the next one, *Live and Let Die*. They arranged for Tom Mankiewicz, who was writing the new movie and had forged a good relationship with Connery during *Diamonds Are Forever*, to meet with him:

> They wanted me to try and get him back! So, we had this lunch and I told him, 'Look Sean, we've got crocodiles, we've got a boat chase, we've got a lot of great stuff going on in case you want to do one more.' And Sean said an interesting thing, he said, 'I even read in the papers sometimes that it's my fucking obligation to play Bond. Well, I've done six of them, when does the obligation run out, at ten, twelve, fourteen.' And Sean being very much an actor by then, and he wasn't when he started, meaning he really had become a world star, I think he just couldn't wait to go out and act and play other parts.[45]

United Artists were just as desperate for Connery to carry on and made several lucrative approaches. 'Sean was offered the world if he would do another Bond film,' revealed Desmond Llewelyn, who played Q in the films. 'He could have whatever he wanted. But he said no and one American tycoon said, "Well, you've got to admire the bastard!"'

5

The Saintly Bond

Eon began its search for a new James Bond early in 1972, apparently flirting with the idea of recruiting not from the acting fraternity but the armed forces. Ads were taken out in army journals under the heading: 'Are you 007?' That was before the actor's union Equity reportedly stepped in and stopped it.

Throughout the early months of 1972 the producers shot dozens of screen tests and by June the quest had narrowed to a handful of hopefuls. One of those was Julian Glover, a member of the Royal Shakespeare Company before becoming a familiar face to British television viewers after appearances in numerous popular series during the 1960s and early '70s including *The Saint* and *The Avengers*. At the time, the London-born actor was appearing in a BBC espionage show called *Spy Trap* and believes this was the reason Broccoli and Saltzman came calling. 'I was in my early 30s then and quite presentable looking and I was playing a sort of Bond-style character. I wore a suit and tie and things like that, and stood up straight and pointed a gun in the right direction.'[1]

When Glover's agent informed him that the Bond producers wanted to set up a screen test his first reaction was:

Wow, quite simply. But then, God, I don't stand a chance do I. But my agent was very encouraging, 'You never know Julian,' he said. 'You're playing that sort of part now on television.' And so, I went and did the test. Of course, I was absolutely terrified. But it was such an outside

chance. The idea of me playing James Bond was almost absurd, that was something that Sean Connery did.[2]

Off Glover went to Pinewood Studios, and, even though he didn't allow himself much hope, he still approached the audition as professionally as possible:

> I hyped myself up in that I learnt the lines, and I tried to do it as well as I could. I didn't have anyone to direct me, one never does on those things, it's just go on and do it. They roll the cameras and say do this that and the other, and move from there to there. I had a couple of times to practise the scene and then I did it. But I knew I wasn't going to get the part because I heard that someone called Roger Moore was in line for it and having already done three episodes of *The Saint* with him, he was an absolute obvious choice. So that was the end of that and I suppose that my test is on the cutting room floor somewhere. I have to say I wouldn't want it to be seen; the shame, the shame.[3]

Glover did eventually get to appear in a Bond film, not as 007 but as the main villain, the double-crossing Kristatos in 1981's *For Your Eyes Only*:

> When I was playing that part there was some talk among Cubby and Barbara Broccoli about, well now that you've grown up and reached a certain age you might be good for Bond. And I think by that time I probably would have been rather good; more of an Ian Fleming sort. So, there was talk then, but of course I couldn't do it because I'd just played the villain, so that was completely out.[4]

Even so, Julian Glover remains unique in Bond history, being the only actor to screen test for 007, then to play the bad guy. Indeed, this fine actor has made something of a career playing villainous types in *Doctor Who*, *The Empire Strikes Back* (1981) and *Indiana Jones and the Last Crusade* (1989).

Another classically trained actor on Broccoli and Saltzman's list was Jeremy Brett. Born in Berkswell, a village in Warwickshire, in 1933, Brett was educated at Eton College and trained as an actor at the Central School of Speech and Drama in London. His background was really the theatre, playing many classical and Shakespearean parts with the Old

Vic and the National Theatre. His only film appearance of any note was as Audrey Hepburn's luckless suitor Freddy Eynsford-Hill in the 1964 blockbuster musical of *My Fair Lady*.

Brett's screen test went well and although he was never offered Bond, the actor later confessed it would have been near impossible to refuse, but that had he got it, it would have spoiled him. For the rest of the 1970s and into the '80s, Brett floundered badly; how else can you explain guest appearances in American series like *Hart to Hart* and *The Love Boat*. But in 1984 his career was spectacularly saved when he was chosen to play Sherlock Holmes in a series of television dramas that ran for ten years and achieved global critical acclaim and popularity. One can ponder at how well Brett would have done as Bond, probably a little too cultivated and lacking in physical threat, but it's hard to argue against him being the greatest personification of Conan Doyle's legendary pipe-smoker.

By the early 1970s, 30-year-old Jon Finch was on something of a roll. After starting his film career in a couple of Hammer horrors, Finch, who was born in the town of Caterham in Surrey, worked for Roman Polanski in his screen adaptation of *Macbeth* (1971) and then for Alfred Hitchcock in *Frenzy*. According to the actor's obituary in the *Guardian*, Finch was offered Bond but turned it down, to the puzzlement of many. Maybe it wasn't that surprising given his private nature and mistrust of stardom. 'I couldn't be a star at the expense of my life,' he said in 1973. 'I don't want to get anywhere near being like Michael Caine or Oliver Reed. They're great at it; it's their bag. It's not mine. I like to be completely unrecognized. I just keep out of the limelight.'[5] With a statement like that, doing the Bond films would have been anathema to him.

Finch's screen persona was very much one of brooding intensity, although his performance as Michael Moorcock's secret agent, superhero, adventurer Jerry Cornelius in the sci-fi film *The Final Programme* (1973) showed a light comedic touch that would have worked well as Bond. And the physicality of the role wouldn't have been a problem either given that Finch did his National Service in the Parachute Regiment and stayed on as a member of the SAS Reserves. It wasn't to be, and Finch's career faded as the decade wore on. He might have got a career lift in 1979 when Ridley Scott cast him as Kane in *Alien*. Unfortunately, after just a few days on the set he fell ill and was replaced by John Hurt. Finch died in 2012.

Since his first run-in with Bond back in 1968, Michael Billington had been cast as Colonel Paul Foster in the cult Gerry and Sylvia Anderson sci-fi TV series *UFO*. He was still working on that show when Bond came back into his life. According to Billington, Saltzman came to the studio to see some footage from the show, as he was planning to follow *Diamonds Are Forever* with *Moonraker* and was looking for some expertise with special effects. Sylvia Anderson, an accomplished casting director, suggested to Saltzman that Billington might be right to play Bond. Indeed, Billington had been cast as Foster to bring a bit of action man heroics to *UFO*. 'When I was spruced up, I did look a little bit Bond-like,' confirmed Billington. 'I think the Andersons felt that could be an influence. Foster was a veiled attempt to introduce a Bond-type character into the series.'[6]

Nothing came of Saltzman's visit to the set of *UFO*, but when the casting for *Live and Let Die* began Billington heard that Broccoli wanted to see him:

> I felt the meeting went well and I liked Cubby as a person. I also think I did well on the test for *Live and Let Die* and liked Guy Hamilton, the director. The scene was a specially written one, which I played with an actress called Caroline Seymour. I heard from my agent that there was going to be an offer made. When it was announced that Roger Moore was going to do it, I was stunned. Getting the Bond role was as close as could be really. I think I was the unanimous choice at one point of both Cubby and Harry and Guy Hamilton; they all at one time or another gave me the seal of approval.[7]

Billington didn't hear from the Bond team for quite a while. The only feedback he received was from Jane Seymour, who had recently co-starred with Billington in the BBC drama series *The Onedin Line* and was playing Bond girl Solitaire in *Live and Let Die*. She told Billington that from time to time Saltzman quizzed her about him, probing questions about his sexuality and such like. Something about Billington's test must have stuck in Broccoli's mind too, because the producer asked the actor in 1977 to appear in *The Spy Who Loved Me*, in a small role as a KGB agent killed by Roger Moore in the famous pre-title ski chase. Billington knew that if he did that picture, it might prevent him from

having another crack at playing Bond. In the end he thought – why not? After all, it was a couple of weeks in St Moritz.

Billington didn't have to wait too long for his next Bond encounter. He had just finished a guest starring role in *The Professionals* TV series when he got the call to go to Paris for another series of tests. The next Bond, *Moonraker*, was in pre-production in Paris and they wanted Billington to stand in as 007 opposite a few potential Bond girls they were looking at. Billington recalled Shelley Hack being one of them, and *Emmanuelle* star Sylvia Kristel:

> During the testing Lewis Gilbert, who was directing *Moonraker*, told me that he thought I should do the next one, but it was up to Cubby. My final obstacle, according to Lewis, would be if Cubby invited me out to dinner on the last night of the tests. He did and we had a pleasant dinner with Cubby, Mrs Broccoli, John Glen, myself and Barbara, Cubby's daughter. Barbara and I spent a night on the town in Paris, with John Glen as chaperone. The next day I was on a plane back to London; and that was that for me and James Bond, or so I thought.[8]

Another actor given a second chance was Patrick Mower. Over the last couple of years Mower had established himself as something of a TV tough guy and heartthrob, with roles in macho cop series like *Callan* and *Special Branch*. In 1972 Saltzman and Broccoli sent for him again and Mower was whisked down to Pinewood Studios for a screen test, playing a scene with Lois Maxwell as Moneypenny. 'I thought I did rather well,' said Mower. 'They didn't. Once again, I missed out as they gave the part to Roger Moore.'[9]

Under very serious consideration was David Warbeck, a New Zealander with a dash of Scottish ancestry. He arrived in 'swinging' London in 1965 and quickly took advantage of his ruggedly handsome features by becoming a successful photographic model promoting everything from Courvoisier brandy and Martini to cable-knit pullovers, and ice cream. Moving into movies, Warbeck had featured roles in the horror films *Trog* (1970) and *Twins of Evil* (1971), along with a small but important appearance in Sergio Leone's *A Fistful of Dynamite* (1971). Warbeck was so confident he'd landed the Bond gig, claiming that the producers told him if Roger Moore didn't want the job, then it was his, that he

contacted journalist Tony Crawley to conduct an interview. This would be released as soon as his news became official. Sadly for Warbeck, that interview never saw print. As we shall see, Warbeck was to get another chance to play Bond in the 1980s.

Another New Zealander, who studied architecture and farmed in Ireland before becoming an actor in Britain, was Noel Trevarthen. He worked a lot on television, appearing in episodes of *Dixon of Dock Green*, *Danger Man* and *The Saint*, as well as on stage and film, notably in *Vengeance of Fu Manchu* (1967) and the Peter Cushing horror shocker *Corruption* (1968). Although he was perhaps too lightweight to carry off Bond convincingly on screen, Trevarthen did speak about coming close to playing the role until Roger Moore was cast. 'It was something of a disappointment,' he said.[10]

When work dried up in the 1970s, Trevarthen moved to Australia and bagged roles in numerous Aussie soaps like *The Sullivans*, *The Young Doctors*, *Home and Away* and *Neighbours*. He died in 1999.

While these tests continued, United Artists made it very clear to Broccoli and Saltzman that this time they wanted an established actor with solid professional experience playing Bond; in other words, not another Lazenby. Incredibly, the studio set their sights on Paul Newman and Robert Redford. The producers even approached Clint Eastwood. 'I was offered pretty good money to do James Bond,' the Hollywood legend revealed in 2010. 'This was after Sean Connery left. My lawyer represented the Broccolis and he came and said, "They would love to have you." But to me, well, that was somebody else's gig. That's Sean's deal. It didn't feel right for me to be doing it.'[11]

Broccoli sought out another American, and a friend, Robert Wagner. The two of them had known each other for years, since the late 1940s when Wagner was a young aspiring actor and Broccoli worked for Charles Feldman, a leading agent. Still, it came as a surprise, and a shock, when Cubby floated the idea of him playing Bond, as Wagner wrote in his memoirs:

> There was no formal offer but Cubby thought that I was a viable candidate to replace Lazenby. I thought about Cubby's suggestion for about two seconds, but realised it just wasn't a good fit. 'I'm too American,' I told Cubby. 'James Bond has to be English. Roger Moore is your guy.'

Broccoli felt that he owed something to John Gavin too, who had graciously accepted the Connery situation on *Diamonds Are Forever*. Guy Hamilton meanwhile was again pushing for Burt Reynolds, who had since grown in status as an actor with appearances in films like *Deliverance* (1972). This time Hamilton's choice of Reynolds had the backing of Saltzman, according to screenwriter Tom Mankiewicz. 'Harry was not averse to casting an American and Burt Reynolds was very seriously considered. In the end Cubby put his foot down and said, "Bond must be British." Cubby had another fixation which was he had to be tall. Cubby wanted Bond to be over six feet.'[12]

In interviews Burt Reynolds confirmed that he was offered the chance to follow Sean Connery as 007 but rejected the opportunity. In his autobiography he wrote, 'Cubby Broccoli came to me and said, "We want you to play Bond." And I said, in my infinite wisdom, "An American can't play Bond. The public won't accept it."'

By the late 1970s Reynolds was the number one box office attraction in America. When his career faltered badly in the 1980s and '90s, he took a more cynical view regarding his missed 007 opportunity, regretting it but also seeing the funny side; after all, this is the man who said no to playing Han Solo in *Star Wars*. Reynolds always believed that he could have played the Bond role well, which indeed he could have. Reynolds had suavity, a good comedic touch and could be vicious when he had to be, combined with great screen charisma.

Back in the UK, agents across London continued to put up their clients for the part. That's how Robin Hawdon found himself one morning making his way to the offices of Eon Productions. Born in Newcastle upon Tyne in 1939, Hawdon began his career in repertory theatre, notably at the Bristol Old Vic before playing a variety of roles in London's West End. Moving into television he enjoyed a recurring role in the 1960s BBC soap opera *Compact*, set in the offices of a glossy magazine. He also began to appear in films, like the lead role in Hammer's *When Dinosaurs Ruled the Earth* (1970) and as a secret agent (James Word of Department 5) in the notorious British sci-fi sex comedy *Zeta One* (1969).

The initial filtering-out interviews had been conducted by Eon's production assistant Dyson Lovell, whom Hawdon happened to know because they were at RADA together. At an earlier meeting Lovell passed on a few helpful tips for Hawdon's meeting with the producers:

First of all, dress conservatively, in a business suit with white shirt and not too flashy tie. Make yourself look as hunky as possible – put shoulder pads in your jacket and lifts in your shoes. Be sure to get into the conversation that you like girls, because they are fearful of casting someone gay as James Bond. And finally, practise your walk. They will decide from the way you walk into their big office, and all the way from the door to their desk, whether you are James Bond material or not.[13]

When the day came, Hawdon put on his only tailored suit, added the homemade shoulder pads and shoe lifts, and returned to the offices. 'In the outer waiting room were several other hopefuls, most of whom I knew at least vaguely, all dressed in smart suits, probably with shoulder pads and shoe lifts. "Hi, Robin. Hi, Simon. Hi, Ian," we greeted each other in deep voices, and with Bondian expressions.'[14]

One by one the others were called and were marched through a big mahogany door into the main office. 'When my turn came,' says Hawdon, 'I went, quaking inwardly, through the door, and did my James Bond walk (with difficulty as the carpet pile was several inches deep) towards the big desk at the far end of the room. Behind it sat the two stout Hollywood moguls, one smoking a cigar if memory serves.'[15]

The interview passed in something of a haze, as Hawdon listed his career credits, with the obligatory mention that he had had various romantic female encounters, and was now married. By this point in his career, Hawdon had begun a burgeoning second career as a writer of novels and plays. Indeed, the previous year he had written a screenplay for Eon for a proposed film about the Battle of Trafalgar. Suitably impressed, Broccoli turned to his partner. 'I think we should test this boy, Harry. Whaddaya think?'

Harry nodded. 'Yeah, yeah. We'll give you a film test, kid. Couple of weeks. We'll let your agent know.'[16]

Hawdon thanked them, did his best James Bond walk back to the door, then rushed off to the nearest telephone to tell his agent. The two weeks passed, with both Hawdon and his wife Sheila on tenterhooks. Then his agent rang. 'Sorry, Robin, but the test has been cancelled by the film's director, Guy Hamilton. They didn't give a reason.'[17]

Undeterred, Hawdon managed to wrangle a meeting with Guy Hamilton. 'I donned my Bond outfit and went to see him. He was an austere looking man, who was polite, but strangely uncommunicative about the reasons for cancelling the test. I left none the wiser.'[18] A week later, Hawdon opened his morning paper to see the news that Roger Moore had signed to play Bond. That was the reason why the Bond makers had been non-committal; negotiations with Moore had probably been going on throughout the auditioning process.

Once he got over the initial disappointment, Hawdon came to realise that probably he'd had a lucky escape. 'I would never have lived up to Sean Connery's iconic portrayal. My marriage would probably never have survived the Hollywood holocaust, and I would not have had the happy and fulfilled writer's life that followed.'[19]

Someone else who was relieved at not becoming James Bond, indeed walked away from the possibility of it happening, was Australian actor Tony Bonner. Born in 1943 in Manly, a suburb of Sydney, Bonner arrived in London in 1969 after finishing two years playing helicopter pilot Jerry King on the enormously popular television show *Skippy*. He joined an agency and began to pick up interesting work. In London he hung out with fellow countryman George Lazenby around the time he had the Bond job. Bonner even gave Lazenby a bit of advice:

Because I knew him reasonably well. And when he got the opportunity from Cubby and Harry I said to him, 'Just be a good guy, George, don't be a smart arse, clever guy. This is your first film, so just be respectful, be wanting to learn, and the British crew and Cubby and Harry will carry you through and it'll be great. Don't be a crazy bastard.' But George just wanted to be George and it ruffled a few feathers.[20]

Bonner agrees with the view many hold that if Lazenby had done another couple of Bonds he might have been a success:

What the problem was, and not just George, with a lot of actors that come along and get roles unexpectedly they should immediately start mentoring with an actor that they like and respect and start learning

what the industry's about, what to do, how to find moments, how to find a character and make that character interesting. And I believe if things had gone better for George and he did a little study and a little homework, I think he could have gone on to quite a successful career.[21]

This was the difference with Bonner: when the Bond chance came along, he already had plenty of experience behind him. At the time he was working at Pinewood playing the guest lead in an episode of *The Persuaders* with Tony Curtis and Roger Moore. It was during the making of that episode that Bonner and Moore began a friendship that lasted until Moore passed away:

> We just hit it off from the moment we first met. And whenever I came back to England or Europe, or I was in Los Angeles and Roger was there, or when he came to Australia, which he did often, we would catch up. Roger was a great guy, with a great sense of humour. He knew that he had a certain on screen charm and resonance and he enjoyed that. He knew he didn't have the subtleties to be one of the great actors, and I don't think he ever aspired to that. He aspired to being happy and to connect with what he was doing in whatever film he was making. But he didn't inflate his own ego. He was just a charming, helluva guy.[22]

Bonner's brush with Bond really began when he was making the film *Eyewitness* (1970) opposite Susan George and directed by John Hough on location in Malta. One of the producers on it was Irving Allen, Broccoli's old producing partner who had an office at Eon's HQ in South Audley Street. 'Johnny Hough was saying some nice things about what I was doing in the film and that got back to London,' Bonner recalls:

> Then I did *The Persuaders* and Roger and I were both called in to talk to the producers. One thing I was told was that they were interested in getting away from the dark look of Sean and Lazenby. So, they were thinking of going with an actor who was fair, which is one of the reasons why Roger got it and one of the reasons why I was in the frame because physically we were not like Sean or Lazenby.[23]

Bonner's meeting with Broccoli and Saltzman was casual and relaxed. It wasn't an audition as such; they already knew about him, and knew his work. Later word came back through Bonner's agent that they were looking to arrange a screen test. That's when Bonner left the country and headed for a break in Spain:

> It was kind of becoming real. And I was scared that I was going to get it. I was doing pretty well at the time, I'd done some good films, the word about my work and about myself was good, and I just thought, holy hell man, if I get Bond, everything changes and will I be able to handle that.[24]

Like a lot of actors Bonner struggled with low self-esteem issues – that if things were going well, maybe he didn't deserve it. 'I'm one of those funny people who love giving everything I possibly can but it's not easy for me to accept things. And in my life, I've run from success many times.'[25] It happened again some years later when he scored a success in an American TV movie and a positive buzz started to generate about him, so he upped and left Los Angeles. 'My agent said, "Where the fuck are you going?"'[26] It was much the same reaction when he finally got back to London from Spain. 'My agent said, "Where the hell have you been? You had a shot at this." When I saw Roger again, he said to me, "What happened to you, dear boy?"'[27]

By then the news on the acting grapevine was that Roger Moore had the Bond gig. Bonner was delighted for his friend and one of the first to congratulate him. And looking back today, he doesn't regret at all what happened, since he went on to carve out a long and satisfying acting career, that also included directing and teaching. 'I was quite honoured and flattered that I was even in the discussion for a while. I suppose I was close. But who knows. It could have changed my life immeasurably and who knows whether that was going to be for the better or not.'[28]

While he deliberately avoided the screen test, had the role been offered to him Bonner says:

> Unequivocally, I would have said yes. And I would have tried to put my own stamp on it and find an element of Bond that Sean or George

The Search for Bond

hadn't played. When I work as an actor I like an audience not to get bored with the character I'm playing, for them to keep thinking, what's this guy going to do next. What's he going to say. I want an audience to be engaged with what I'm trying to do on the screen. That's what I would have shot for. To make James Bond me.[29]

Interestingly, Bonner has connections with some of the other Bond actors too, not just Moore and Lazenby:

Pierce Brosnan was married to an Australian friend of mine, the actress Cassandra Harris. And I worked with Daniel Craig on an episode for George Lucas of the *Young Indiana Jones Chronicles* in 1993. It was interesting working with Daniel back then when he was just a jobbing actor. You would never have dreamt that one day he was going to be James Bond.[30]

As contenders came and went, always at the back of the producers' mind was someone who was considered the most realistic option almost from the start of the process – Roger Moore. Saltzman especially was a big advocate. Sue Parker, Saltzman's PA, recalled the producer calling Moore to reassure him: 'Hang in there. I think it's all going well. We are seeing this person and that person. You'll get it.'[31] Sue also doubted that Dana Broccoli was that keen on Moore. 'I remember Harry saying, "You know, she's trying to put the knockers on it."'[32]

Moore had in fact known the producers for many years, going on trips to casinos with them; he numbered amongst Saltzman's regular poker school. And whenever a new Bond film came out the producers always invited Moore to see it at their private screening room in South Audley Street.

Over at United Artists, executives were doubtful whether Moore could make the transition from television star to movie star. They had backed his 1969 spy film *Crossplot*, the actor's first cinema outing since leaving *The Saint*, and it flopped badly. But they were aware of his history with the role. That he was amongst the list of candidates for *Dr. No* though never formally approached. That an offer was on the table to do *On Her Majesty's Secret Service*, but he was still doing *The Saint*, and

then again for *Diamonds Are Forever*, but he was tied up with another TV show *The Persuaders*.

Moore was determined that, if the Bond role came around again, he would have no commitments this time. While *The Persuaders* had proved a hit in Europe, in the all-important American market it lost in the ratings war. Still, TV tycoon Lew Grade was anxious to make a second series, according to the show's creator and producer Robert S. Baker. 'Lew wanted to make more *Persuaders* but Roger didn't. By that time Roger had the offer to play Bond. He was being groomed by Broccoli and Saltzman. So, at the end of the series, we knew Roger was going to be Bond.'[33] Shrewdly, when Moore agreed to do *The Persuaders*, he refused to sign a long-term contract that might see him saddled with the show for years and thus unavailable should the Bond role become free. 'Roger had no contract to do *The Persuaders*,' Baker confirmed. 'Tony Curtis had a contract, but Roger wouldn't sign, so it just became a gentlemen's agreement.'[34]

It was Saltzman who called Moore up with the good news. 'Are you alone?' he asked. 'You mustn't talk about this but Cubby agrees with my thinking in terms of you for the next Bond.'[35] Ironically, Moore's phone number at his home in Denham was – 2007. At the time Moore still had his curly locks left over from *The Persuaders*. 'Cubby and Harry kept on saying, "Your hair's too long." I kept having inches cut off. They then declared, "You're too fat, gotta lose some weight." So, in the end I got so desperate I asked them why didn't they get a bald-headed, thin fella to start with.'[36]

Roger Moore was born in London in 1927, the son of a police constable. From an early age he showed artistic sensibilities, but not for acting, rather art. Upon leaving school at the age of 15 he accepted a job as a trainee animator at a film company. The job lasted just a few months when he was sacked for failing to collect a can of film. With some friends, Moore went along to Denham Studios to audition to be film extras for the historical drama *Caesar and Cleopatra* (1945) starring Vivien Leigh and Claude Rains, then the most expensive picture ever made in Britain. Moore's dashing good looks literally stood out from the crowd and he was spotted by the film's first assistant director, Brian Desmond Hurst. Encouraged to audition for RADA, Moore got in

and found himself in the same class as his future Miss Moneypenny, Lois Maxwell.

Following RADA and military service, Moore acted in repertory theatre and did some modelling. In 1953 he moved to New York with his wife, the singer Dorothy Squires, and found acting jobs on television. Soon he was put under contract to MGM and appeared alongside such stars as Elizabeth Taylor in *The Last Time I Saw Paris* (1954) and Lana Turner in *Diane* (1956). Returning to England, Moore took the leading role in the historical action TV series *Ivanhoe* (1958–59) and became a well-known television personality. His fame rose higher still when he was chosen in 1962 to appear as The Saint.

On 1 August 1972 it was made official, and Moore was introduced as the new James Bond at a press conference at The Dorchester hotel. No sooner had the announcement been made than *Cosmopolitan* magazine wrote to Broccoli and Saltzman asking if Moore would pose as a nude centrefold with a Walther PPK covering the more important parts. Moore answered, 'Not even with a Thompson sub machine gun!'

The producers talked up their new star as being closer to Fleming's literary creation than the previous two incumbents. 'Fleming saw Bond as himself,' said Saltzman, 'as a kind of disenfranchised member of the establishment, Eton, Harrow, and Cambridge. And Sean was none of those. Fleming would have been delighted with Roger, however. He is the classic Englishman. He looks good and he moves good.'[37]

Asked by the press what was going to be different about his 007 from Connery, Moore replied, "White teeth!" That one jokey response was the key to how Moore intended to play Bond, to chisel off the hard edge surrounding the character and approach the whole thing in a far more sardonic way, as though he were sharing the joke with the audience. Clearly lacking the killer instinct that made Connery's Bond such an appealing bastard, the filmmakers wisely played to Moore's very different strengths, a sophisticated wit and gentlemanly charm. Connery knew the world of Bond was fantasy but the trick for him was to make it as believable as possible. Moore took the opposite approach. He knew Bond was utterly ridiculous to start with and not to take the role too seriously. 'Bond has nothing to do with the real spying world. I mean, what sort of spy is recognised in every bar in town.'[38]

The tongue-in-cheek approach was probably the major contributing factor as to why Moore got the nod over all the other Bond wannabes. The overly comic tone of *Diamonds Are Forever* had been a huge success and the rest of the 1970s 007 movies followed a very similar path; it seemed to fit the new era. Moore was the perfect actor to pull off the lighter comic touch the series was now adopting. In both *Live and Let Die* (1973) and *The Man with the Golden Gun* (1974) you can see Moore trying to hit the right balance between the humour and the toughness. He finally nailed it with his third Bond appearance *The Spy Who Loved Me*.

The man most responsible for Bond's new sense of humour was an American called Tom Mankiewicz, who wrote *Diamonds Are Forever* and then Moore's first two entries. He recognised that Moore's strong points as an actor were in exact contrast to Connery. 'They were very different people to write for,' said Mankiewicz:

> When Sean walks into a room on screen there's a twinkle in his eye and he looks like a bastard. It looks like violence might happen at any moment. Roger looks like a nice guy. But Roger oddly enough, because I'd read the books, was much closer to Fleming's idea of Bond. Bond was terribly English, not British, English, and I always thought of Fleming's Bond as a slightly more muscular young David Niven and I would have thought that Fleming would have been happier with Roger in the beginning.[39]

The problem facing Moore at the beginning was that he had to deliver what audiences expected of the Bond character, but also avoid direct comparisons to Connery's image. Guy Hamilton, given the task of blooding the new Bond, was conscious of the mistakes made with Lazenby. 'They asked him to step into Sean Connery's shoes – in other words he was playing imitation Sean. Not imitation Bond.'[40]

Preparing the film, Hamilton was extremely conscious, for example, of the way Moore should be introduced. The decision was made that for the first time in the series Bond would not feature in the customary pre-title sequence. 'I think it might have been death if we had brought him on in the first couple of minutes walking down a staircase wearing a white dinner jacket.'[41] Interestingly, when Moore does make his

appearance the filmmakers chose against the classic scene in M's office, given its connotations with the past. Instead, M goes to Bond's apartment to give him his mission. There were other subtle changes too: Moore smoked cigars rather than cigarettes, refrained from ordering a vodka martini — shaken not stirred — and in his first 007 outing avoided wearing a tuxedo. In this way Moore developed his own personality and was quickly accepted by audiences.

The shadow of his predecessor, however, haunted Moore throughout pre-production on his debut Bond. He confessed to Guy Hamilton, probably mockingly, that reading the script he could hear only Connery's voice saying, 'My name is Bond, James Bond.' Hamilton took him aside and told him flat, that Sean was Sean, and that he should just be himself.

In truth, Moore was too established and experienced an actor to be truly bothered or nervous about taking over from Connery. As he said at the time, hundreds if not thousands of different actors had played Hamlet down the years. He'd not even been the first actor to play The Saint. His introduction to Bond, however, was almost a fatal one. The famous boat chase through the Louisiana bayous was to be the first sequence in the can. Out rehearsing with the boats one day, Moore was tearing along at 60mph when the vehicle suddenly went out of control and hit a large corrugated shed jutting out from the bank. Luckily Moore's injuries weren't serious — a cracked tooth, numb shoulder and a busted knee that meant he couldn't do any of the running and jumping usually associated with the role for a few days; hardly an auspicious introduction into Bondage. Despite this and the punishing schedule, Moore was having a ball. 'I often stop in the middle of a day's work and say, Jesus Christ they're really going to pay you for being a kid and living out your fantasies!'[42]

When *Live and Let Die* opened the press were relatively kind to Moore. This from the *Sunday Times*' Dilys Powell: 'I confess that now and then I missed the handsome shark-mouth of Sean Connery, but Mr Moore is all right. The throwaway lines are neatly thrown away.' Felix Barker of the *Evening News* was right on the money when he said:

> What you will want to know is how Mr Moore's saintly feet fit into Sean Connery's discarded shoes. Comfortably, I'd say, rather than impressively. For all his easy boyish charm he lacks the hard, sardonic

quality of his predecessor. But I still think we will grow to like the new incumbent well enough.

Of course, there were detractors, as there would be for much of Moore's reign, like this from the *Monthly Film Bulletin*: 'Moore makes a very British 007, somewhere between Patrick Macnee and Fleming's original concept, but the style only works occasionally. Otherwise, he develops his role charmlessly, from a clownish fall-guy in the first half to a caddish automaton in the second.' And this from Alexander Walker: 'The school bully was replaced by the school prefect.'

Whatever the critics said, *Live and Let Die* was a sizeable hit and the producers raced the next Bond into production while the image of the new 007 was still fresh in the mind of the public. But there was one man who wanted to rain on Eon's parade. He wanted to take over from Roger Moore and become James Bond. Today famous as a bestselling novelist, former MP and one-time prisoner, his name is Archer, Jeffrey Archer. In 1975 Archer had just resigned as an MP over financial problems and turned instead to writing. It was his friend, Sir Michael Havers, then Attorney General, who arranged a meeting for Archer with top London agent Michael Whitehall. 'Jeffrey burst into my office like a tornado,' recalled Whitehall in his memoirs, 'and, after much handshaking, pressed a bulky envelope into my arms.' It was a proof copy of his debut novel *Not a Penny More, Not a Penny Less*. But that wasn't the reason for Archer's visit.

'I want to play James Bond,' he said, 'and you can get it for me.' Whitehall enquired how much acting experience Archer had. 'None,' came the reply, 'but I know I can do it.' Whitehall suggested that maybe Archer had left an acting career a bit late in the day. 'I don't want an acting career,' pronounced Archer. 'I just want to play James Bond.'

Fortunately, Archer's novel became an instant bestseller and he put his acting aspirations on hold and the nation was saved the too dreadful to contemplate spectacle of Jeffrey Archer as 007.

I contacted Mr Archer to see if there was any truth in this, admittedly, far-fetched tale and received this answer from his personal assistant:

In answer to your question, there is no truth in this story and Jeffrey has never wanted to play Bond – it would be farcical. However, he was

asked to write one of the follow-up books by his agent, but turned it down. Jeffrey was in the middle of writing the *Clifton Chronicles* series of books and didn't want to break off from that.

It is an interesting revelation that Jeffery Archer was approached to be one of the Bond literary continuation authors.

Even more bizarre was Michael Jackson's bid to become James Bond. This was just after the release of the film *The Wiz* (1978) where Jackson co-starred with Diana Ross in a musical reworking of *The Wizard of Oz*. Jackson was a client of Michael Ovitz, one of the top agents at CAA. In Ovitz's memoirs, he recalled a meeting that was held at Jackson's home where the singer announced his intention to star in an action movie. Unfortunately, as Jackson began talking his hat fell into a bowl of guacamole on the table in front of him. Undeterred, Jackson placed the hat back on his head, only a large blob of guacamole remained on the brim. With Ovitz was fellow agent Ron Meyer, who nudged his colleague and the two men watched as the guacamole blob slid down the brim until it eventually fell off. Meyer burst out laughing. Unable to control himself, Ovitz followed suit. Jackson got up and stormed out of the room.

Ovitz followed his client and spent the next fifteen minutes trying to calm him down and explain that he had not been the focus of their laughter, rather the errant blob of guacamole:

> Finally, Michael's face cleared. 'Okay, Ovitz. Okay,' he said. 'But I want to play James Bond.' I am proud to report that I didn't laugh, this time. I nodded emphatically, as if I were really thinking through the possibilities, and then I said. 'You're thinly built. You're too sensitive. You won't be credible as a brutal block of stone. You'd be great at it, of course, but it'd be bad for *you*.'

Meanwhile Roger Moore had captured world audiences and made the part of James Bond his own. In the late 1970s, with *The Spy Who Loved Me* and *Moonraker* (1979), the series reached a commercial high point that it hadn't enjoyed since the mid-1960s, and successfully navigated the collapse of the Broccoli/Saltzman partnership, when Saltzman left the world of Bond, leaving Broccoli sole producer of the franchise. When

it came time to film *For Your Eyes Only*, the first 007 movie of the 1980s, the Bond team faced a problem. Moore's original contract was for just three films and, so far, he had resisted Broccoli's attempts to tie him down to a new multi-picture deal, with the actor preferring instead to negotiate each individual film in turn.

Moore had begun to moan about how lengthy and gruelling the schedules of the Bond films were becoming, as Connery did before him, and drop hints that he didn't much fancy taking another six months out of his life to play 007 again. Or was this a bluff to get more money. Broccoli stood by his man. 'As long as Roger would like to do them, we would like him to do them.'[43] However, there was a caveat: 'It won't deter us if we have to find another actor.'[44] And so began the game of poker that Broccoli and Moore played against each other whenever production of the next Bond reared its head, and which ultimately led Broccoli to consider Moore just as much of a pain in the arse as Connery was.

Despite the astronomical success of *Moonraker* at the world box office, Broccoli took to heart the stinging criticism that the franchise had gone too far into the realms of the fantastic and unbelievable and decided a course correction was in order. His first action was to bring in a new and hungry director, John Glen, who began on the Bonds as an editor on *On Her Majesty's Secret Service* and then as second unit director on the previous two entries. Broccoli contemplated an even bigger change. With Moore in his fifties and still having failed to commit to playing Bond in the next film, perhaps now was a good time to herald a new approach that brought Bond not only back to earth, but back to basics, and maybe that required a new actor.

High on that list was Michael Jayston, who had starred as a 007-type spy in the BBC's thirteen-part series *Quiller* in 1975. 'I think it was me, Patrick Mower, and a couple of other chaps,' Michael recalls:

> I met the director John Glen at Eon's office in South Audley Street and talked to Cubby Broccoli. Cubby was quite a jolly man, I liked him a lot. The whole interview lasted for about half an hour. It was just a general chat, we didn't really talk about Bond all that much. We mentioned one or two of the stunts in the film, but we didn't go to any depth at all. But how far it would have gone down the line I don't

know. I think it was just a tentative step and then Roger decided to do some more – and more – and more.⁴⁵

By 1980 Jayston was already an established actor with numerous roles in television and movies. Born in 1935 in Nottingham, Jayston performed with the Royal Shakespeare Company and later the National Theatre, under the auspices of Laurence Olivier. When he won the lead role in the historical epic *Nicholas and Alexandra* (1971), a career in Hollywood beckoned, but Jayston instead returned to the theatre and television drama, notably the lead role of Mr Rochester in the BBC's 1973 adaptation of *Jane Eyre*. Despite this welter of experience Jayston gave himself little chance of landing Bond:

> I never particularly thought that I'd get a toe hold into that thing; there were so many people up for it. I thought it would have been a great idea playing Bond, but it was too vast an idea to think about at the time. It would have been a life changing thing. It still is, now.⁴⁶

How much of a different kind of Bond would Jayston have made?

> I guess I would have tried to play Bond with some sort of intelligence, really. The one-liners would have been a bit difficult, but you've got to play them and believe in them. If the jokes are there, you've got to play them and play them for all they are worth.⁴⁷

Interestingly Jayston did eventually get to play James Bond, in a BBC radio adaptation of *You Only Live Twice* in the mid-1990s. 'They were going to do a lot of the Fleming novels, but it wasn't viable because Bond doesn't work on radio, it's about action really.'⁴⁸ And how did Jayston go about inhabiting the role of Bond on radio? 'I just played it sort of butch.'⁴⁹

Nicholas Clay was also considered, a British actor then rising in prominence with appearances in two high-profile movies set for release in 1981, as Lancelot in John Boorman's *Excalibur* and as the gamekeeper Mellors opposite *Emmanuelle* actress Sylvia Kristel in *Lady Chatterley's Lover*. Born in 1946 in London and trained at RADA, Clay began his career with small parts in film and television, usually in period dramas, and was a member of Laurence Olivier's National Theatre company.

It was third time lucky – or unlucky – for Patrick Mower. Ushered once again into Eon's boardroom, he sat opposite Broccoli, plus fellow producers Michael G. Wilson and Barbara Broccoli. Mower thought the vibes were good and afterwards decided to have a celebratory glass of champagne with his girlfriend at the White Elephant restaurant, a hangout for all the top actors. By coincidence, as he crossed the street Sean Connery himself came out of the club. Mower had never met Connery before and passed brief pleasantries with him before watching the star walk away down Curzon Street. 'Out with the old, in with the new,' said Mower's girlfriend. Alas, it wasn't to be.

It wasn't to be either for another perennial Bond contender, Michael Billington, who recalls being fitted out with a suitably Bondian wardrobe and flown out to Corfu, where the crew were in pre-production on *For Your Eyes Only*, to undergo a photo shoot. Nothing came of it.

The name of David Robb also began appearing in the media linked to the Bond role. Born in London in 1947, but raised in Edinburgh, Robb had enjoyed roles in BBC television adaptations of *Romeo and Juliet* and *Wuthering Heights*, along with the classic *I, Claudius*, but being linked to 007 came as a complete surprise. 'I never met for it, tested for it, interviewed for it. I never met Cubby Broccoli, and yet suddenly from nowhere this extraordinary explosion of publicity kicked in that I was the next Bond.'[50] Robb had just joined the William Morris Agency, amongst the biggest in the world, and his agent rang up asking, 'Darling, is there something you haven't told us?' Robb replied, 'No, I honestly don't know what this is.'[51] It was indeed a mystery. One curious side effect of all this was that Robb was inundated with phone calls. 'And not only from friends you haven't met for 20 years, but tailors saying, would you like a couple of Savile Row suits for nothing.'[52]

In the end Robb sussed out what may have happened:

I think Roger Moore's people were arguing about money and holding out. Now, I don't look that much like Roger Moore, but loosely speaking we're the same colouring and I've got an aquiline face, and I think the powers that be simply flicked through *Spotlight* and thought 'HIM,' and they dropped the story to wake Roger Moore's agent up.[53]

Years later Robb made a film in India called *The Deceivers* (1988) with Pierce Brosnan, just after Brosnan's missed opportunity to play Bond due to a contractual obligation to the TV show *Remington Steele*. 'And he was pretty miffed,' says Robb:

> And we were lolling around the hotel pool one day and I said, 'You know what, it's probably the best thing that ever happened to you. Bond's a dead duck. It's like The Who still being together, it's an exhausted franchise.' But, of course, he did eventually get it so I sent him a card saying: 'Congratulations Pierce, well deserved. If you need any future career advice, please don't hesitate to contact me.'[54]

Coming perhaps closer than anyone was David Warbeck, a candidate back in 1973, and whose career in the intervening years had rather stagnated. Then in his late thirties, Warbeck underwent three days of tests on a closed set at Pinewood under the stewardship of John Glen. But actor and director didn't quite hit it off. According to Warbeck, Glen failed to get his sense of humour:

> For example, there was a sequence where somebody sticks a gun in my back while I'm on the telephone and I thought it would be a great visual gag if when he says 'put your hands up' you've still got the telephone in your hand with the cord attached. And so, you whack him with the telephone and then you try to strangle him with it, tie him up with the cord while the person on the other end is still talking! It would have been a good visual as well as plot gag, but John Glen wouldn't see that and that's when I thought 'uh oh!' he's not taking my opinions or suggestions.[55]

To be fair to Glen, maybe the director was under orders to steer away from the kind of comedy that had been a hallmark of Moore's reign. Certainly, Warbeck seemed keen to imbue his Bond with a tongue-in-cheek sort of humour. Anyway, Warbeck told Broccoli he couldn't work with Glen and another director was brought in, John Hough. This is a bit of a stretch to believe – that Broccoli would ever allow any actor to tell him who was going to direct the movie. Or maybe the producer just wanted to placate what could be his new Bond star. Hough had directed

Warbeck twice before, in *Twins of Evil* and most significantly in *Wolfshead: The Legend of Robin Hood* (1973), where Warbeck played the lead. Broccoli had seen that film (a pilot for a proposed TV series that never got made) and liked it. Since then, Hough had directed *The Legend of Hell House* (1973) and Disney's *Escape to Witch Mountain* (1975). According to Hough, he was told the Bond people planned to make two 007 movies back-to-back, using two directors who would both alternate and do a Bond each.

Warbeck's test seemed to go well and he had his own ideas, too, about playing the role:

> I always think that Bond should be an older guy myself. I think he should be in his late forties, early fifties and have that look ... jaded and tough and cynical. And you've got to believe that he can fucking kill at the same time. Roger could never do that, but Connery certainly could, and that was the territory I was heading for; a much rougher, tougher, gritty look.[56]

For a second time Warbeck felt confident he'd got the role, only to lose out, he says, because a cash-strapped United Artists, haemorrhaging funds to Michael Cimino's runaway *Heaven's Gate* production, pulled the idea of making two Bonds at the same time. In any case, Moore coming back scuppered Warbeck's chances anyway.

John Hough's dream of making a Bond film took a serious nosedive when Moore returned too. Both men were involved in a serious dispute on *The Saint* TV series and Hough knew they couldn't work together. And so it proved. 'My father was going to direct *For Your Eyes Only*,' says John's son, Paul Hough. 'But I know Roger Moore lost him the job.'[57]

Years later when Warbeck bumped into John Hough again, they reminisced about their close encounter with 007. 'Dave, whatever happened there?' asked Hough. 'What was going on because they had great amounts of dosh lined up and you were Bond.'[58] In the meantime Warbeck unexpectedly became a cult star of Italian exploitation cinema, most notably in Lucio Fulci's *The Beyond* (1981). His subsequent career, however, involved appearances in low budget straight to video offerings. Warbeck died of cancer in 1997 aged just 55.

Moore later admitted that it was always his intention to return as Bond, and that Broccoli testing new actors was all part of a negotiation

ploy to make him accept the deal on the table for fear of being replaced. In all his time as Bond, Moore and Cubby never once discussed financial matters, that was always left to the agents. It was a game of poker, with Moore unwilling to undervalue himself and to get the best possible deal for what he thought he was worth. In the end a deal was struck.

Probably the most relieved man was John Glen, worried about embarking on his debut Bond with a new actor in the role. When he first signed on as director, he 'had been told categorically that Roger Moore was out of the picture'.[59] In charge of the tests Glen found none of the actors suitable and so was delighted that Moore was back. Just in case, though, Glen had devised an opening scene in which Bond lays flowers at the grave of his dead wife, Tracy. It was a clever device to help any new actor in the role immediately establish a link with Bond's past. When Moore returned, instead of ditching this graveyard vigil, the makers kept it in as the prelude to yet another wildly over the top pre-credit sequence. The rest of *For Your Eyes Only* is much more reality-based, with Moore giving his best performance as Bond.

When the next Bond film, *Octopussy*, came around it was a case of déjà vu with Roger Moore. It couldn't have come at a worse time. Following the monumental flop of United Artists' *Heaven's Gate* in 1980 the company was perilously close to financial collapse, and that had serious implications for Eon. Fortunately, the studio was saved when it was purchased by MGM. The new chairman Kirk Kerkorian, an airline mogul and Las Vegas hotelier, knew the Bond series was United Artists' most reliable asset and that it was imperative Moore return as James Bond in the first 007 under the new MGM/United Artists banner. Stability was the order of the day.

Broccoli prepared to enter a new round of negotiations with his leading man. However, this time he found the actor more resistant than ever. Was Moore after an even bigger salary this time round, perhaps realising that in the face of competition from Sean Connery's return in the rogue Bond film *Never Say Never Again*, which was being shot at the same time as *Octopussy*, Broccoli might be reluctant to blood a new actor? Or did Moore feel that he was just too old now to play the spy? In a perfect demonstration of how tense things were between the two parties, at that year's Cannes Film Festival a giant billboard publicising the new Eon 007 film featured a generic Bond figure – with a blank face and a question mark.

With negotiations at an impasse, Broccoli set his sights on several younger successors, notably Oliver Tobias who came to international prominence in 1978 as the male lead opposite Joan Collins in the controversial sex film drama *The Stud*. Born in Zurich in 1947 to a Swiss father and German mother (both actors), Tobias moved to England aged 10 to attend boarding school. Encouraged by his mother to study acting, Tobias' breakthrough came in 1968 when he was in the original London production of the musical *Hair*. He began to appear in international films and made a big impact as King Arthur in the ITV series *Arthur of the Britons* (1972–73). Other prominent film roles included *Arabian Adventure* (1979). 'The Bond approach was made through my agent,' says Tobias:

> And also, through the Stunt Association, a lot of whose members had worked with me on all sorts of swashbuckling shows and knew I was handy with all that physical stuff. I was then sent over for some training sessions to prepare for this fight routine that was going to be part of my Bond screen test.[60]

While all that was going on Tobias met with Broccoli and was surprised when the producer took more of a keen interest in him than he seemed to do with most other prospective Bond candidates, even taking him shopping one day around the best London stores choosing what he was going to wear as Bond. 'He'd say "These are the types of shoes I would suggest", and we got all the gear together. Cubby was almost like a father figure to me. He even took me to his hairdresser and got my hair cut there. I got on very well with him.'[61]

The day of the test arrived and Tobias called in for duty at Pinewood Studios, meeting up with not only John Glen, who was overseeing the audition, but also Barbara Broccoli and Michael G. Wilson:

> It was all quite nerve-wracking because of the expectancy. You're jumping into a kind of vacuum, you're not all starting together, this is an ongoing product where you have to fit in. I was a well-versed actor in film technique, but you had to fit into the style of what they imagined. I think I had old Cubby on my side, but there were other considerations.[62]

The test, so far as Tobias recalls, was a scene from a previous Bond movie, where 007 confronts a sultry woman and is persuaded to relinquish his gun and fall into bed with her:

> It was that type of thing. We shot it and it all went well. The fight sequence was somewhat different because they said to me, James Bond fights like this, and I said, well I fight like this. So, I never took any bloody notice and just did my thing. And then I waited, but it didn't work out.[63]

Shoot ahead to the year 2000 and Tobias worked with Broccoli's widow Dana on the historical musical *La Cava*, which she adapted for the stage from her own novel:

> Dana called me 'My King'. I played this Spanish king who gets done in at the end. We did that musical for a year in the West End and I obviously got to know Barbara much better. And we talked about the Bond test and she told me that I was just too young for the role. And I guess I was. I don't actually regret it, it's not like; oh God, I didn't get it. The whole process was quite overpowering because you become Bond, don't you. I'd lived a fairly free and easy life but with Bond, you become it, that's your life, I suppose, and that's quite daunting. I remember feeling quite worried about that. It's life changing stuff.[64]

Cubby Broccoli must have seen in Tobias a real alternative to the smooth and refined Roger Moore. Here was a young actor that embraced the new decade, and his dark, smouldering good looks harked back to the earthy Connery. But how would Tobias have played Bond if the offer had arisen?

> I never really thought about it. I think like everybody you bring your own personality to it. I can't comment on every Bond actor, certainly the first one was very well cast, so it is a question of casting, and the producer's discretion, and I think the old man had a good eye for that, old Cubby, and they chose me because I was a certain type. I don't think after that there's a lot you can do to change yourself. I'd have just played him as myself. I mean, I'm not going to play

Richard III, it's playing Bond. It's putting on a suit, it's ladies; that should come naturally.[65]

For the remainder of the 1980s and '90s and beyond, Tobias continued to enjoy a varied career, mainly in theatre. He was also involved with Lasham Airfield in Hampshire where parts of the elaborate airport chase sequence were shot for *Casino Royale* (2006):

We shot a big stunt here at the airfield, so I got to work with the Bond team in the end. Looking back now on my Bond test it was an interesting experience to say the least, and it was a great privilege to meet Cubby. He was a very charming gentleman.[66]

Another strong contender was Lewis Collins, who'd won huge popularity as Bodie in the hit action television series *The Professionals*. It was because of this hard-hitting cop show that Collins was for many commentators and fans the perfect choice to be the next James Bond. Born in 1946 in Birkenhead, Collins was a keen sportsman in his youth before turning to music, playing in numerous local bands. After that he drifted into a succession of odd jobs before deciding to become an actor and attended drama school in London. Following work in repertory theatre and small roles on television, Collins gained his first major exposure to audiences with ITV's hit 1970s sitcom *The Cuckoo Waltz*, where he played the playboy lodger of a couple of newly-weds. But it was when Anthony Andrews dropped out of *The Professionals* in 1977 and Collins was cast opposite Martin Shaw that he achieved massive fame.

Regarded by many as leading man material, when *The Professionals* series wound down Collins starred in *Who Dares Wins* (1982), a film drama inspired by the 1980 Iranian Embassy siege in London foiled by the SAS. A big hit in Britain, the film's producer Euan Lloyd claimed that when Barbara Broccoli saw it, she suggested her father ought to set up a meeting with Collins. One was duly arranged, only it did not go well. 'I was in Broccoli's office for five minutes, but it was really over for me in seconds,' said Collins. 'I have heard since that he doesn't like me. That's unfair. He's expecting another Connery to walk through the door and there are few of them around. I think he's really shut the door on me. He found me too aggressive.'[67]

Collins admitted that during the meeting he adopted a know-it-all kind of attitude, but only as a defence mechanism to hide an actor's obvious nervous tension:

> I felt they were playing the producer bit with fat cigars. When someone walks into their office for the most popular film job in the world, a little actor is bound to put on a few airs. If Cubby couldn't see I was being self-protective I don't have faith in his judgement.[68]

So far as Euan Lloyd was led to believe, Collins made the 'fatal mistake' of turning up for the interview dressed closer to his Bodie character than the more sartorially elegant Peter Skellen, the character he played in *Who Dares Wins*. 'Possibly it was over confidence on Lewis' part. I am sure he would have made an excellent Bond.'[69]

According to Michael Billington, who heard this from a source within Eon, Collins was rejected for an entirely different reason, that he asked for too much money to play Bond and so was politely shown the door. Whatever the reason, Collins would have made a tough and down-to-earth James Bond, a radical departure from the whimsy of Moore. 'It would be nice to get back to the original Bond,' said Collins. 'Not the character created by Sean Connery – but the one from the books. He's not over-handsome, over-tall. He's about my age and has got my attitudes.'[70]

Collin's post-*Professionals* career was something of a disappointment: a few TV roles, notably opposite Michael Caine in a 1988 *Jack the Ripper* miniseries, and a couple of action movies made abroad. In the mid-1990s he moved to Los Angeles, working intermittently, but became disillusioned with show business and retired. He died in 2013 at the age of 67.

Curiously, Collins' co-star in *The Professionals*, Martin Shaw, was asked personally by Barbara Broccoli to test for Bond. And he said no:

> I just didn't want to play him because it dominates everything you've done or go on to do. I was having dinner with Barbara. She'd seen me in *The Professionals* and begged me to do a screen test. She was astonished when I said 'no thanks'. Although, in retrospect, it might have been a good idea to have had a go at it.[71]

In a bid to put even more pressure on Moore to sign on the dotted line, American actor James Brolin was flown to London to perform three days of extensive tests. This included a brutal fight scene; a sequence with Indian tennis player Vijay Amritraj, who was to play Bond's contact in *Octopussy*; along with a love scene with actress Maud Adams, already cast as the film's female lead.

Brolin, who was born in Los Angeles in 1940, was a well-known and decent film performer with a string of starring roles in top American movies like *Westworld* (1973), *Capricorn One* (1977) and *The Amityville Horror* (1979). His Bond test was seen and liked by United Artists and for a brief period it looked like Brolin might take over from Moore. After all, Broccoli had come very close before to hiring an American actor and Brolin and the producer talked about what to do about his all too obvious accent. The decision was made that he would not attempt a British voice, rather go for a mid-Atlantic accent. Brolin also found a flat in London that he was going to stay in for the duration of the shoot and began working out with some of the stunt team to get trained up for the action scenes. 'Then I went back home to collect all my stuff,' said Brolin. 'I'm home about a week and I got a message that Roger Moore decided to do *Octopussy*.'[72]

Brolin's career continued along a very satisfactory path; he's won two Golden Globes and an Emmy and received a star on the Hollywood Walk of Fame in 1998, the same year he married Barbra Streisand. But did he regret losing out on Bond? 'I'm a fatalist, in a way, I just went, ok, alright. But I look back and I think, it would have been a great thing.'[73]

Michael Billington was once again tested, and for the last time too, ending his long association with Bond. Perhaps more than anyone else Billington got the closest to winning the coveted 007 role, narrowly missing out repeatedly, as he believed, because the time was never quite right:

> The timing was the very essence of it. You had to be what they wanted at a time when they wanted you and that all depended on who the chief executive at United Artists was and if they didn't feel like taking on the responsibility of putting another Bond on, then they just kept on with whoever it was. Why Tim Dalton got thrown into it later was

that the chief execs at UA said, no more Roger Moore. But I'd already gone off the scene by that time. If that had happened two pictures earlier I would have been thrown into the role. But it was just that Roger managed to hang in there for a couple more movies and Cubby couldn't change the actor without getting the approval of the executives. I don't know how I would've fared in the role because I thought the movies were real turkeys by then. I think the turkeys started with *For Your Eyes Only*, so how I would have fared I don't know. It wasn't really until *GoldenEye* that things really got back on track, they'd got new writers in, a new director and they approached it in a much more adult way. Fortunately for Pierce, he was available at the right time.[74]

Whether or not Brolin or Collins or Tobias or Billington would have cut it as Bond, in the end Broccoli and United Artists decided against launching a new actor in the role up against a resurrected Connery. And so nobody was really surprised when at the eleventh hour a new deal was struck with Moore, who was convinced that this would be his final fling as Bond. The huge success of *Octopussy*, which beat Connery's *Never Say Never Again* at the global box office, may have been an influence on Eon's decision to persuade Moore to carry on, despite the actor's increasing recalcitrance, believing as he did that the public thought he was now too old for the part. 'I'm playing James Bond again because I feel sorry for Cubby,' Moore told the press with characteristic humour. 'He'll have a terrible job finding anybody else who will work as cheaply as I do.'[75]

When *A View to a Kill* (1985) was greeted with general disappointment it looked like the Moore era had run out of steam. Critics were beginning to comment on his unsuitable age. One noted, 'He's not only long in the tooth – he's got tusks!' A newspaper cartoon had Q presenting Moore's Bond with his latest gadget – a turbocharged wheelchair. 'Some critics were rather nasty, saying Roger was too old and the like,' says John Glen:

Well, it was his last Bond, and really the truth was we couldn't find anyone to measure up to him. We couldn't show United Artists an alternative. And so we were particularly glad to have him for the film. I think he'd have liked to have finished with *Octopussy*, but we needed him.[76]

The Saintly Bond

By this stage Moore knew that his tenure as Bond was well and truly up. Fast approaching his sixtieth birthday, he was not at an age to be dodging bullets and bedding nubile nymphets. Lois Maxwell revealed how Moore confessed to her at the close of filming on *A View to a Kill* that he was tired beyond belief of making movies. He meant it too. That December, Broccoli invited Moore to his Beverly Hills home and the men came to a mutual agreement over lunch that it was time for a younger actor to take over.

In January 1986 Moore publicly confirmed that he had played Bond for the final time. He'd said that before, of course, but this time it was for real. 'I've had a lot of fun playing Bond,' he told the press. 'But it was jolly hard work. Just think of all the dangers I won't have to face again. No more jumping out of helicopters, dodging snakes, bending down to kiss all those beautiful women. No, this really is the end. I'm moving on.'

And move on he did, into semi-retirement as far as his film career was concerned. In the 1990s something very different and far more significant took over Moore's life when he became a goodwill ambassador for UNICEF. The job gave him an interesting perspective on his work as Bond, especially filming in all those far-flung locations like Brazil and India, places he revisited again for UNICEF, as he explained to me in 2001:

> It is funny, I used to go to those countries and was so occupied with my own agenda. I was aware of the poverty around me, but now I feel terrible guilt that I was sort of uncaring and unfeeling, very selfish. Today, I see them through different eyes with UNICEF. So, I'm very grateful to Bond, because the Bond image helps me gain some celebrity to be of use to UNICEF.[77]

This sterling charity work led to a deserved knighthood in 2003. Roger Moore passed away in 2017 at the age of 89.

1 London fashion model Peter Anthony won a 1961 *Daily Express* poll sponsored by producers Cubby Broccoli and Harry Saltzman to find the perfect candidate to play Bond in *Dr. No*. (Chronicle/Alamy Stock Photo)

2 No other actor was considered to play Bond more times than Michael Billington, seen here on a night out with the Broccolis: Cubby, his daughter Barbara and wife Dana. (MediaPunch Inc./Alamy Stock Photo)

3 Cubby Broccoli took Hollywood actor Eric Braeden out to lunch to ask him about the possibility of playing Bond, only to find out Braeden was German! End of interview. (Eric Braeden)

4 This is one of several photographs taken of TV actor Michael McStay which were to have been printed by a newspaper if the rumours were correct that he was going to be the new Bond. (Michael McStay)

5 Acknowledged as the world's greatest living explorer, Sir Ranulph Fiennes tested for Bond after George Lazenby left the role, only to fall at the final hurdle. (Mirrorpix)

6 Determined to replace Sean Connery, singer/actor Jess Conrad did a photo shoot posing as 007 and visited Cubby Broccoli at his office, with disastrous results. (Jess Conrad)

7 Appearing together in an episode of *Department S*, Patrick Mower and John Ronane were both considered as possible replacements for Sean Connery. (ITV/Shutterstock)

8 Star of films such as Alfred Hitchcock's *Psycho*, John Gavin signed on the dotted line to play Bond in 1971's *Diamonds Are Forever*. (Cinematic/Alamy Stock Photo)

9 Australian actor Tony Bonner was appearing in an episode of *The Persuaders* when both he and Roger Moore were asked to screen test for Bond. (ITV/Shutterstock)

10 When contract negotiations broke down with Roger Moore in the early 1980s, Broccoli tested several young actors to replace him, including Oliver Tobias. (Richard Young/Shutterstock)

11 Star of US mega soap *Dynasty*, John James, was asked by Cubby Broccoli to consider playing Bond but refused the idea on the grounds he wasn't British. (Everett Collection Inc./Alamy Stock Photo)

12 Young hopeful Mark Greenstreet tested for Bond in the mid-1980s when the concept was to return Bond to his days in the Royal Navy and his first tentative steps as a spy. (Mirrorpix)

13 Neil Dickson had just played another iconic English literary hero in Biggles, when he was interviewed about the possibility of replacing Roger Moore. (Neil Dickson)

14 Up-and-coming actor Mark Frankel, then playing a Bond-like hero in US television drama *Fortune Hunter*, vied with Pierce Brosnan to star in *GoldenEye*. (Snap/Shutterstock)

15 Ex-boxing champion-turned-actor and pundit Glenn McCrory certainly had the physical attributes to play Bond and was interviewed by the producers. (Glenn McCrory)

16 Living a dream. Former locksmith Roger Barton Smith spent thousands on such things as photoshoots in a bid to catch the attention of the Bond producers. (Both Roger Barton Smith)

6

The Shakespearean Bond

Moore's departure from the series offered the opportunity for a timely rethink. A new actor in the role of Bond meant a change of direction, an overhaul. With that in mind screenwriters Richard Maibaum and Michael G. Wilson thought it the perfect opportunity to turn the clock back to focus on Bond's first ever assignment, to tell the story behind how this man became the legendary 007. In essence an origin story, one that was twenty years before Hollywood cottoned on to the idea of 'reboots' with *Batman Begins* in 2005. A treatment was written in which Bond becomes a young naval officer, a wild one that can't be disciplined. When Bond finally becomes an agent, he is reminded by his grandfather of the family motto – the world is not enough – and manages to redeem himself on a dangerous mission. Wilson and Maibaum liked the story, but Broccoli sensed that audiences didn't want to see Bond as an amateur spy, learning his trade. This had been one of the strengths of the series, that the origins of the Bond character were kept in the shadows. In *Dr. No*, Bond arrives on the scene, bang, fully formed. Broccoli told his writers to come up with something else.

However, two very early candidates to replace Moore were Mark Greenstreet and Michael Praed, both in their mid-twenties, which leads one to think that they were being considered while the idea of having Bond as a young naval officer was still being debated. Indeed, Praed recalled that when his agent called him up about the Bond job, he explained that the idea was to set the new film in the 1950s and start with Bond still at university.

Mark Greenstreet was new to television when he played the plum lead role in the BBC serial *Brat Farrar*, adapted from the crime novel by Josephine Tey, about a young man who inveigles his way into a loving family by pretending to be a long-lost child. Shown at the start of 1986, the serial made an immediate impact, with an average viewing audience of over 7 million, and Greenstreet was receiving 100 fan letters a day.

With his handsome looks and blonde hair, Greenstreet had a very Roger Moore look, and at the time was represented by an agent called Louis Hammond who looked after a lot of the contemporary young actors like Ray Winstone, Neil Morrissey and Liam Neeson. Mark was the new boy on his team:

> I was only two or three years out of drama school and still living in the house I rented with a fellow student in Leytonstone. I got a call from Louis who said, 'You've got an interview for a film.' I said, 'That's great news, what's the film?' He said, 'The new James Bond movie.' I said, 'That's amazing, what's the part?' He said, 'James Bond.' I went, 'Are you serious?' So, it was a bit of a shock.[1]

A meeting was arranged for Mark at Eon's office in Mayfair:

> And it was a bit like going into M's office, all this wood paneling, so you felt you were already in the movie. Debbie McWilliams was there, the casting director, Barbara Broccoli, Michael G. Wilson, and John Glen. They were unbelievably nice, and they asked me what I felt about the Bond movies. I had completely grown up with Sean Connery and the Roger Moore era, but I said my favorite Bond movie was *On Her Majesty's Secret Service* and they all looked at me as if I was crazy.[2]

Next, they wanted to know what this young actor could bring to the role of James Bond. Mark admitted that while he had enjoyed the Roger Moore films, he felt that the more recent outings in the series lacked what Sean Connery brought to the part, an animalistic quality, and that the spy element, the brutality of the real spy world, was largely missing in favour of a much more tongue-in-cheek approach. As the conversation moved forward, Mark came to understand that the producers faced

a dilemma, carrying on with the Bond series very much as before, or tilting it in a much younger direction.

> With the brat pack movies in Hollywood, with young actors like Emilio Estevez and Rob Lowe, there was a mood, I felt, within the Bond people at that original meeting, that they were considering finding a really young Bond to get that youth audience back into the cinema. Years later when Daniel Craig got Bond and they did *Casino Royale* they sort of tapped into that initial thought from the conversation with me of having him just getting his license to kill.[3]

Mark heard from his agent that the interview went well and they wanted to test him. He had a few days to prepare. One of the things he did was to rent out all the Bond films from his local video store to watch again, to see what he liked, what he didn't like and what he could bring to the character:

> I always loved the fact that Sean Connery had this amazing pantheresque walk or gait, almost like a dancer with precision of movement, an economy of movement. And I remember whenever he was trying to be surreptitious, he'd open a door and just gently lean back and push it shut, while his whole facial attention is looking around the room he's about to search. And I remember at my test I was doing one of those and I literally lent back but I still had my finger in the door.[4]

Mark also got some advice from his agent. 'Louis was a lovely guy and a drama coach as well, he did say, "Listen, the audience will want to see you, don't try and be somebody else, use all the bits of you that will work for being this man." I guess that's what I probably tried to do.'[5]

Mark was impressed when he arrived at Pinewood. They had built a complete set and he had a costume fitting for a dinner suit and a shoulder holster for a gun. They also tried out various hairstyles on him. The test was going to be comprised of the hotel room scene from *From Russia with Love*, and having seen the film many times it was a sequence Mark knew well. Bond comes into the room having carried out a mission, as John Glen explained, 'Now, Mark, remember you are James Bond, you've just been out and killed somebody so you're a bit weary, but you're

cool.' Bond gets undressed, orders breakfast on the phone, then senses someone is nearby, and discovers it to be Tatiana. The producers had brought in the actress Fiona Fullerton, a Bond girl in *A View to a Kill*, to play the part for the test. Mark says:

> When Bond meets Tatiana it's the thing of the flirtation, the sexuality, him fancying her like crazy, but at the same time not trusting her. Maybe she's going to have a gun under the bed. But he needs her to get to the next stage of his job which is to get the Lektor decoder. There's lots of layers going on, so from an acting point of view it's a fabulous scene to play.[6]

For Mark the whole day was an out of this world experience. 'But it was a genuine experience. So, it had that dichotomy of being so extraordinary and yet completely real. And it was great fun.'[7] It started with him being picked up at his flat and chauffeur-driven to Pinewood.

> The crew were very nice, particularly the camera operator who said, 'Man, you've got it. You really nailed that.' And John Glen was utterly charming and very helpful. He gave direction and I did my best to follow it. The day was just so beautifully done and organized. It was as if you were actually making a genuine scene in the movie. But the thing I did feel was that I was stepping into a family. The crew all knew each other. And everything was geared to enable you to be brilliant.[8]

At one point, while the lights were being set up for another shot, Mark needed to go to the bathroom. Still dressed in his dinner suit, he left the stage and found a toilet.

> And I was standing there on my own at the urinal and the door banged open and there was this clank clank sound and this man went to the loo about three urinals down. We looked across at each other and he said, 'What are you here for?' And I said, 'James Bond. What are you?' And he said, 'Aliens.' And it was Michael Biehn in all that marine getup. I think they were doing pickup shots. And I said, 'You look the part.' He said, 'So do you, man, good luck.'[9]

Ultimately it never happened for Mark. The idea of doing a young Bond was ultimately ditched. He carried on acting and then went into production and directing with his own independent production company. In the mid-2000s he was set to direct a picture and was trying to cast Daniel Craig in the main part of an ex-naval intelligence officer now a private detective:

> And we were dealing with his agent and he was very positive, he'd read the script. His concern was he felt the character was a little bit similar in style to the character he played in *Layer Cake*. We were close. We hadn't had a rejection. We were sorting out the budget in the hope that Craig would say yes, and we didn't hear, they went a bit quiet on us. Then I saw the news and Daniel Craig was heading up the Thames on a Royal Navy boat as the new Bond, and I thought, fuck that, I've lost him.[10]

Michael Praed came to prominence as Robin Hood in the enormously successful ITV television series *Robin of Sherwood* which first aired in 1984. Praed appeared in the first two seasons and then left the show (replaced by Jason Connery), and went off to America to play a regular guest slot in the mega soap *Dynasty*. He was living in Los Angeles when his agent called one day asking if he owned a blue suit. Praed didn't. In that case, urged his agent, he was to go out and buy the most expensive blue suit he could find. The reason was that Cubby Broccoli wanted to see him at his office at United Artists. Praed couldn't think why Cubby Broccoli wanted to see him. And his agent was none the wiser, either.

A few days later Praed made his way to the United Artists building. He got in an elevator to the designated floor where a secretary cheerfully greeted him: 'We've been expecting you. Mr Broccoli will be out presently.' A few minutes later a door opened and out walked Broccoli. 'He invited me in,' recalled Praed:

> He was unbelievably charming. And we talked about innocuous stuff, like, how was your journey here? How do you find the weather in Los Angeles? Do you have a swimming pool? I answered them politely. Then he said, 'Now look, in a minute there are going to be some

people coming through that door,' and he pointed to the end of his office, which was miles away because it was an enormous office. He said, 'They're going to come in and they're just going to stand behind me and look at you. They may ask you some questions and they may not, but just kind of ignore them.'[11]

A group of people did indeed come in, and one of them may even have asked Praed a question. And then they left. The conversation with Broccoli continued for a few more minutes and then he rose from behind his large desk and offered his hand: 'Michael, it's been an absolute pleasure to meet you. Thank you so much for coming.' Likewise, Praed said it had been great and made his goodbyes. 'I got in my car, bewildered as hell, got back to my house, called my agent and said, "I've just had the most bizarre meeting in my entire life." I explained to him what happened, and my agent said, "Well, we'll see."'[12]

Some time passed, then Praed's agent called with the news that Roger Moore had announced he was no longer going to be playing James Bond and that Praed was one of only two actors in the mix to replace him; the other one presumably being Mark Greenstreet. Praed's agent explained that he wasn't in direct competition with this other actor; one was the fair, smooth type, or the Roger Moore type, while the other was much darker and rougher, so the Sean Connery type. It all depended which way the makers wanted to go. The plan was for Praed to do a screen test, again directed by John Glen. It was the usual scenario, a love scene followed by a fight sequence choreographed by a stuntman. Praed felt particularly confident with the fight scene, having played such a physical role as Robin Hood. The test took something like three or even four days to complete:

And the director said to me one day, 'Michael, have you got a really big passport?' I said, 'What do you mean? I've got a passport.' He said, 'There are big ones you can get that have got like 60 pages in them, because you're going to need one of those.' I thought, ok. That's quite encouraging. A few days passed and my phone went and my agent said the immortal words, 'Michael, it's not official, but you've got it. You've got the part.' And I remember thinking, I've cracked it. It's like I won the lottery.[13]

Suffice to say that neither Praed nor Greenstreet landed the role. In the case of Praed's agent, perhaps he got caught up in the excitement of his client potentially landing the biggest gig in movies and slightly jumped the gun. Praed has spoken about being taken out shopping by Barbara Broccoli to buy some suits and clothes so he was obviously being seriously considered. Maybe it was a case of when Broccoli rejected the young Bond idea the search began to find slightly more mature actors.

During his twelve-year tenure as Bond, Roger Moore became totally synonymous with the character, and one of the most recognisable faces in the world. He was going to be as tough a job to replace as Connery had been. The makers were looking for an actor who could put his own personal stamp on the role while still embodying the classic 007 characteristics. Interestingly, Broccoli's search for Bond number four took him to Australia. Inevitably names like Mel Gibson and Bryan Brown were tossed around, but they were too established. Although Jerry Weintraub, chairman of MGM/United Artists, did suggest hiring Gibson for a two-picture deal worth $10 million. Gibson has confirmed since that he was offered the job around this time but decided against it, fearing being typecast. A big fan of Connery, Gibson saw how he struggled for years with his career trying to escape his total identification with the role.

Instead, Broccoli turned his attention to a trio of up-and-coming young Aussie actors. Andrew Clarke, born in 1954 in Adelaide, was best known for regular roles in soaps *Prisoner Cell Block H* and *Sons and Daughters*. But it was a lead role in the 1985 television miniseries *Anzacs*, which followed the lives of a small group of Australian soldiers during the First World War, that got him noticed by the Bond team and he was flown over to London for a screen test. According to Clarke the test went so well that he was presented with a contract to sign. Certainly, Bond was a role that Clarke wanted to play, having been a fan of the films growing up, but when he read the contract he was shocked. The money on offer wasn't very good, but worse, he would be tied down to doing five Bond films over a period of ten years. He tried to negotiate, asking them to double the money and halve the years. He was shown the door. While thrilled to be asked to be Bond, he couldn't accept it on those terms. He felt that Eon wanted to own him body and soul. 'There was no option. It was cut and dried. The contract on offer was just so abysmal I couldn't accept it.'[14]

Ironically Clarke ended up playing another discarded Roger Moore role, that of Simon Templar in *The Saint in Manhattan*. This was a pilot episode that aired on CBS in 1987. Alas the critics panned it and CBS axed the series. Still, Clarke was amongst the most popular Australian TV actors of the 1980s and '90s with a string of high-profile roles, including starring in the popular drama *The Man from Snowy River*.

Also considered was Antony Hamilton, who was actually born in Liverpool in 1952 and adopted by an Australian family soon after birth, growing up on a sheep farm in Adelaide. A classically trained dancer, Hamilton performed with the Australian Ballet Company, and much like Lazenby was discovered by a fashion photographer.

For the next ten years Hamilton worked extensively as a top model around the world, frequently appearing in magazines such as *Vogue* and *GQ*. Inevitably Hollywood beckoned and Hamilton won a co-starring role in the 1984 action/adventure TV series *Cover Up*. It was the success of this show, no doubt, that prompted Broccoli to test him. According to some reports, Broccoli decided against using Hamilton in the belief that audiences would not accept him as Bond because of his blonde hair. In other reports the two men jointly agreed that the actor's open homosexuality would work against him in the role. Whatever the reason, Hamilton continued in television and films, becoming probably best known for playing agent Max Harte in the 1988 TV revival of *Mission: Impossible*. Hamilton tragically died in 1995 from AIDS-related pneumonia.

The third young Australian actor was Finlay Light who was then a top model in Australia. According to Light, Barbara Broccoli arrived in Australia and a meeting was set up. It wasn't a screen test as such, rather a videotaped interview with Barbara asking questions. She flew back to Los Angeles with the tape, which obviously caused some interest because John Glen was the next one to catch a flight out to Australia and spent a couple of hours with Light chatting. The decision was made to bring the young Australian to Los Angeles to undergo a full test. It couldn't have gone any better and Light remembers being presented with a contract to sign that he says was the size of a Tolstoy novel. Andrew Clarke recalled something similar, that the contract he was asked to sign was at least fifty-five pages long.

The Shakespearean Bond

Light had done a little bit of stage work and TV but was asked to undergo a course of voice coaching, along with stunt training. Meanwhile, reports started to appear in the press that he had been cast and Light began to get a taste of what life as James Bond was going to be like. 'Suddenly there were TV crews knocking at my door and I felt, oh my God, if this is what it's going to be like.'[15] A private person, Light found it all stultifying.

The Broccolis had loved Light's test and everything was looking good when word came back from United Artists. They found nothing wrong with him as a person or his acting ability. They just didn't want to go with an unknown. As Light recalled:

> Barbara Broccoli said, 'The thing that you've got is exactly the same enigmatic charisma as Sean Connery. We've never seen that with anyone else we've tried to cast in the role.' She was being candid, and of course it was very flattering but, at the end of the day, it went down to a business decision.[16]

Light was left somewhat traumatised by events: 'Not that I was being avaricious in wanting it.'[17] He was excited about the prospect of making the film and working with John Glen who he liked and got on with. 'But it is what it is, and there's no point crying about it. Basically, I'm quite a shy person, and I don't think I could have dealt with the notoriety and the fame.'[18] Light continued to work in the business, doing television commercials whilst based in Sydney, but in the end decided to walk away from the entertainment world.

Broccoli had hoped to announce the new 007 at Cannes that May. The launch never happened. It was clear that choosing a new Bond was proving even more troublesome than usual. So, once again, Broccoli looked to America and Tom Selleck, the star of one of TV's most popular current shows, *Magnum*. Another hot television actor seriously considered was John James, a face known all over the world thanks to his role as Jeff Colby in the soap opera blockbuster *Dynasty*. Born in 1956 in Minneapolis, James was genuinely bewildered when his agent rang one day out of the blue with the news that Broccoli wanted a meeting with him at MGM to talk about the role of James Bond. 'I said, what!' James recalls with humour:

And my agent said, 'No, they're serious.' I was kind of shocked because I just assumed that the role of Bond would always be an Englishman. So off I went and drove through the gates at MGM and proceeded up to Cubby Broccoli's office where he was seated behind his desk with a couple of other producers.[19]

It was a very informal meeting which began with Broccoli congratulating James on the success of *Dynasty*, then among the top-rated shows in America:

He also talked about the international appeal of the series, I think at the time it was being shown in about 90 countries. Maybe that was one of the reasons why I was considered. I also think the style of *Dynasty* played a part, characters usually wore tuxedos, and certainly my character had a definite demeanour about him that probably made them think of me.[20]

Once the niceties were over Broccoli got down to business and wanted to know James' feelings about 007:

I told him I saw my first Bond movie while holidaying with my parents aboard the cruise liner the *Queen Elizabeth* in the Bahamas, it was *Goldfinger*. I said I was obviously a big fan of Bond, but then I cut to the chase and said, 'Thanks for the offer but I hate to tell you this Mr Broccoli but my feeling is that Bond should be played by an Englishman. I'm very flattered that you would think of me for this role but I just feel in my gut that it would be a mistake, that I'd be hung, drawn and quartered by Bond fans as an American playing this role. After all, he is the consummate English gentleman.'[21]

James had played English before, appearing alongside Roddy McDowall in a theatre tour of *Dial M for Murder* as the ex-tennis-playing murderer. 'But Bond was different. Bond is a trademark, and it's extremely important that the right person play that role.'[22]

This was an incredibly honest reply by James, undertaken with some considerable guts:

> And I remember Broccoli being quite taken aback by this actor turning him down. But I think I made the right decision. Do I regret it? Here's what I do regret. I regret not being in such a high-quality production. The Bond people, they really pull out all the stops. But I just knew that however good my English accent was the audience would know and the publicity surrounding the film would focus on my being an American, and unless I was anything other than a smashing success, my career would be in difficulty. I would be crucified, absolutely crucified. I was really concerned about that.[23]

Not that James didn't think he could have done a good job had Broccoli managed to persuade him to change his mind. So how would he have gone about playing Bond?

> I would have probably carried on with what they obviously saw and liked about my role on *Dynasty*. I would have stepped it up a notch, of course, this very quiet, reserved type, almost like James Coburn in his early movies. There was also my age; I was around 30, so I would have been a young Bond. Roger Moore was now much too old and the style of his movies had run their course, and I think Broccoli was looking to re-invent the series and ended up really coming out of left-field with his eventual choice of Timothy Dalton. Interestingly, with *Casino Royale* and Daniel Craig, I think that's what they were trying to do 20 years before.[24]

As the months passed it was clear that Broccoli shared the view of most commentators and fans that Bond could not be played by anyone other than a British actor. 'Keep Bond British' was a frequent plea in the showbiz columns of the UK tabloids. And so, who better than the son of the original James Bond? At the time Jason Connery had taken over from Michael Praed as the star of *Robin of Sherwood*. 'Jason Connery would be a continuation of the real Bond, his father Sean,' one journalistic supporter wrote. 'He is the obvious choice.'

A few years later in 1990, Jason Connery played Ian Fleming in a TV movie about the author's wartime life, so the question of him playing Bond inevitably arose again. As he commented himself:

This is the first time I have actually stepped into something where I am bound to be compared – but really I don't think that I would ever play Bond. My father's last Bond film was called *Never Say Never Again*, so I won't say never say never because you never ever know what's going to happen, but I really don't expect it. It's not something that I'm anxious to do.[25]

In fact, Jason Connery was never approached at any time to play Bond, as the actor's agent informed this author.

Someone else with a 'Bond' connection was Charles Dance. Since making his film debut as a henchman, with no line of dialogue, in *For Your Eyes Only*, Dance had begun to forge an interesting career after his breakthrough role in the ITV miniseries *The Jewel in the Crown* (1984) and a role opposite Meryl Streep in the film drama *Plenty* (1985). One day his agent called. 'It's happened, darling.'

'What's happened?' asked Dance.

'You've been asked to test for Bond,' she said.

'Really?' went Dance, understandably intrigued.

'I urge you not to do it.'

'Why is that?' Dance enquired.

'One, well, think how you'll feel if you don't get it. And two, I think it will limit your career.'[26]

Dance took his agent's advice and declined an invitation to test, believing that she was probably right. 'I had not nearly enough experience for something like that and I would have fucked it up.'[27]

One name that kept popping up in news reports as a potential Bond since the early 1980s was Ian Ogilvy, not unnaturally since the actor succeeded Roger Moore as Simon Templar in the *Return of the Saint* TV series in 1978. 'Every time the newspapers had a blank page to fill, they'd always do, who's going to be the new Bond, and put my picture up along with a whole bunch of other actors,' says Ogilvy. 'I was pretty easy about it. I just thought it was funny.'[28]

Ian Ogilvy was born in Woking in 1943 and educated at Eton. Aged 17 he got a job as a stagehand at the Royal Court Theatre in London, then after six months was offered a place at RADA. Following drama school, Ogilvy became friends with the young filmmaker Michael Reeves and starred in his debut film *Revenge of the Blood Beast* (1966). Ogilvy starred in

Reeves' next two films, *The Sorcerers* (1967) and *Witchfinder General* (1968) before the director's untimely death. Stage work and TV appearances followed, notably a recurring role in the classic 1970s ITV series *Upstairs Downstairs*. Then came Ogilvy's breakthrough when he was chosen as the new Saint.

Ogilvy never knew just how close he came to being Bond in 1986 until he was having lunch one day with friends. One of the guests happened to be Charles 'Jerry' Juroe, head of publicity for Eon. After lunch Juroe asked Ogilvy if he could have a word. Ogilvy recalls:

> He took me to one side and he said, 'I don't know really whether I will tell you this but you're a nice guy so I think I will.' I was most intrigued. He carried on. 'We've been looking at lots of people. I'm not part of the decision making process but I know about it. Your name was very seriously considered because of the whole Roger Moore/Saint connection. But the decision has been made. If we wanted another Roger Moore, you'd have got the part, but we don't, we want another Sean Connery.' And the relief I felt, I swear, was so great, it was, thank God for that.[29]

A strange reaction one might think upon learning that you were a hair's breadth away from winning one of the most coveted roles in cinema. But Ogilvy has his reasons:

> You see, I don't really think I was right for Bond. I didn't have a hard enough edge. I don't think Roger was right for Bond either, by the way. So that's as close as I came to it. But that would have worried me being the new Bond. Being the new Saint I thought, yeah I can handle that, but being the new Bond is a very different kettle of fish because it's much more international and people have much stronger opinions about Bond. And it would have altered my life completely, probably for the better, but I think I would have been unfavourably compared. I also think I was physically wrong for it. I think I was too slight, physically.[30]

In the late 1980s Ogilvy moved permanently to America, carving a healthy niche for himself guesting on numerous American TV shows.

In more recent years he has found a new career as the author of several successful children's books.

Another quintessentially English actor considered was Marcus Gilbert. Born in Bristol in 1958, Gilbert wasn't that long out of drama school, and was represented, ironically enough, by the same agent as Timothy Dalton:

> This agent had a very illustrious client list, and I was young and promising and he facilitated the opening of lots of doors. I was lucky to be seen by the likes of Zeffirelli and Miloš Forman. So, without wishing to sound arrogant, Bond was just another audition. Sure, it put a bigger smile on your face and it was exciting, but you didn't want to get carried away with the possibility because you had to get over the first hurdle.[31]

That first hurdle was an interview at Eon's office in Mayfair. 'They were all there,' recalls Gilbert, 'Cubby Broccoli, Michael G. Wilson and Barbara. I can't remember what I was asked, I think they just wanted to sample the man sitting before them. They probably wanted to hear all the right things.'[32] It's difficult, especially for a young actor, to enter such an arena completely in the dark, unable to affect the outcome, and unable to second-guess your inquisitors because you don't know what they're looking for:

> But these are not considerations you take on when you go through the door because you believe you can do it otherwise you wouldn't be there. I remember all that spontaneity, all that confidence and self-assuredness that accompanies youth, so you always think you stand a chance. You can also go in with the appropriate attitude, but I'm not sure I had that.[33]

Another factor might have been Gilbert's stock English good looks. He was very much in the same mould as Ian Ogilvy, and so following on from Roger Moore wouldn't have been seen as distinctive enough. 'I think it's a question of timing,' says Gilbert:

> The producers are looking for something different. They're looking for a certain thing, a certain flavour and if you don't provide that for

them then they'll spread the net a little wider. It's obviously something very specific that they're looking for. And that turned out to be Tim Dalton, who we thought was in for the long run until they decided that he wasn't what they were looking for and then Pierce Brosnan was cast. So that interview really was my one and only chance at Bond. I didn't necessarily blow it; it was just that the timing was bad. At least I was seen for it, ultimately pointless, but there we go.[34]

Gilbert went on to become something of a heartthrob in the late 1980s and early '90s, appearing in a couple of TV adaptations of Barbara Cartland novels, *A Hazard of Hearts* (1987) and *A Ghost in Monte Carlo* (1990), as well as Jilly Cooper's racy drama *Riders* (1993). In later years Gilbert founded his own film production company and looks back on his 007 close encounter with mild amusement mixed with a twinge of regret:

My interview didn't lead to a screen test, by that time they'd gathered what information was pertinent, and in my case there wasn't enough to go any further. Conceivably at that time I wasn't right for the Bond role, at 27 I was just too young. I really wish I'd been a few years older and gone in there with a stronger attitude. But it was nice to be considered. It was good – but it could have been better.[35]

The search continued, and casting director Debbie McWilliams came up with a very real possibility – Sam Neill. 'I think Sam stood a very good chance in those early days,' she has said.[36] Michael G. Wilson was also keen on him, as was director John Glen. 'Sam Neill was one of the last actors I tested,' said Glen, 'and I remember thinking he was very good indeed.'[37] Neill was born in 1947 in Omagh, Northern Ireland, the son of a Harrow- and Sandhurst-educated army officer and third generation New Zealander; his mother was English. The family moved to New Zealand in 1954 and Neill caught the acting bug while at university. After working at the New Zealand National Film Unit as a director and actor, Neill appeared in the celebrated Australian picture *My Brilliant Career* (1979), which in turn led to his selection to play Damien Thorn in *Omen III: The Final Conflict* in 1981.

It was the strong impression Neill made in the 1983 British TV drama series *Reilly, Ace of Spies* that brought him to the attention of the Bond

team and he was duly brought to London for a screen test. The result impressed everyone who saw it, except the one person who really mattered – Broccoli was not convinced. Neither did it transpire was Sam Neill, who responded to my interview request with this email:

> I was once pushed by an ex-agent into a test for Bond. I am still not sure why I agreed. Actually in hindsight I think I was more easily bullied in those days. This is a role I never wanted, nor would have accepted. I was clearly unsuited for it. Only in the rarest of cases, is it anything other than a poison chalice. Acting James Bond is one thing, but 'being' James Bond I would find insufferable. By the way I've thought all the Bonds were terrific in their own way. Much better than I would ever have been. And I'm sure they all enjoyed it, just as I never would.[38]

Ultimately Sam Neill didn't need Bond to succeed, carving out a highly successful career in movies such as *Dead Calm*, *A Cry in the Dark*, *The Hunt for Red October*, *The Piano* and *Jurassic Park*.

So, if Broccoli didn't want Sam Neill, who did he want? The answer was French actor Lambert Wilson, who just a few years earlier had played the love rival to none other than Sean Connery in Fred Zinnemann's period drama *Five Days One Summer* (1982). Born in 1958, Wilson trained at London's Drama Centre (a couple of years after a certain Pierce Brosnan had left), and for his Bond screen test was asked to recreate the *From Russia with Love* hotel scene where 007 finds in his bed the sultry Tatiana, played by the actress Maryam d'Abo. He was then put through his action paces with a fight scene.

Wilson's languid, youthful features were in the end deemed unsuited to Bond. In any case, he suspected that Bond fans would not have accepted a French actor in the role. 'I think I was frightened when I heard about the fact that I could possibly play it,' he later revealed. 'I think it's important not to be internationally famous because it's important to be free and to be able to walk without being recognised. I think if you're James Bond in the entire world then you lose your freedom.'[39]

Ironically, it was Maryam d'Abo that ended up impressing the makers more, winning for herself the Bond girl role in *The Living Daylights*. Wilson continued a modestly successful career, appearing mainly in

French films and theatre, branching out occasionally into the realm of the Hollywood blockbuster with *The Matrix* movies and Halle Berry's disastrous *Catwoman* (2004).

It's difficult to appreciate just how tough it is casting a new Bond, mainly because people have an expectation of what the character is like, especially by the mid-1980s after the role had been essayed by three actors. Probably by this time it was the image of Roger Moore rather than Sean Connery that was fixed in the mind of the public.

However, the producers did feel that they had at last found somebody very special and a real contender. Timothy Dalton's connection to Bond went all the way back to 1968 when Broccoli interviewed him for *On Her Majesty's Secret Service*. Dalton had just made his film debut alongside Peter O'Toole and Katharine Hepburn in the historical drama *The Lion in Winter* and was seen as something of a hot new property. Showing considerable balls, Dalton declined Broccoli's offer to play Bond although he was incredibly flattered to be asked:

> I thought Sean was a tremendous Bond – too good, actually. It would have been a very stupid move to try and take over from him. But there was a second, more practical reason. I was only about 24 at the time. And Bond can't be that young. He must be a mature man. Basically, I considered myself too young and Connery too good.[40]

In 1980 Dalton was again considered, when Moore's continuation in the role was muddled:

> I went to see Mr Broccoli in Los Angeles. They didn't have a script finished and also, the way the Bond movies had gone – although they were fun and entertaining – weren't my idea of Bond movies. They had become a completely different entity. Roger does a fantastic job, but they were different kinds of movies.[41]

It was Dana Broccoli who came up with the suggestion that maybe they should try Dalton again. But there was a complication; he was appearing in London's West End in two Shakespearean productions and then had committed to star in a ditzy film adventure comedy with Brooke Shields called *Brenda Starr*. Dalton bowed out.

With Dalton out of the running Broccoli and the executives over at United Artists agreed that the new Bond should be an actor that many magazines had been touting for some time as the heir apparent – Pierce Brosnan. The 33-year-old was then the star of the American television detective show *Remington Steele*. Indeed, a review in the *Washington Post* for the very first episode noted: 'Pierce Brosnan could make it as a young James Bond.'

Brosnan made it very clear he wanted the job. Even better, he'd suddenly become available when NBC cancelled *Remington Steele* after the fourth season. The timing seemed perfect and Brosnan looked tailor-made to slip into 007's tuxedo. All everyone had to do was wait until the network's option on recommissioning the series, if it so wished, ran out in sixty days. It was a tense time, during which Brosnan was secretly flown to London to perform a three-day screen test. Under the supervision of John Glen, Brosnan impressed everyone. Glen's only reservation was that although he was in his early thirties Brosnan looked much younger. The test footage was sent to Hollywood and MGM/United Artists gave the go-ahead.

Quickly the Eon publicity machine got to work and a series of photographs were taken of Brosnan all ready for his imminent unveiling: one had him posing in a tuxedo Bond-style, another standing beside Broccoli's Rolls Royce outside the 007 stage, then seated in the producers' Pinewood office, then smiling with director John Glen looking at storyboards for *The Living Daylights*.

Presented with the script of the new Bond, Brosnan lay it quietly on his bedside table, too afraid to tempt fate and read even a page of it until the ink was dry on his contract with Eon. But the ink never got dry.

Back in the states the publicity surrounding Brosnan and Bond boosted ratings for the summer reruns of *Remington Steele* and caused a major rethink at NBC. On 15 July 1986, the fifty-ninth day of the option period, literally with just hours to go before Brosnan could officially sign the Bond contract, NBC programming chief Brandon Tartikoff reversed his earlier decision to cancel the show. Brosnan had no choice but to return and saw his chance to play 007 slip through his fingers.

Even worse, after just a few of the new episodes the network decided to cancel the show again, this time permanently. Brosnan's fury was directed at those faceless executives at NBC who had manipulated his

life at this most crucial moment and now left him with only the crushing question of what might have been; what could have been and what should have been.

With Brosnan gone, it looked like the search was going to have to start all over again. English actor Neil Dickson happened to be in Los Angeles at the time. He'd just played that most English of literary heroes, Captain W.E. Johns' Biggles, in an updated big-screen adventure. He'd also appeared in a major American TV miniseries called *Sins*, along with Timothy Dalton:

> My agent at ICM called me and said, 'You've got to go to the Irving Thalberg building at MGM and meet the Bond people.' I got in my rented car and drove over there and it was like, wow, here we are, amazing. But I couldn't possibly see how I could be Bond anyway if I'd done Biggles, and technically I was on a three-picture deal for that.[42]

Neil Dickson was born in 1950 and following graduation from the Guildhall School of Music & Drama worked in repertory theatre. While playing Dean Rebel in the play *Trafford Tanzi* at London's Mermaid Theatre, he was talent-spotted and cast in a major role in the biblical miniseries *A.D.* This led to his casting in *Sins* and then as airman extraordinaire James Bigglesworth.

Dickson arrived at the Thalberg building and was shown into a large office. He sat down in front of a desk and facing him was Cubby Broccoli, sat in the middle, flanked by Barbara Broccoli, Michael G. Wilson and John Glen:

> It was quite intimidating in one way. I don't think I was particularly nervous though because I didn't think I could be Bond anyway. And one of the first things I said to them was, 'Look, I can't play Bond because I've just done Biggles.' And I remember Barbara Broccoli saying to me, 'Neil, you've done Biggles, that's done, and Biggles is Bond. And Bond is Biggles. It's all the same.' Then I said, 'But I'm not six foot two. I'm five nine and a half.' No, no, that's fine they said and told me they had offered Bond to Mel Gibson. And he didn't want to get involved in another franchise like *Mad Max*. So, we had this lovely meeting, it was delightful, they were all very charming. And in typical

English fashion I was very self-deprecating and didn't want to impose myself. And they said, 'It's been very nice meeting you and we'll see you again.'[43]

Biggles by this stage had opened to mixed reviews, as Dickson recalls. 'One review said: *Biggles*. Boggles. Bunkum.'[44] Back in London Dickson met two high-ranking people from UIP, the company that distributed Paramount and Universal films outside America and had international distribution rights to certain MGM/United Artists titles. 'As a result of that, I didn't hear anymore.'[45] The next thing Dickson was in Dublin promoting *Biggles* with Duncan Clark, head of marketing and distribution for UIP, who had a good relationship with Barbara Broccoli:

We were sharing the Elizabeth Taylor/Richard Burton suite at the Gresham Hotel. The suite is two bedrooms divided by a bar. The Gresham was a favourite of the Burtons. We flipped a coin to see who was going to be Elizabeth Taylor and who was going to be Richard Burton, and said I'll see you at the bar at seven. And Duncan came in and said, 'I've just had Barbara Broccoli on the phone, they're floundering. They need to find a Bond.' I said, 'I've seen them twice. Don't mention my name again, they're probably sick of it,' because my London agent was still pushing and pushing. And he said, 'Well, what do you think?' I said, 'Listen,' and I won't take credit for this because I know he'd been in the mix, but I said, 'Tim Dalton. I've worked with Tim and we all know he's a fantastic actor. So, what about Tim.' Duncan said, 'I don't think he's very interested in doing it.' And that was it, the next thing Tim was doing Bond. But he was very reluctant to do it. I don't think he wanted to get caught up in the whole deal. He's a very serious actor.[46]

That meant the end of the Bond road for Dickson of course. 'Life goes on,' he says. 'It wasn't meant to be. Had I been offered it I wouldn't have hesitated. When I got Biggles people said, aren't you worried about being typecast? I said, fucking, bring it on.'[47] In those days following his agent's call and the Bond meeting taking place, Dickson had time to go through in his mind how he would play the role:

The Shakespearean Bond

Tim Dalton, I know, wanted to take out a lot of the fluff humour, he wasn't comfortable with that, he wanted to dull it down. He wanted a much more serious James Bond, which ultimately is what Daniel Craig did, and still got the humour in. And I would have done exactly the same. I would have liked to have brought a more serious tone to it but still kept the old school charm.[48]

The *Biggles* movie ended up flopping at the box office so any intended series was thwarted. Dickson, though, continued to work in television and film:

Some people have said to me over the years, were you ever up for Bond? I say, yeah, I did meet them a couple of times. In a funny kind of way, it's like a little badge of honour. But I honestly didn't think I was right for it. So, I went into that meeting and was absolutely frank and honest about it. I do remember a lot of intense looking. I could see Cubby Broccoli staring at me. Barbara was so nice. Years later I bumped into her in a store in Beverly Hills, 'Hi Neil, how are you doing?' They were nice people. That's why it's such a successful franchise.[49]

It was Cubby Broccoli that looked again at the schedule and returned to Dalton who was just finishing *Brenda Starr*. At first Dalton did not want to be tested, adamant that his track record as an actor was sufficient. In the end Michael G. Wilson explained that, while nobody doubted his talents, they had to see him as Bond, just to get an idea of what they were dealing with, what they had on camera. Dalton finally agreed and in the tests all his years of training and experience shone through. 'Timothy Dalton is our man,' declared Eon executive Charles 'Jerry' Juroe:

The one thing that impressed me about Tim was his incredible and believable likeness to the Bond character. When we studied his screen test every one of us believed he could have been a former Commander in the Royal Navy. He behaved as though he had the ability to be a spy and he looked as though he wouldn't think twice about killing somebody coolly and cleanly. It was a pretty impressive screen test.[50]

Very quickly Dalton was asked to put pen to paper on a three-picture contract.

When the announcement of his casting was leaked to the press early in August, Dalton was still in Puerto Rico finishing *Brenda Starr*. Almost immediately the set was inundated with reporters all clambering to get at him.

Born in Colwyn Bay, North Wales, on 21 March 1946, Dalton was the son of an advertising executive and became interested in acting at the age of 16 when he saw an Old Vic production of *Macbeth*. It was around the same time that Dalton first encountered James Bond, catching a screening of *Dr. No* at his local Odeon. Having grown up on a cinema diet of black and white British war movies and drawing room comedies, Dalton connected immediately with this new and vibrant piece of entertainment. '*Dr. No* just came and took cinema by the scruff of the neck and banged it right down into today.'[51] Dalton is significant in being the first actor to play Bond who saw a 007 film in his youth.

After two years of study at RADA, Dalton distinguished himself in the theatre before being catapulted into the world of movies when he was personally selected by Peter O'Toole in 1968 to play the young king of France in *The Lion in Winter*. Other roles in historical films followed: *Cromwell* (1970), *Mary Queen of Scots* (1971) and he took the lead in *Wuthering Heights* (1970), a performance that led one American critic to hail him as 'the greatest acting find in the last decade'. Indeed, Dalton seemed an ideal Bond candidate having played some of literature's greatest lovers: Heathcliff, Romeo in a 1973 Royal Shakespeare Company stage production and Rochester in a 1983 BBC TV serial of *Jane Eyre*.

After such a startling beginning, Dalton's later acting choices were erratic to say the least, including a role in the dire comedy *Sextette* (1978), opposite the then 91-year-old Mae West. When he did appear in mainstream movies it tended to be as a supporting player, such as *Flash Gordon* (1980), playing an Errol Flynn-inspired space prince, and the mystery *Agatha* (1979), opposite Dustin Hoffman and Vanessa Redgrave, with whom he had a long and heavily publicised on/off relationship.

The choice of Dalton as Bond drew immediate comparisons to Sean Connery. His dark Celtic looks were a definite throwback to the original 007 and Connery was amongst the first to applaud his selection and

hoped that the Welshman would be able to stamp his personality against the hardware.

The schedule of the new Bond film was so hectic that as soon as Dalton completed his final scene on *Brenda Starr* he flew to London, a little jet-lagged but raring to go to work. It was another week before he was officially unveiled as James Bond at a massive press conference on location in Vienna. In front of the world's media Dalton explained that he wanted to approach the project with a sense of responsibility to the work of Ian Fleming. These weren't glib sound bites by Dalton: he genuinely respected the source material and studied the novels for clues on how to play Bond, expressing a desire to recapture the essence of the literary character. Here was a man who could get killed at any moment and that stress and danger was reflected in the way he lived.

Dalton singled out *Casino Royale* as his favourite of the novels, the most evocative. Especially the passage where Bond described getting his 00 licence, revealing an element of self-disgust at the killings he was required to perpetrate. 'It superbly proves the point,' said Dalton, 'that he is a man living in a rather ruthless, vicious world, and does have a license to kill.'[52] It was this element of Fleming and the world he created that Dalton wanted to bring back into the films. Today one can only imagine just how good Dalton would have been had they made *Casino Royale* for him as his debut. The actor talked about his hope to maybe one day make a film of Bond's inaugural mission. 'But to make a film of *Casino Royale* properly, it would be so outside what is currently accepted as Bond on film, but it would make a bloody good picture. Done as written. It would make a great film.'[53]

Due to the complications of finding a new Bond, *The Living Daylights* was written as a sort of generic Bond adventure. With Dalton's casting, portions of the screenplay were rewritten to fit his interpretation of Bond; quips and comedy scenes more suited to the Moore era were reduced or cut altogether. Dalton had made it known during negotiations that he wanted the films to go in a more serious direction and this was a condition of him signing on. Dalton knew this approach might not find favour with a mass audience and has hinted that not everyone connected with the Bond franchise shared his vision. Most did though and realised that they had to move Bond away from the excesses of the Roger

Moore era and present a suitably realistic and gritty world for Bond to roam. In Dalton they had the perfect actor to realise this new shift in tone, taking as he did the role and his responsibilities utterly seriously. 'I don't think we've ever had the potential with an actor that we've got with this man,' claimed John Glen.[54] Nowhere was this better exemplified than by Dalton's approach to stunts. Critics complained about the obvious use of stunt doubles for the ageing Moore and so it was indeed a breath of fresh air that the new actor was willing, and able, to throw himself into the action, whether clinging to the roof of a Land Rover hurtling down a mountain or driving a huge oil tanker.

But there was one fear eating away at the back of Dalton's mind. He knew that among Bond fans and regular cinemagoers there were almost two divided camps, one faction preferring the style of Moore, the other the style of Connery. And they could both band together and dislike his.

As it turned out Dalton was a hit and, in 1987, *The Living Daylights* outgrossed the previous two Bond pictures in the UK and scored around Europe too. Dalton received some of the best press yet for a debut Bond performance:

> The most impressive factor in the film is one Timothy Dalton, who is so damn good as James Bond you feel like asking where he's been since Connery left. Although he's only done this one, I feel safe to proclaim Dalton the best of the four, and one that Ian Fleming would have approved of.
>
> *Starburst*

'The fourth Bond registers beautifully on all key counts of charm, machismo, sensitivity and technique' – *Variety*.

> Dalton develops the best Bond ever. Dalton does not play a pompous, mean-spirited Bond like Sean Connery or a prissy, sissy Bond like Roger Moore. Both were as aggressively heterosexual as pubescent Playboy subscribers. Dalton creates a dashing and endearing secret agent. And unlike the creaky Connery and the mushy Moore in their later years, he looks fit for derring-do.
>
> *Washington Post*

There were, however, detractors. 'Dalton hasn't the natural authority of Connery nor the facile charm of Moore, but George Lazenby he is not. It's an able first go in the circumstances, though perhaps it could do with a bit more humour' – Derek Malcolm, the *Guardian*. But the *Evening Standard*'s Alexander Walker thought Eon had made the wrong choice in going for semi-realism after the flippant Moore era:

> Dalton doesn't begin to share the joke with the audience the way that the other Bonds did. He looks as if he takes it all for real and dislikes much of it. Broccoli should decide what kind of Bond he wants, for at the moment he hasn't got one. And it's no good saying, 'Give him time, you can't be Bond first time off.' Connery was.

Then there was this from Roger Ebert of the *Chicago Sunday Times*:

> The raw materials of the James Bond films are so familiar by now that the series can be revived only through an injection of humour. That is, unfortunately, the one area in which the new Bond, Timothy Dalton, seems to be deficient. He's a strong actor, he holds the screen well, he's good in the serious scenes, but he never quite seems to understand that it's all a joke.

This lack of humour may explain why Dalton was never a hit in the all-important American market. When *The Living Daylights* opened across America it didn't do as well as hoped, selling fewer tickets than any 007 film since *The Man with the Golden Gun*. Dalton was a relatively unknown figure on the international stage and despite Broccoli's statements to the contrary, many casual American observers simply believed that Dalton was Pierce Brosnan's substitute.

Despite all this Broccoli felt confident that Dalton was the man to lead Bond into the 1990s, and so work began on his follow-up. While *The Living Daylights* was to some extent a compromise movie, with much of the script written prior to Dalton's casting, *Licence to Kill* (1989) was totally constructed around his portrayal and pushed the character even more in the direction the actor wanted. 'We've got the film back in the world James Bond should inhabit,' Dalton told the press. 'We've left the tongue in cheek humour and caricature behind.'

Sadly, the great experiment failed and *Licence to Kill* performed even worse at the American box office, selling only half the tickets sold for *Octopussy*. It didn't help that big hitters like *Indiana Jones*, *Lethal Weapon 2* and *Batman* were competing for cinemagoer's hard-earned dollars at the same time. But even in Europe the film proved a disappointment. Were audiences not responding to Dalton's Bond or was it that the formula had been played around with too much? Ironically after years lambasting the 007 series for being too 'cartoonish', some reviewers were now complaining that Bond was too tough and real.

Following the poor commercial performance of *Licence to Kill* in America, MGM/United Artists urged Broccoli to rethink the franchise once again, which many commentators were saying was wilting fast. The Bond series was pruned of some of its longest serving collaborators. Out went John Glen, who had directed the last five movies, and most significantly Richard Maibaum, screenwriter on the Bonds since day one. Maibaum passed away not long after.

Broccoli now went in search of fresh blood. According to *Variety* some of the names approached included *Rambo* director Ted Kotcheff, John Landis, director of *The Blues Brothers* and *An American Werewolf in London*, and *Indiana Jones* writers Gloria and Willard Huyck. 'There is a desire to get some new people involved and get a fresh slant on the material,' claimed an MGM spokesman. 'It's obvious that the series is a little tired.'

Suddenly all work on the new Bond, which had a tentative release date of late 1991, was halted when MGM/United Artists was sold to Pathé Communications and there began a long-drawn-out legal fight between Cubby Broccoli and the new company over the cut-rate sale of Bond TV rights. In 1992 another problem arose when MGM/Pathé's new chairman Frank Mancuso made his views known that he didn't visualise Dalton continuing in the Bond role. Mancuso brought in executive John Calley to revitalise the United Artists brand. One of Calley's ideas included a Bond relaunch and he reportedly presented Broccoli with a short list of potential actors that included Brosnan, Ralph Fiennes, Hugh Grant and Liam Neeson. Broccoli remained adamant that, when Bond 17 appeared, it would be starring Dalton.

It was around this time that the Mel Gibson for 007 rumours, which first surfaced a few years back, began again and rumbled on. Around the

time of the 1992 Cannes Film Festival, rumours were flying around that producer Joel Silver, the man behind the *Lethal Weapon* and *Die Hard* franchises, hoped to acquire the 007 rights and had already spoken to Mel Gibson and to Richard Donner, the director of the *Lethal Weapons*, about doing three Bond movies. 'Putting in Mel Gibson alone would fresh up the genre,' said Silver. 'He has the same good looks and the same boldness as Connery. And casting an international star would make the film an international vehicle.'[55] This was an odd choice of words, since Bond was already a worldwide phenomenon, although in recent years it had slumped in some crucial markets. And that, said Silver, was Broccoli's mistake in casting Dalton, a highly respected actor, but not a big box office draw. And the 1990s were already becoming a decade of *big* stars: Stallone, Schwarzenegger, Gibson, Bruce Willis, etc. 'You can't build a star like you could in the old days. You're better served having a well-known personality; that's the way I would do it.'[56] Silver's plans, however, never went anywhere.

The legal dispute over TV rights concerning the 007 franchise finally came to a satisfactory conclusion in the spring of 1993 and pre-production resumed on the new Bond film. Cubby Broccoli had steered the series through one of its most precarious periods. But at what cost? He was now suffering a serious heart condition and decided to take a back seat on the new film while Michael G. Wilson and his daughter Barbara took main responsibility. One of their first actions was to hire Michael France, author of the recent Sylvester Stallone action block-buster *Cliffhanger*, to write the script that ultimately became *GoldenEye*. As France began work, 'it was sort of generally assumed that it would be Tim, even though there was kind of a cloud over his casting'.[57] France believed that the failure of *Licence to Kill* had been unfairly laid at the door of Dalton by the studio, an opinion shared by the producers. 'Michael and Barbara both thought he was a great Bond, and so did I. In writing the first draft, I tried to write it with him in mind.'[58]

It is certainly clear that during pre-production on what evolved into *GoldenEye*, the producers still wanted Dalton. Early in their search for directors, Barbara and Wilson looked at Renny Harlin, the Finnish director who had helmed *Die Hard 2* and *Cliffhanger*. At his interview Harlin made no bones about the fact that he didn't think Dalton should be Bond. That in his opinion the actor didn't personify what James Bond

was about. 'I said, "I think you should recast James Bond, and Pierce Brosnan should be Bond." And they said, "No, no, we are happy with Timothy Dalton. He's James Bond and that's how we want to do it." And I turned down the movie because of that.'[59]

Other voices, with more influence than Harlin, were saying much the same thing. By now MGM/United Artists were making loud noises that they wanted Dalton replaced. With such a long gap already between movies it made perfect sense for them to recast the role for a new generation of moviegoers. Overseeing the revitalisation of the franchise for the 1990s and beyond was Jeff Kleeman, who as a development and production executive at Paramount Pictures helped launch the Jack Ryan franchise with *The Hunt for Red October*. Kleeman joined MGM/United Artists in 1993 as Executive Vice President of Production and hosted numerous meetings and conferences where Cubby, Barbara and Michael G. Wilson made a strong case for keeping Dalton. 'They did genuinely love him and for good reason,' said Kleeman. 'I'm sure they were disappointed we didn't want to make it with Timothy.'[60]

Dalton was on location filming the CBS miniseries *Scarlett*, playing another iconic literary figure, Rhett Butler, when he was sent France's script for Bond 17. One can only imagine how he must have felt, knowing that most of the studio executives wanted to see the back of him. At least he took solace in the personal backing of the Broccolis and Michael G. Wilson, in other words, the Bond family. Still, when push came to shove, with the new Bond script in front of him, Dalton took the only reasonable step he could. He resigned in April 1994. A statement was released to the press:

> Even though the producers have always made it clear to me that they want me to resume my role in their next James Bond feature, I have now made this difficult decision. As an actor, I believe it is now time to leave that wonderful image behind and accept the challenge of new ones. The Broccolis have been good to me as producers. They have been more special as friends.

Eon opted not to stand in Dalton's way and released their own press statement. 'We regret Timothy's decision. We have never thought of

anyone but Timothy as the star of the 17th James Bond film. We understand his reasons and will honour his decision.' They forgot to say that Dalton's decision to walk probably saved Cubby Broccoli, under pressure from MGM, the unpleasant task of having to fire the actor.

In 2007 Dalton looked back on his tenure as Bond with genuine fondness:

> It was a remarkable time of my life. I don't think anyone except the few people who have played James Bond can tell you how strange and special it is and how much your life changes. I have no regrets about doing it at all. There's virtually no privacy at all except that which you carve out for yourself. I made a documentary about wolves and was 500 miles from the North Pole. My little plane flew into this small Eskimo village that I was to stay in and all the Eskimos started saying: 'It's James Bond! Come and eat some raw fish!' You're known everywhere.[61]

7

Born to Be Bond

With Dalton gone thoughts immediately turned to Pierce Brosnan, but although he was given the role in 1986 there was a surprising reluctance in the Bond camp to instantly make him an offer. Maybe some feared he would be too much of a Roger Moore type given the way he played Remington Steele with a very light touch. Others thought that he lacked the physique. But in the ensuing years Brosnan had matured as an actor, showing an improved range and depth. He was excellent as a KGB agent that Michael Caine must track down before exploding a nuclear device in Britain in *The Fourth Protocol* (1987) and showed a by now well-honed comedic touch in the popular Robin Williams comedy *Mrs. Doubtfire* (1993).

Pierce Brosnan was born in 1953 in County Meath in Ireland, the only child to a local carpenter. Brosnan's mother moved to England looking for work after his father abandoned the family and, in 1964, at the age of 11, Brosnan joined her in London. Leaving school, Brosnan studied at art college and then at London's Drama Centre. Working in theatre it was his romantic good looks that won him a film career. His debut was for Bond director Guy Hamilton in the 1980 Agatha Christie drama *The Mirror Crack'd*. 'It was just a day's work,' Hamilton was to recall. 'I needed a handsome guy and I grabbed a copy of *The Spotlight* and there he was.'[1] Next Brosnan played an IRA hit man in the gangster classic *The Long Good Friday*.

In the summer of 1980 Brosnan joined his wife, the model and actress Cassandra Harris, on location in Corfu where she was appearing in *For

Your Eyes Only as the doomed Countess Lisl. It was here that Brosnan met his future boss Cubby Broccoli for the first time. A role in a major TV miniseries, *The Manions of America*, encouraged the couple to take their chance on making it big in Hollywood. Remarkably it was Brosnan's very first audition that landed him the role of Remington Steele, a dashing private eye.

It was during that first visit to Los Angeles that Brosnan and Cassandra dined at Cubby Broccoli's home. Brosnan later recalled driving back to their hotel in a rental car, jokingly delivering the immortal line, 'The name is Bond, James Bond.'

Brosnan's success in *Remington Steele*, his smooth debonair charm and stylish wardrobe, fostered in the minds of the public that here was a Bond in the making. It seemed that Brosnan was at the top of every commentator's list as Moore's natural successor. Indeed, when Brosnan went on David Letterman's chat show in 1985, he was asked point-blank. 'Aren't you going to be the new James Bond?' Brosnan was reticent in his replies, blaming the tabloids for all the rumours. 'You'd be good as Bond,' Letterman pressed. 'I'd have a crack at it,' Brosnan finally admitted.

Despite losing out to Timothy Dalton, the shadow of Bond rarely ever seemed to move away from Brosnan. He appeared destined to be plagued for the rest of his life as the guy who almost got to play James Bond. In the late 1980s he even appeared in a couple of Bond-like commercials for Diet Coke, wearing smart suits and battling ninjas. There were also reports linking him with fellow Irishman Kevin McClory's attempts to produce yet another rogue Bond movie.

When Dalton stepped down as 007 the press launched into a frenzy of speculation as to his replacement. Film critic Gene Siskel proposed Denzel Washington. *Entertainment Weekly* printed an article where Hollywood luminaries gave their advice on how to invigorate the series, including the suggestion that Bond be changed into a woman and Sharon Stone be cast. This was the first time the idea of Bond becoming a woman was mooted and calls for an actress to play Bond would reach near-lunatic levels in the 'era of woke'.

Certainly, the filmmakers at this stage were not going to mess too much with the formula. According to Michael G. Wilson, James Bond now stood alongside the likes of Sherlock Holmes, Batman, Superman

and Tarzan; he was totally identifiable and now part of our modern mythology. And too established a character to make him into something else.

As far as the bulk of the press and public were concerned, there was only one candidate for 007, and Brosnan knew it. The producers did spend a couple of months looking at different people, to see if anyone else had come along in the meantime that they ought to consider. One of those was Giles Watling. Born in 1953 in Chingford, Essex, the son of actor Jack Watling, Giles was primarily a theatre actor. He is perhaps best known as Oswald the vicar in the Carla Lane BBC sitcom *Bread*. When that comedy finished in 1991 Watling found himself with not much work, but a young family and a big house to run. Cash was in short supply:

> Then around 11.30 one evening my phone rang. The voice on the other end apologised for the lateness of the call but he felt that time was of the essence. He said he'd recently seen me in a production of *Jamaica Inn* at the Lyric Theatre, Hammersmith, where I had been playing the rough-tough Jem Merlyn. He said he thought my performance was very good. Now at this point I thought I'd got some kind of fan or crank on the line as he hadn't as yet given me his name. Thank God I didn't go into patronising mode – instead I asked politely who this was. 'Lewis Gilbert,' he said.[2]

Of course, Watling knew of Gilbert's cinematic pedigree:

> He asked if I was working. No actor likes to admit that he hasn't heard a peep out of his agent in ages. 'Bits and pieces – nothing grand,' I lied. Then he said, 'Would you mind if I put your name in the hat for Bond?' I had no idea what he was on about and foolishly asked him to expand. He told me that he had discovered that Timothy Dalton's run as James Bond was coming to a slightly premature end and that Eon Productions were casting about for the next man in line. That could well be me. At this point I recalled that Lewis had directed no less than three Bond pictures. My knees went weak. Would I mind? Would I like to think about it? Would I Hell! 'Thanks for thinking of me,' I said – or words to that effect. Lewis told me he would have a word with Cubby in the morning. Sadly Cubby was ill.[3]

Watling experienced an odd combination of numbness and exhilaration; and also a bit of déjà vu. Back in the late 1980s he was down to the last two for the part of The Saint in a new series of films featuring Leslie Charteris' hero. He did the screen test, quite well he thought, but the role made famous by Roger Moore and Ian Ogilvy finally went to Simon Dutton and the series failed spectacularly. Watling admits:

> The rest of this little episode in my life is something of an anti-climax. I mean you would have noticed if I'd actually got the Bond job so it goes without saying that it went to someone else. Over the next couple of months there were a few more little frissons of excitement. My agent was approached by Debbie McWilliams, the Eon casting director, saying that Barbara Broccoli would like to see me. My agent was starting to mention money; undreamed of sums. Then someone at Eon called me and said that they really wanted to cast Pierce Brosnan as Bond. If they couldn't get him they would give me a call. They never did. Perhaps *The Saint* might not have been a bad thing after all.[4]

Watling is good humoured about his 007 close encounter and remains somewhat bemused as to what exactly Lewis Gilbert saw in him:

> I guess it was the fact that the role I played in *Jamaica Inn* was a bit of a rogue, charming with a cruel streak. In addition – even if I do say it myself – I was quite fit at the time, tanned and spent a part of the play wandering around half naked. Bond perhaps? I don't know. I did do quite some work on how to approach Bond during the time it was a possibility. I worked out and re-read a couple of the books for a start. Bearing in mind Dalton's earthy, realistic, slightly humourless approach I felt that it might be good to reintroduce some of the fun. After all Bond is a fantasy figure – we have to suspend disbelief. Why not push the boundaries a little. Having said all that I really believe that Brosnan was a great Bond.[5]

Someone Barbara Broccoli did get round to seeing was Glenn McCrory, but again the spectre of Pierce Brosnan rather put the kibosh on things.

Born in 1964 in Annfield Plain, County Durham, McCrory was a former professional boxer who held the IBF version of the cruiserweight world championship. By the time he retired from the ring in the early 1990s he was already working as a Sky commentator and pundit as well as picking up bits of acting work in episodes of TV shows like *Casualty* and *Crocodile Shoes*. The Royal Shakespeare Company even offered him a contract to tour with them. Acting was always something that McCrory loved and wanted to have a go at: 'I had two loves as a kid growing up, movies and boxing. And boxing in a mining town in the North East was a bit easier to get into than the acting profession.'[6]

McCrory was on the books of top London acting agency Scott Marshall and it was Marshall's wife, Denise, who called McCrory up one day with some news. 'Oh Glenn,' she said, 'we've got an enquiry for you. Can you come down in a couple of days? They want to see you for Bond.'

'Oh wow,' McCrory said and asked what the role was:

I thought it was for a baddie or something like that. She goes, 'Oh, James Bond.' She wasn't filling me with confidence because she seemed flabbergasted. Then I had a couple of days of just dreaming of going from the boxing world champion to in a few years being the biggest name on screen, James Bond, the guy that every man would like to be.[7]

The two days passed quickly and McCrory was on the train heading to London. 'I put my best Bond accent on, and I ordered my tea shaken not stirred.'[8] He arrived at the offices of Eon in South Audley Street and went into a set of very plush rooms where he was greeted by both Barbara Broccoli and Michael G. Wilson:

And I sat with them and had a perfectly nice meeting, got on really well. But I'd read in the paper on the train going down, this headline, Brosnan for Bond. Because he was the main contender. When I saw that I kind of went into the meeting thinking, you've brought me down here for nothing. I got a bit annoyed. And they said, 'No, no, we still want to finalise a couple of other people.' They made it plain they weren't looking to screen test me, to put me through any of that.

They just wanted to find out what I sounded like, what I looked like, what my character was. So, we had a long chat. And then my agent phoned a couple of days later to say that Pierce Brosnan had been cast.[9]

Looking at someone like McCrory was almost like going back to the likes of Sir Ranulph Fiennes; this was very much a case of the producers looking outside of the box, trying something left field and seeing if it worked. 'I was obviously just a wild card. But it was quite an honour. Most people laugh if anybody says you auditioned for Bond – oh yeah – but I actually did.'[10]

Certainly with an ex-boxing world champion in the role of Bond, when a baddie gets punched, they're not getting up again. Obviously, McCrory would have brought that kind of physicality and realism to the part:

> When you went from Sean Connery to Roger Moore, I can believe Connery doing that stuff. I can believe him beating three guys up and throwing one off a boat. I couldn't really believe Roger Moore doing it. Or Timothy Dalton. I couldn't see them having a proper scrap. So, you're dreaming thinking, I can do that and look real doing that, and people will believe it. But it was just destined to be a dream.[11]

One of the complaints about Brosnan was that he didn't carry enough of a physical threat. That's something Daniel Craig did later bring to the role, that street fighter element Connery had. 'You do get that with Daniel,' says McCrory. 'But to me Daniel Craig is not as suave. He's got that roughness but not that debonair quality which is so important.'[12] That's the reason why Connery was so perfect: he combined both the charming playboy side of Bond and the thug. And that's rare to find both qualities in an actor. 'That's the greatness, that's the wonder of Bond,' says McCrory. 'The fact that you've got this debonair man who can hang out in casinos, who can mix with the elite, who is intelligent, but then he can get down and nasty and take out half the Russian army.'[13]

McCrory thinks he would have been capable of pulling off that smoother side of Bond but thinks that perhaps his age proved to be a

disadvantage; at 30 he was too young: 'Ian Fleming wrote it for a man in his 40s who had been through life a little bit. I was still a bit young.'[14] Despite that, had the offer come, unhesitatingly McCrory would have said yes. 'I would have jumped in. When you've sparred with Mike Tyson in his prime and jumped in the ring with Lennox Lewis, it's not going to put me off putting on a dixie bow and having to fight with some stuntman.'[15]

Back when McCrory's agent first rang up with the news she had laughed and said, 'A Geordie Bond.' That was almost as daft as a Scottish one, McCrory hit back with. Of course, we did end up with a Scouse Bond thanks to Daniel Craig. Just a year after losing out on Bond, McCrory appeared in the celebrated BBC drama series *Our Friends in the North* starring Daniel Craig. 'It was quite funny, me dressed in my tuxedo as a doorman throwing Daniel Craig out of this nightclub was as close as I ever got to Bond.'[16]

Casting director Debbie McWilliams was to confirm that ten British actors were seen or tested and taken seriously as possible alternatives to Brosnan. Ralph Fiennes revealed years later that he had a meeting with Cubby and Barbara but it didn't lead to anything:

> There was a discussion, once, some years ago, about my playing 007. I don't think I would have been very good, but I did feel that I could have had a crack at it if it had been set in the 1950s. I love the books and I always saw them in black and white, gritty, noirish, and very dangerous. And probably very politically incorrect![17]

Fiennes would go on to play M in the Daniel Craig Bonds.

And Liam Neeson, fresh off a Best Actor Oscar nomination for *Schindler's List*, was contacted by Barbara to ask if he was interested. Neeson said he was. 'And then my lovely wife [Natasha Richardson], God rest her soul, said to me, "Liam, I want to tell you something. If you play James Bond, we're not getting married."'[18] Neeson decided against taking a meeting with the Broccolis. 'She gave me a James Bond ultimatum. And she meant it! Come on, there's all those gorgeous girls in various countries getting into bed and getting out of bed. I'm sure a lot of her decision-making was based on that!'[19] Often afterwards Neeson

would tease Natasha by going behind her back, making his fingers as though he was holding a gun, and humming the James Bond theme.

Out of all the candidates, it was perhaps Mark Frankel that came the closest to giving Brosnan a real run for his money. 'There was always a thing when I was a kid,' recalls Frankel's son Fabien, now a successful actor himself. 'It was always like, yeah, your dad was really close to playing Bond. Or your dad would have been a great Bond. That's what all my dad's friends used to say.'[20]

Mark Frankel was born in London in 1962 and despite achieving success as an under-21 tennis player, his heart was set on the stage and he took a variety of jobs, including minicabbing, to pay for acting classes. He got his first break when he was spotted by a casting director in a fringe play above a pub in Earls Court and won the lead role of the young Michelangelo opposite F. Murray Abraham in the TV miniseries *A Season of Giants* (1990). He had only been out of drama school for a month.

More television followed, then he starred in two independent British features, playing a Jewish estate agent who discovers his father is a Yorkshire pig farmer in the comedy *Leon the Pig Farmer* (1993) and the romantic comedy *Solitaire for 2* (1994). Curiously, both films also starred Maryam d'Abo, who since her casting in *The Living Daylights* had remained close to Barbara Broccoli and the Bond team. It's possible that Maryam may have mentioned Frankel to the Broccolis. Certainly their interest was piqued when Frankel won the starring role in an American action-adventure TV series called *Fortune Hunter*, playing ex-British agent Carlton Dial now in the business of recovering stolen property. The show made its debut on American TV in the summer of 1994. Promoting the show, Frankel spoke about how it was every young boy's dream to play James Bond and that he grew up watching the movies with his father. 'In America you have Superman, Batman; a lot of superheroes. For us in England, James Bond is our superhero.'

Photographs of Frankel in various Bond-like poses clearly demonstrate that he had the dark, matinee idol looks to pull off Bond, and he was asked to meet the producers. 'From my recollection, they were really keen on Mark,' recalls Frankel's wife, the French actress Caroline Besson:

But Pierce Brosnan was going to be James Bond. Then the plan was that maybe Mark would get it afterwards. Was that a definite, I don't know. But was that talked about? For sure. I think that was the idea. You've got to remember that Mark was quite young, so it would have worked out that Pierce was Bond and then Mark would be next. Nothing was signed, but it was discussed.[21]

Tragically this was not to be. Mark Frankel died in a motorbike accident in 1996, aged just 34. Cinema was robbed not only of a potential Bond, but a promising British leading actor. 'Mark would have been an excellent Bond,' says Caroline:

> I think he fancied himself as Bond. He was very suave Mark. We all thought he would be a perfect Bond, in the Connery mould. It was almost a natural thing and it felt completely right. He had done *Fortune Hunter* and that series was not so far away from Bond in some ways. Certainly, his interpretation of *Fortune Hunter* was James Bond. He got inspired by James Bond to portray that character.[22]

Caroline cannot recall if Frankel conducted a screen test or just met with the producers. 'But I do remember the discussions. And I remember the excitement. And I remember the real possibility that once Pierce Brosnan finished as Bond it was going to be Mark. Or he was certainly going to be high on their list.'[23]

Thanks to a high-profile role in the HBO fantasy drama series *House of the Dragon*, Fabien Frankel has been spoken of as a potential Bond to follow Daniel Craig. In 2023 some friends sent him an article listing the next generation of actors that could be Bond and his name was on it. Like his father, Fabien is a big Bond fan and recalls being introduced once to Barbara Broccoli at a dinner. 'We didn't get into the specifics of my dad auditioning for Bond or anything like that, but she said that she had been very fond of my dad and was very sad when he passed. It was a very lovely encounter between the two of us.'[24]

With the public and commentators fully expecting Brosnan to be anointed the new James Bond, a meeting took place at Cubby's Los Angeles home. All the Bond hierarchy were present. Jeff Kleeman recalled what happened: 'Cubby, who had been sitting very quietly,

tapped his cane on the floor, not in a super dramatic way, but just gave it a single tap. Everybody stopped talking and all turned to him. He very simply said, "We should go with Pierce."'[25]

Brosnan was in his kitchen, with his fiancée Keely Shaye Smith, when his agent called with the news. 'I was giving Keely thumbs up, doing the James Bond gun signal. I put the phone down and I gave my wife to be the biggest kiss. We opened a bottle of champagne and I went out and had my photograph taken with a huge shit-eating grin on my face.'[26]

Dalton's replacement was always a foregone conclusion. *GoldenEye*'s director Martin Campbell regarded Pierce as being in better shape than he was back in 1986, when he was too fresh-faced. Now there was a bit of weathering, a bit of age. Brosnan agreed that he was too young before and not sufficiently experienced or equipped as an actor to play a role that might have been too intimidating. It was also a case of unfinished business. Brosnan was to describe the fact that Bond had come round to him again as remarkable. 'When something happens for the second time in your life it carries a certain significance.'[27] Back when he lost the role to Dalton he couldn't even bring himself to see his films and was certain the actor would inhabit the role for many years.

It's not hard to see why Brosnan was a favourite to play Bond for so long. He brought great wit, style and sophistication, along with some vulnerability. He was almost a greatest hits package of the four previous incumbents. Offered a three-picture deal, with an option for a fourth, Brosnan signed on the dotted line at the beginning of June. Faxes soon hit the desk of every tabloid in town, cordially inviting the press to 'Meet the New James Bond' in the drawing room of the Regent Hotel in Piccadilly on 8 June at midday. Even though the assembled hacks had already pretty much announced Brosnan's crowning, there was rapturous applause when Brosnan entered the room to the strains of the James Bond theme. Amidst the clatter of the press and the barrage of flash-guns Brosnan appeared calm and collected. As one reporter said to his colleague, 'Look, this man's Bond already.'

Dressed in an Armani suit, Brosnan sported a very non-Bond-like full beard, preparation for playing Robinson Crusoe in a forthcoming TV film. He sat down and was bombarded by questions such as 'what kind of swimming costume will you wear?' handling each of them with panache. He also outlined his philosophy towards the character.

He wanted to see what was beneath the surface of this man, what drove him on, what made him a killer. He realised, too, that it was all a fantasy, a bit of fun, but there was no reason why the films couldn't blend both elements of characterisation and action. He revealed that back in 1986 he bought all the Fleming novels and now revisited them, along with watching some of the early films. He also dipped into a couple of biographies on Fleming himself and was to gain more insight from them than he did reading the literary Bond, 'because it was mainly Fleming projecting his image of himself into Bond'.[28]

When Brosnan left Ireland as a young boy to come and live in London, the first film that he saw in his local cinema was *Goldfinger*. And throughout his tenure as James Bond Connery remained the template: he was the man Brosnan had to compete with, knock down, stand tall beside. It was his presence, Brosnan confessed, that permeated the set of *GoldenEye* each day. The shadow of another Bond was looking over Brosnan too. On the wall of his dressing room hung a fax sent from Roger Moore. It read: 'From the old Bond to the new one. Kill em sport!' Moore also made a point of visiting the set and meeting Brosnan. Dalton, too, sent Brosnan a letter wishing him well.

When Brosnan was shooting *The World Is Not Enough*, his third Bond, he had one particularly taxing scene set in an underground bunker, dodging an explosion, and hurtling down some wires with a huge fireball racing behind him. The scene went well, and Brosnan's work was finished for the day. Out in the car park at Pinewood he was putting his gear into the boot of his car when he looked up and saw the unmistakable presence of Sean Connery, 'the big man', as Brosnan called him:

> He was standing there right in front of me and he said, 'I've just seen what you did there, very good.' I was silent. And then he asked me a question. He said, 'Are they paying you enough money?' I'm not sure if I answered and it didn't really matter because the great man had seen me do my bit of Bond. And then he was gone.[29]

It was now five years since the release of *Licence to Kill* and the world had gone through some momentous upheavals, not least the fall of the Berlin Wall. This meant that *GoldenEye* would be the first Bond film released to post-Cold War audiences. The producers not only had to introduce a

new actor as Bond but traverse the winds of global political change, and there were many commentators who believed it couldn't be done, that Bond was a has-been, a dinosaur without an enemy to fight now that communism was all but extinguished. What those critics were ignoring was that, even at the height of the Cold War, the Russians were rarely the villains in a Bond film; invariably it was lone maniacs or criminal conglomerates like SPECTRE that pitted their evil wits against 007.

The job of breaking Brosnan in as Bond and reinventing the series after its long absence, no mean feat, fell to Martin Campbell. A New Zealander with experience working on British television, Campbell wanted a return to the Connery classics in terms of mood, criticising the Roger Moore films for taking the series to a comic strip level. Campbell was critical, too, of Dalton's reign, for having no sense of style or glamour and too little humour, which he considered to be essential to the Bond mix. Campbell wanted Brosnan to play Bond as cool under pressure and to always handle the action in a calm and controlled way.

When *GoldenEye* opened at the end of 1995 it was a smash hit, selling 24 million tickets in America, almost three times that of *Licence to Kill*. Critical acceptance of Brosnan was largely positive. 'Brosnan makes a solid gold debut,' said *Variety*. The *Daily Mirror* offered, 'And while Brosnan has yet to displace Sean Connery in people's affections, other Bonds will soon be forgotten.' The *New York Times*, though, held mixed views: '*GoldenEye* unveils Pierce Brosnan as the coffee-bar James Bond: mild, fashionable, and nice in a very 90's way. Mr. Brosnan, as the best-moussed Bond ever to play baccarat in Monte Carlo, makes the character's latest personality transplant viable – not to mention smashingly photogenic.'

The production of *GoldenEye* was overshadowed by the ill health of Cubby Broccoli. And it proved to be the last Bond film he produced. He died in 1996, time enough to appreciate the stunning success of the film around the world and the acceptance of his new James Bond. More than that, Brosnan had nothing short of saved the franchise, evidenced by the release in 1997 of *Tomorrow Never Dies*, which was just as big a hit.

However, following the release of his third Bond movie, *The World Is Not Enough* (1999), Brosnan made it known that he wanted a longer gap this time between Bond assignments. The last few years had been hectic to say the least and churning out Bonds in quick succession made

it difficult for the actor to establish a body of work away from the franchise, which he hoped 'to give [him] longevity after the Bond train finally stops'. On the other hand, a financially ailing MGM/United Artists wanted a Brosnan Bond out in the marketplace as fast as possible, as it was the studio's only product making serious money.

Brosnan's original contract for three films had now expired, and while the actor hadn't ruled out the possibility of re-enlisting for more Bonds, his replacement killers were circling already and the rumour machine started up again, more so than ever before.

Dougray Scott was rumoured to be the Bond producers' first choice to replace Brosnan should the Irishman decide not to return and was to later claim that he was approached. Born in Fife, Scotland, in 1965, Scott had recently played the baddie in *Mission: Impossible 2* (2000) and admitted that the shadow of Sean Connery would weigh heavy in any decision to take on the 007 role. 'I'm very flattered that people consider me good enough to play James Bond. But I couldn't play that part any better than Sean did. To be honest I am not convinced I am suave enough so I doubt I would do it.'[30] A few years later in another interview Scott was asked what kind of James Bond he would have been. 'Scottish, manly. I think Sean Connery was phenomenal. He had a great sense of humour and I think I'd try and bring that to it. As well as the dangerous strong side.'[31]

The next candidate given credence by the press was another Scotsman, and at the time little-known, Gerard Butler. Swapping law school for acting, Butler's film debut was as Billy Connolly's young brother in *Mrs Brown* (1997), quickly followed by a minor role in *Tomorrow Never Dies*. Butler's breakthrough was playing Dracula in Wes Craven's 2000 take on the vampire legend and, although a box office flop, his charisma was clear.

It's interesting to note that the first two possible Brosnan replacements hailed from north of the border. Indeed, one Scottish newspaper, the *Daily Record*, reported in April 2001 that Barbara Broccoli was determined to have another Celtic Bond. It said she had fixed up a summer meeting with 32-year-old Butler to discuss the role. 'Gerard is one of the two people Barbara has appointments with,' a source said. 'They are meeting to discuss replacing Pierce after his final movie.'

The notion of Gerard Butler – 'the Scottish unknown', as the tabloids called him – was sound. Here was a relatively unknown actor that would

be able to grow into the Bond role and make it his own, as Connery had done all those years before. But the producers slammed the reports and just wanted the rumours to stop, complaining that their office had been inundated with calls all week. As far as they were concerned Brosnan was Bond for the foreseeable future. During an interview on Capital Radio in August 2019, Butler was to reveal that he did have a meeting with the Bond people. It led nowhere, just as well since the actor confessed that he wouldn't have liked being compared in the audience's mind with Bond actors of the past.

Other young actors 'hotly tipped' to be the next 007 started to be thrown into the mix, some with more credibility than others. Greg Wise seemed a good choice. He had a dark Connery look about him and had come to prominence in films like *Sense and Sensibility* (1995). 'It would be great to do it,' he said. 'The producers saw me, but I had these very unsexy sideburns for some period thing, which spoilt my chances.'[32] Even so, just a few days after the meeting a journalist from the *Sunday Times* got in touch asking if it was true that Wise was training with the SAS to get in shape for playing Bond. It wasn't.

And there was a report suggesting that Barbara Broccoli was planning to meet Colin Wells, a young British actor who had come to prominence starring in a short-lived revival of the 1970s television action series *The Professionals* in 1999. The truth was a little different, as Colin explains:

> As far as I can remember when we were filming *CI5: The New Professionals* a poll was taken as to who should be the new James Bond and apparently my name came out top, followed by Mel Gibson. *The Professionals* had quite a following in Australia and there was a large fan club for my character, so maybe the poll was taken in Australia; Mr Gibson being an Ozzie and all? I was told at the time that with one of the bookies I was the 6/1 favourite? My agent at the time did put me forward to play a 'baddie' in whatever film was to be made and apparently the message came back that they wouldn't see me: 'Just in case.'[33]

The Welshman Ioan Gruffudd was another potential candidate. The 26-year-old heartthrob, best known for his leading role in the BBC's *Hornblower* drama series, claimed it was all hearsay about taking over from Brosnan, but admitted he'd be thrilled to be asked. Back in

2000, Gruffudd did have the good sense to realise he was too young. 'Maybe we could go back in time a bit, back to his young life, back to his SAS training.'[34]

Gruffudd's name would be linked to Bond for the next few years. In 2011 he revealed how he believed all the rumours about him playing Bond started:

> I did a six or seven-page spread in British *Esquire* magazine with Pierce Brosnan on the cover, so inside they made the whole magazine Bond-themed. My fashion spread and interview I was dressed in fantastic suits, driving a fantastic car, and they said, 'This is our next tip for Bond.' I think people started taking bets on it from that point onwards! Whenever it comes up, my name is associated. I'll be honest, I did have a meeting with Barbara Broccoli, but it was around the same time that I'd literally just got cast as Mr Fantastic. It was impossible to tender for another franchise at the time.[35]

Less credible was Robbie Williams, who threw his hat into the ring when a close source of the singer told the *Sunday Times* that he was willing to take acting lessons and take a sabbatical from his music career for the chance of winning the role. Williams' 1998 album *I've Been Expecting You* traded on the Bond myth with its song 'Millennium' (using snatches of the *You Only Live Twice* theme) and video that saw the pop star dressed in a tux, driving an Aston Martin DB5 and strapped to a *Thunderball* jet pack. Any dreams Williams might have had were dashed when Eon casting director Debbie McWilliams declared, 'Robbie Williams, bless him, I don't think is quite what we're looking for.'[36]

Another high-profile candidate was Russell Crowe, having done a pretty useful quasi-Bond turn in the recent thriller *Proof of Life*. He was tough, utterly commanding, ruthless and not altogether unattractive – thus ticking every box on the Bond application form. Unfortunately, Crowe was already a superstar on his own terms after the success of *Gladiator* (2000) and journalists deemed him too fine and subtle an actor for the largely one-dimensional character of Bond. 'The last thing you need is a great actor,' wrote the *Guardian*. 'Look at the way the series atrophied during the reign of the highly intelligent Timothy Dalton.' John Glen, however, believed that Crowe was the 'only man'

who could take over the licence to kill. 'I see the Bond movies going on for another 20 years and I can't think of anyone better than Russell to fill his shoes.'[37]

If not Russell Crowe, then how about his fellow Antipodean, Hugh Jackman, who had come a long way from life as an Australian stage musical actor to be one of Hollywood's hottest new leading men? Former stuntman Vic Armstrong, the second unit director on the Brosnan Bond films, had just worked with Jackman on a movie called *Kate & Leopold* (2001):

> This was before the *X-Men* films, before anybody really knew who he was. I'd certainly never heard of him. But after returning home I went straight up to Pinewood and saw Barbara Broccoli. 'Look,' I said. 'I know Pierce has got one or two more Bonds in him but I've seen the next James Bond, Hugh Jackman, he's fantastic. He's got all the right characteristics, he's Australian, so he qualifies, and Australians have a great dry sense of humour that's very British. Plus, he's a good-looking guy, great character and great fun to work with. I think he's just magnificent.[38]

Whether or not Barbara took Armstrong's advice seriously, Jackman's name would certainly be linked to the Bond role over the years. 'But his career had advanced too much,' says Armstrong. 'He'd done *X-Men* and had proved himself to be a bigger star than somebody that needed to do Bond. It wouldn't have been a good career move. But back in those days he would've made a terrific Bond.'[39]

If we believed the press at the time, then Colin Firth, who it seemed wowed most of the UK's female population with his star turn as Fitzwilliam Darcy in the 1995 BBC drama *Pride and Prejudice*, was ready to jump at the chance of replacing Brosnan. A Bond fan (the first film he saw as a kid at the cinema was *On Her Majesty's Secret Service*), Firth was always hopeful that the role might come his way. In 2004 he discussed the possibility:

> I once said I'd have to see if they offered it. It got inflated from 'expressed an interest' to 'desperate for the part.' I think it's much

better to dodge that question. It's bizarre, something like Bond, because you'd probably do it at a price in terms of your other options in some ways. But it's such an enormous thing that I don't think anyone can really answer that question unless they have the offer on the table.[40]

That offer never came. In 2015 Firth was lamenting the fact that, as far as Bond was concerned, 'that ship has sailed',[41] and jokingly revealing that he took on the role of a spymaster in the *Kingsman* films because he was never going to play Bond.

It did seem that every young British actor with his own set of teeth was under consideration, proof that after four decades the old franchise was still managing to cast a bewitching spell over male actors in their mid-thirties. Ultimately, the producers quashed any rumours that a younger actor was being lined up. Brosnan would return as 007. But even as *Die Another Day* went before the cameras it didn't stop lazy journalists throwing new names into the mix, such as Christian Bale. After his pumped-up, chainsaw-wielding *American Psycho* (2000) turn, Bale had moved up a league and his screen persona appeared to be well suited to Bond. It was this performance that apparently caught the interest of Barbara Broccoli who was keen to offer him Bond. But was Bale ready to exchange indie cred for a mega-franchise? 'One part of him is really tickled, and the other part is like, will that typecast me forever?' said his press agent, adding that Bale was a Bond fan. In the end, of course, Bale signed up for another franchise – playing Batman. In an interview for *Esquire* magazine in January 2015 Bale revealed that he was never approached to play Bond.

Other tabloid favourites included Jude Law, who certainly had the looks and acting chops for the role, and yet another Scottish actor Iain Glen, who played the villain in the first *Tomb Raider*; a film that coincidentally also starred a certain Daniel Craig. And then there was Clive Owen, who came into the reckoning after his role in *Croupier* (1998). It seemed now that journalists were picking contenders solely on how good they looked in a tuxedo. Owen dismissed the rumours as 'media hype' and felt it imprudent to discuss such matters anyway since Brosnan was still Bond, and happened to be a pretty good one.

One of the more bizarre candidates was suggested by a former Bond. In April 2002 Roger Moore put his eldest son Geoffrey's name forward, insisting he had the right stuff, despite a lack of acting experience. Proprietor of successful London eatery Hush, Geoffrey had made only fleeting forays into acting. 'I think Geoffrey has the necessary charm, wit and sophistication to be 007,' said Moore senior, who originally suggested his son for the role to Cubby Broccoli in the early 1990s. 'He is much better looking than me and much more talented, so I think he would be perfect for the role.'[42] When interviewed not long after his father's intervention, Geoffrey said, 'I would grab the opportunity to do a test when Pierce Brosnan moves on.'[43] That test never materialised.

In a bid to shut up all this newspaper talk, Brosnan arrived at the Cannes Film Festival in May 2002 informing the gathered journalists that he was not ready to quit as Bond. But this game of speculation was just too much fun for the media to drop and there was one name that repeatedly cropped up – Clive Owen. The actor was currently appearing in Robert Altman's *Gosford Park* and even the esteemed director was asked for his view on the matter. 'People keep saying that he should be the next James Bond. I hope he doesn't do it because that would lock him into that role as an actor. But I have no doubt that he will be asked, because he has all that Bond-type stuff.'

On the eve of the premiere of *Die Another Day* that November, Brosnan confirmed he had accepted an invitation from the producers to make another Bond movie. 'Once you sign on the dotted line to play this role you become an ambassador to a legacy which is so long-standing in our culture. It is like no other role an actor will do.'[44]

Nothing very much of anything was heard until early 2004 when words such as 'opaque' were being bandied around by Brosnan regarding his status as to coming back for a fifth time. There didn't seem to be much happening on the production front either with the actor's hints of a creative paralysis affecting Eon regarding what direction to go with the new film. This lack of progress was grating for Brosnan and for fans.

News filtered out that the impasse had its origin in the negotiations over Brosnan's fee. His agents believed, with justification, that the success of the resuscitated Bond franchise had a lot to do with Brosnan and that his new pay cheque ought to reflect this. So, were all these press

stories about the hunt for a new, younger Bond part of a negotiating strategy? After all, back in the days when Roger Moore demanded a higher salary Broccoli would haul in a load of young hunks and start auditioning them.

Adding a new twist to the story, however, was one Quentin Tarantino. The maverick director made it known that he was interested in directing a period version of *Casino Royale*, an idea that won Brosnan's nod of approval.

Casino Royale would eventually be made, but not with Tarantino. Nor, most cruelly of all, with Brosnan.

8

The Blonde Bond Bombshell

Since the release of *Die Another Day* Eon had been very busy, overseeing the West End musical hit *Chitty Chitty Bang Bang* and developing a spin-off movie featuring Jinx, the Halle Berry character from *Die Another Day*, which ultimately was never made. With the back-to-basics *Batman Begins* in the offing and something very similar in the pipeline for the Superman franchise, Eon executives thought Bond himself had grown stale and required a reboot. They wanted the next generation's Bond, someone younger audiences could relate to.

But replacing Brosnan was going to be an almighty task. Even though his movies never reached the artistic plateau of Connery's *Goldfinger* or Moore's *The Spy Who Loved Me*, or even Dalton's *The Living Daylights*, Brosnan himself was always worth watching and his movies made money – serious money.

It wasn't long before the big gun candidates started to be rolled out. Jude Law came top of a reader's poll in the March 2003 issue of *Total Film*, finishing just ahead of Ewan McGregor and Christian Bale. Few of the star nominees bothered to give any credence to such poll results. Later that summer, reports about Iain Glen playing Bond hit the papers again and one sensed the actor was getting rather pissed off with it all:

> I really do find all this speculation very, very boring. I would be deeply flattered to be asked; who wouldn't? If I have to be honest I don't want to take on the mantle of Bond when the bandwagon might roll off the hill; though Bond does have a distinct history of reinventing itself. I

fear that there are a great many other very capable actors ahead of me in that particular line.[1]

Still, the name that remained most heavily linked to Bond was Clive Owen. Out of perhaps all the candidates, Owen suited the character best and approaching 40 he was the perfect age. Born in Coventry in 1964, Owen attended RADA, where his contemporaries included Ralph Fiennes, and cut his teeth in serious theatre. His good looks inevitably saw him cross over into television, notably as the yuppie hero of the early 1990s ITV drama series *Chancer*. Moving into films, it was 1998's *Croupier*, directed by Mike Hodges, that proved to be Owen's breakthrough. A recurring role in a series of glossy ads for BMW raised his profile even higher, as did his role as an assassin out to kill Matt Damon in *The Bourne Identity* (2002).

In interviews questions usually arose about the Bond rumours and he'd bat them away with good humour. 'I think it was something to do with wearing a tux in *Croupier* and driving fast cars in BMW short films,' he joked.[2] But Owen couldn't deny that speculation had recently intensified about him being the front-runner. Martin Campbell had just directed Owen opposite Angelina Jolie in the romantic thriller *Beyond Borders* (2003) and spoke about his brooding quality and that if chosen he would take the Bond franchise back to the Sean Connery era.

For a lot of commentators and fans it did seem that Clive Owen was somehow destined to take over from Pierce Brosnan – so it was something of a shock when he didn't and Daniel Craig was chosen instead. While praising his performance in Spike Lee's 2006 police drama *Inside Man*, the *Guardian*'s film critic Philip French noted that Owen was the actor 'who many think should now be playing Bond'. A profile of Owen in the *Independent* in August 2012 went by the headline: 'Clive Owen steps out of the shadow of James Bond.' And when the actor made his Broadway debut in 2015 in the Harold Pinter play *Old Times*, the *New York Times* Twitter account ran with: 'Some have speculated he should play James Bond. For now, Clive Owen's working on Broadway.'

It was an opportunity missed. Stories vary about why he didn't get the role: Owen turned it down, wanted too much money or was simply never approached. Certainly, having actors like Clive Owen linked to Bond inevitably gave rise to questions about whether, at 50, Brosnan was

getting too old to play the part. Brosnan himself was enough of a realist to know that any potential fifth Bond appearance would probably be his last anyway. The hope was to be allowed to bow out gracefully, in style. Of course, the age factor never troubled Roger Moore, and Brosnan didn't look like his age either. But movies and audience demographics had changed since the Moore years and the feeling was that, moving the franchise forward, Brosnan was less likely to win over a new generation of moviegoers, especially with the advent of the Jason Bourne films starring Matt Damon, an actor in his early thirties. It's a point of view that appears strange given the box office triumph of *Die Another Day*. Maybe that film's excesses, with its invisible car and ice palace that was lambasted by both critics and fans, had given the producers pause. There was no point in topping that film's spectacle, so instead of trying, why not take a step back. For the first time since the idea was originally mooted during pre-production on *The Living Daylights*, there was talk of returning to the early days of Bond – maybe even his first mission.

This news gave rise to consternation within the Bond fan community that a Commander in the Royal Navy couldn't and shouldn't be played by some freckle-faced youth. Nerves were further frayed when it was reported that Eon were focusing their sights on Orlando Bloom, who shot to fame as the elf Legolas in the *Lord of the Rings* trilogy and as Will Turner in the *Pirates of the Caribbean* franchise. It wasn't until several years later that Bloom went on record about a desire to play Bond: 'I grew up loving those films.' Promoting his 2017 spy drama *Unlocked*, directed by *The World Is Not Enough*'s Michael Apted, Bloom compared Bond a little bit with how Johnny Depp played *Pirates*' Jack Sparrow. 'That twinkle behind the eyes is what I always saw in both Sean Connery and Roger Moore, and what they did. And I love what Daniel Craig did, which was muscular and dynamic, and I think there's a combination of all of that that's really interesting.'[3]

A campaign began to keep Brosnan *in situ* and the Bond office was inundated with letters in his support. Such a public response left the producers in a real quandary: stick with the status quo, or change the franchise yet again? At the end of July 2004, in an interview with *Entertainment Weekly*, Brosnan finally answered the question that everyone wanted to know. 'That's it,' he announced. So, it was all over. 'We went out on a high and I look back affectionately at that time. But

I've said all I gotta say on it. Bond is another lifetime.' He then added: 'Behind me.'

It wasn't a mutual decision, as it had been with Roger Moore and that cosy chat with Cubby. He hadn't walked away from the role like Sean Connery got to do. The producers had decided to move on without him. Essentially, he was fired and it left a very bitter taste in his mouth. Brosnan had been willing and eager to do a fifth and final Bond, claiming that Barbara Broccoli and Michael G. Wilson had asked him to return, although no contract was ever signed. And then, somewhere in the negotiations, they changed their minds. One minute he was James Bond, the next he wasn't and he was looking at a door that had been slammed shut in his face. But that's show business, he rationalised; it had always been a dirty business.

The trick in finding a new Bond was casting an actor that could appeal to women's tastes while at the same time be respected by men. This is where Brosnan, like Connery before him, scored so highly. Any new actor also required real screen presence and charisma, along with some kind of track record as a performer. It was preferable if he was British, and in his mid-thirties, someone who could take on the role for ten years and really make it his own. It was a balancing act, not least in finding an actor at the right moment in his career. That disqualified established major players like Jude Law, Ewan McGregor and Hugh Grant. Never offered the role, Grant had already ruled himself out:

> I don't think that's particularly up my alley unless the films were reinvented and taken back to their original period – the late 50s and 60s – that would appeal to me. But I think Bond looks a bit weird in 2002. If you go back to the early ones the costumes, that general air of chauvinism, I think it works better. They don't have that Ian Fleming flavour that I really liked in the books anymore.[4]

According to *Parade* magazine, when they asked their readers in June 2004 to vote for who should be the next James Bond the overwhelming winner was – Adrian Paul, the British-born star of the American TV series *Highlander*. It was a name that hadn't previously been mentioned, although it wasn't the first time Paul was connected with the Bond job. 'I did an interview with the producers years ago,' he says. 'The first time

Pierce Brosnan was selected for the role and couldn't play it due to his commitments on *Remington Steele*, but I was too young then. So, it has always been something I thought it would be fun to play.'[5]

A Bond fan since he was a kid watching Sean Connery, Paul was both delighted and taken aback when his fans began an internet petition to have him installed as the new James Bond following the *Parade* magazine poll. 'This time around I wasn't interviewed or even contacted by the producers,' says Paul:

> Most of the buzz came from the general public. I think I have been put in an odd position. Most people think I am American or something in-between because most of the roles I have played over the years have been geared toward the American audience, so maybe that had something to do with it, or maybe they were going after bigger names for the role.[6]

Paul moved to America in the mid-1980s, having been born in London in 1959 and become first a model, then a dancer and choreographer in Europe. Shortly after his arrival in America he won his first TV role as a Russian ballet dancer on the mega soap *The Colbys*. More guest appearances on television followed and film roles before he was cast in 1992 in the role that brought him international fame: Duncan MacLeod in *Highlander*. The fantasy TV series, based on the film franchise, brought Paul huge cult celebrity status. However, if the 007 role had come his way, how would Paul have approached and played it?

> I always believed that Bond had qualities that set him apart from other legendary figures; a tongue in cheek humour, style, danger, panache and daring. There have been many Bonds with some of these qualities but not all of them. I think I would have looked into incorporating all of them. Every actor who has played Bond has chosen a different aspect of him and today Daniel Craig's take on Bond is really good, he's given the character a new twist.[7]

In interviews Brosnan spoke highly of the potential of Clive Owen and Hugh Jackman as Bond, but only truly endorsed one actor for the part: his co-star in three Bonds, Colin Salmon, who played MI6's Charles

Robinson. Salmon occasionally stood in as Bond in screen tests to audition potential actresses and, when Brosnan saw some of this footage, he made the remark that Salmon would make a great Bond himself. The press got hold of the story and ran with it and for a while Salmon was hotly tipped. But no serious discussions took place.

Other fresh names entering the arena included Australian Eric Bana who came to prominence with the savage film drama *Chopper* (2000) and had recently played the title role of Bruce Banner in *Hulk* (2003). Bana was quick to scotch the rumours, saying he wasn't interested and it wasn't something he had ever really contemplated. Bana claimed he only heard he was a contender while watching the evening news in his Melbourne home and thinking that he knew next to nothing about it.

Then there was Rikki Lee Travolta, a member of the famous Travolta clan, being John's half-nephew. Born in 1975, with a mixed heritage of Italian and American Indian, Rikki was a child star touring in theatrical productions before becoming a recording artist. Capitalising on his pop career, Rikki headed tours of Broadway classics like *Joseph and the Amazing Technicolor Dreamcoat* and *West Side Story*. Actually, this wasn't the first time Rikki's name had been linked by the press to the Bond role. In the late 1990s, the American entertainment channel E! reported that he was being considered along with Mel Gibson and Tom Cruise. 'That was a surprise,' says Rikki:

> Pierce Brosnan was in contract negotiations at the time to continue the role, which he did. So, my representatives and I just figured my name had been floated as a possible threat to motivate Pierce to sign. Mel Gibson, Tom Cruise, and myself – that's a three-tiered threat. No matter what Pierce would consider a viable threat to his claim on the Bond role, those three names seemed to cover the bases if the motivation was to get him to worry about being replaced so he'd sign without hassle.[8]

So, when the rumours about Rikki being considered to take over Bond reappeared in August 2004, his initial thought was that lazy journalists were just picking up on that old E! television report. However, the rumours kept building. At one point, bookmakers were taking strong bets – and with odds that he was not just in consideration, but a firm

favourite. 'That's the point all of my representatives started wondering what was going on,' says the actor:

> A rumour like that can start innocently enough, but it was going on for years and seeming to gain momentum every day. That's the point that we started noticing a lot of inaccuracies about me in the media. There was the rumour that I wasn't a member of the Travolta family – obviously not true, although we did have a good laugh about it. Then there was a rumour that I had turned down the Bond role and that was the only reason that Daniel Craig was offered the part. Completely untrue. Even if I had turned down the Bond role, which I didn't, I would never undermine another actor's time in the limelight by publicizing it – yet here were supposed quotes being attributed to me.[9]

Eventually it was discovered that an internet ring operating in countries like America, Japan and Britain was behind the stories. 'Crazy stuff,' says Rikki. 'What possesses people to start rumours like that is beyond me.'[10] The whole situation was resolved in 2007 when Rikki came to a settlement with the lead perpetrators who were required to pay for the hosting of a website dedicated to recanting all the rumours they started.

But it was Eric Bana's name that the media seemed the keenest to regurgitate. Reports in the UK press seemed to suggest that the actor had already been offered the part and was weighing up whether to accept or not. Putting the whole Eric Bana as Bond story to bed, the actor's press agent Staci Wolfe informed this author, 'Mr Bana was never considered, nor did he or his representatives have any discussions with anyone at any time regarding the role of James Bond. It's just an incorrect rumour that started on the internet.'

Years later Bana talked about his name being linked to the role and how he wouldn't have wanted to play it. 'It would have been too much fame for my head.'[11] With his debonair looks and physical presence, it's not surprising his name was mentioned for Bond – only he had no interest in becoming one of the most famous men on the planet. 'I'm largely able to do whatever the hell I want, whenever I want. It would have been a great loss.'[12] In mid-2005 Bana was filming *Munich* co-starring Daniel Craig and so was amongst a select few people who knew he was being courted to play Bond.

With the press always looking for a new contender, enter stage left Dougray Scott — again! Scottish paper the *Sunday Mirror* was adamant that it was merely a matter of time before Scott was named as the new James Bond after Ladbrokes announced that they had stopped taking bets on the actor following a flurry of activity. Days later, after the story was picked up by newspapers around the world, the *Daily Record* revealed that Scott's imminent casting had been a false alarm, confirmed as such by no less a personage than the actor's mother.

Now Brosnan made another intervention, suggesting his fellow Irishman Colin Farrell be given the part. Farrell himself didn't take it too seriously, guessing correctly that Brosnan was just messing with him, causing him grief. Which it did. Working at the time, he'd arrive on set every day with the crew humming the 007 theme and he was asked about Bond in every interview. As it was, Bond wasn't something that he wanted to do. 'There's certain things I don't want to de-mystify and that's one of them. I'll put my ten dollars on the table and watch Brosnan. I've been watching it since I was a kid. I don't need to go there.'[13] Maybe he realised that his bad boy image was something the producers didn't want to contend with, as was suggested in an *Entertainment Weekly* article. 'They won't come near me and they won't. Her Majesty's Secret Service wouldn't have me on the payroll.'[14]

So frenzied did the press speculation become that it did seem as if any British actor of a certain height and age seen walking into Pinewood Studios was immediately linked to the role. This is how Ewan Stewart's name was temporarily linked to the Bond job. Ewan was Scottish and a fine film, television and stage actor, but James Bond he was not, as he readily admits himself. So, why was his name in the frame for Bond? 'I never came within a million miles of being considered for Bond,' he says.

> There was a day screen testing five or six potential Bonds. It was a full-on affair directed by Martin Campbell playing a scene that comes early on in *Casino Royale* where Bond takes out a bent agent, played in the film by Malcolm Sinclair. But they needed an actor to play that part for the tests and I got the job. Then either through a misunderstanding or through the production office throwing me in the mix to muddy the waters the press got hold of the wrong end of the stick and had me down as in the running.[15]

Looking back now Ewan can't recall the actors that he was playing against and if they might have made effective Bonds; certainly, Daniel Craig wasn't amongst them. 'It's difficult to judge, those types of auditions are understandably nerve wracking, maybe they would have been good Bonds. But I can't imagine anyone being better than Daniel Craig.'[16]

The problem with all these endless rumours and names was that there was no natural successor among them. Back in the mid-1990s Pierce Brosnan was the obvious choice to succeed Moore; for years the public sensed that the Irishman would one day be cast as 007. Now, any number of candidates looked likely; no one stood out from the crowd the way Brosnan had done. It was a dilemma that stared the producers in the face every working day because hung on the wall in the office at Eon was a list detailing all the actors who had been put forward by the newspapers – seventy-two names in all.

That the Bond team were scouring every acting agency and actor's CV and past work is perfectly illustrated in a story told by London-born actor Tristan Gemmill, most famous for recurring roles in ITV soap *Coronation Street* and the BBC medical series *Casualty*, when he arrived for his Bond audition. 'I met the casting director and between us on her desk were piles of DVDs of Ewan McGregor movies, Jude Law movies and Hugh Jackman movies. I could barely see her over this pile of DVDs. So, what chance did I stand in that company?'[17]

The bookmakers were having a field day; William Hill announced that Scotsmen Ewan McGregor and Dougray Scott were leading the race, followed by Clive Owen, Colin Farrell, Hugh Jackman and Ioan Gruffudd. Less of a certainty was Tory MP Boris Johnson at a not unreasonable 500/1.

Sean Connery himself now gave his nod of approval in McGregor's direction, but also had a few words of caution. 'He should do it if he wants to do it. But it's a bit of a poison chalice. It is slightly more difficult than people realise because it has to look very comfortable and very easy and very cool.'[18] If Connery was backing a fellow Scot, then Timothy Dalton would back a Welsh contender, Ioan Gruffudd. 'He's got the right kind of mysterious look about him,' he said. 'I think he could be quite sardonic.'[19]

With such high-profile contenders filling column inches, there entered a complete unknown: Roger Barton Smith, who, despite no

previous acting experience, ended up spending £200,000 in pursuit of the seemingly impossible goal of becoming James Bond. It's an extraordinary chapter in the search for Bond and a testament to one man's hopes and dreams.

Born in Sligo, Roger Barton Smith was a successful locksmith with his own business, making loads of cash, but working every hour God sent; he was burning himself out by his mid-thirties:

> I needed to get out. I had five bad accidents, including three car crashes, and every accident was getting bigger and bigger; it was like somebody was tipping me on the shoulder saying, you're not listening. The final straw came when I was moving a safe out of a first floor window and it got stuck and so I pushed it and went out of the window with the safe and landed in the street below on a mobile crane.[20]

Luckily, he landed on the only safe area, a flat bit of steel between the turret and the mobile cab. Still, he was left unconscious, broke his back and lay in hospital for a week. 'So, I decided there and then that I had to change my life.'[21]

Leaving the business, Smith looked for a fresh start and a big challenge and found it in the burgeoning Irish film industry. By the mid-1990s a lot of Hollywood companies were filming in Ireland because of the tax breaks. 'That's it, I said, I'm going to become a movie actor. It was the biggest challenge I could find.'[22] Smith started by getting extra work, learning the ropes and how to perform in front of a camera. Then in 1998 he heard about an audition for a new television series called *The Ambassador* starring Pauline Collins:

> Being on a movie set I learned that if you wanted to get the part you dressed for the part, so I went in dressed in my suit and got the role of the ambassador's driver. And one day on the set the director's assistant saw me in my suit and said, 'You'd make a great Bond.' I was stunned. 'You must be joking. Pierce Brosnan is Bond.' She shook her head, 'Yeah, but they're going to be looking for a new guy, he's only got one movie left, and my dad was a cameraman on one of the Bond movies and I think you'd make a good Bond, you've got a totally different look, and you could pull it off.'[23]

Smith didn't take the comments seriously until a few weeks later when he donned his suit again to help a friend out in a local nightclub working on the door:

> At this club they had pictures of all the Bond actors hanging on the wall, and one of the guys turned to me and said, 'We're going to put you up there because we're calling you Mr Bond.' I said, 'No!' But then I thought; if these people can see it, maybe all I've got to do is plant the seed in the producer's head. I'd been in the sales business myself, and I thought, all I'm really doing is selling myself, I'm the product. So the more I thought about it, the more excited I got. If I could just get the Bond producers to consider me for the role, I might actually be in with a chance.[24]

First Smith had to prove that he had the right ingredients, that he possessed real on-screen charisma. Instead of waiting for the perfect part to come along, he decided to create it himself. Along with a director friend, Smith came up with an idea for a short film called *Black Velvet* based around a tiny Irish village outwitting an American oil company. 'I raised £35,000 from some of my rich friends and also put £20,000 of my own money in.'[25] The film was shot over four days in Sligo but Smith had wildly underestimated the costs of making a movie, even a short one:

> It was eating money like a parking meter and as the costs spiralled my savings dwindled. I took out a bank loan of £10,000 but when that money ran out my dad came to me and said, 'I can give you your inheritance money early to finish the film.' I had to keep going. I had to have something to show for all that money and hard work.[26]

When the final bills came in Smith had spent £120,000, but at least there was a movie to show the Bond producers. 'It's the world's most expensive business card, I joked.'[27]

Black Velvet premiered at the Galway film festival in July 2002 but never found any commercial success. Smith, however, was not about to give up on his dream to become 007 and sent his CV in September to Eon. A month later he received a non-committal response.

Remembering how he'd won the role in *The Ambassador* TV series by dressing for the part, Smith knew that's what he needed to do now. 'I had to actually become James Bond. I went out and bought every Bond movie and watched them all and learnt his mannerisms, his poses and his lines. I bought books on Bond and absorbed every fact and figure.'[28]

The next step was even more ambitious: hiring a professional photographer and paying for a three-day trip to Austria for an elaborate photo shoot:

> I called this ski instructor I knew and said, 'I'm coming over with a photographer, I need a blonde and a brunette, a BMW sports car, a snow mobile and some prop guns,' and he said, 'What!' I also hired a ski instructor to teach me extreme ski jumps and stunts and mocked up an action sequence scenario with armed villains closing in on us. We took something like 1800 photographs in Austria and chose the best six to send to Eon.[29]

Pretty soon the local press in Sligo picked up on Smith's quest to become 007:

> On the plane over to Austria I asked this photographer, 'You must have done some strange jobs in your time.' And he said, 'This is the maddest. You're bringing me to Austria to do a photo-shoot to pose as Bond, it's nuts. In fact, this is so mad there's a story in this.' So, when he got back, he rang a journalist and then I got a call from this newspaper guy saying, 'I've got to come and see you.' And the whole thing just took off and grew and grew.[30]

In the end Smith found himself in the Irish national newspapers, interviewed on Irish radio, in tabloids like the *Sun* and the *Star* and in magazine features syndicated round the world. 'At first people took the piss, but when they saw how serious I was and checked out the pictures on my website, the laughing stopped.'[31]

Right from the very beginning Smith was never less than realistic about his chances, that it was only a one in a million shot. Even so, it was wise in any case to formulate a strategy. He remembered a story about a

friend's father whose company was holding interviews for a job vacancy and twenty people showed up. By the time of the eighth candidate, they'd more or less picked the person for the job, until a note came under the door that read: 'Don't give the job away until you've talked to me.' And this intrigued them, who is this guy, they asked. And it was the last person on the list, and he got the job:

> So, I took that concept and I got a card with a picture of Sean Connery and I wrote across the top – 'Don't give the job away until you've talked to me' – and I sent it to Barbara Broccoli. I'd nothing to lose. I also wrote – 'I hear that you haven't chosen anybody yet. Connery was virtually unknown, why not go back to an unknown, you can mould me any way you wish.'[32]

Expecting not to hear back, four days later Smith got a phone call out of the blue:

> This guy said that he wanted to come and see me, and I thought, that's very strange. I told a friend and he said, 'This guy's a scout.' And I firmly believe still this man was a talent scout. I mean, if you're Barbara Broccoli and you got a note like this from a guy that's been persistent and he's got a movie under his belt, and he's not a nut bag, maybe you should see him, but to keep a distance you send somebody else.[33]

A meeting was arranged, and the guy showed up with a colleague. The discussion centred on making a low budget movie in Ireland; the guy had heard about Smith's film and wanted help and advice:

> On the way home afterwards I went over the meeting in my head; his pal had said nothing the whole way through but watched me and listened to me. I think it was my audition. At one point I stood up and said, 'I'm going to get lunch, do you want anything.' And this guy said, 'I'll get lunch because I want to be able to say I bought James Bond his lunch.' I thought afterwards, that was a strange throwaway line, why would he say that. And then the day they chose Daniel Craig this guy rang me up and said, 'Listen, they picked the wrong guy. I had my money on you.'[34]

Smith knew that persistence was the key: 'Sometimes you've got to go to the last mile, and then you go to the last hundred yards of the last mile, the last metre, the last foot, the last inch, and then you give up. But you never give up until you've gone to the very end.'[35] He was also aware that casting offices are inundated day in, day out with 10x8 black and white stills of actors, most of which end up in the bin. 'I knew that visual impact was important, you had to catch the eye.'[36] With that in mind Smith hired a friend's Lamborghini and had another series of shots taken with the rolling hills of Sligo behind him:

> It was coming up to Christmas and I had this photograph of me with the Lamborghini blown up to three foot high, and four foot long, and I wrote across it: 'To Barbara and Michael, best wishes, have a good Christmas Roger,' and sent it by courier to their production office.[37]

In April 2004, sensing time was running out, Smith put his plan into its final stage, spending £4,000 compiling four separate portfolios that he sent to Eon over four separate days using four different couriers to make absolutely sure they arrived safely. Each was filled with photographs of him in various poses, including those from a new photo shoot with two professional models next to the brand-new Aston Martin. He also enclosed a DVD copy of *Black Velvet*. 'I explained in my covering letter how I was perfect for the lead role in *Casino Royale*. How I was a fresh face.'[38] Two weeks later Smith received a reply from Eon: 'Thanks for contacting us. We will forward a copy of your CV and DVD to our casting director for consideration.' Smith couldn't believe it. 'I read it again. They were actually taking my application seriously.'[39]

When a few months later Brosnan confirmed he would not be returning as Bond the speculation in the newspapers was wild. 'And as each of the big names was ruled out, I felt my excitement grow. Maybe they were going for an unknown. Maybe I really stood a chance. I sent out another copy of my portfolio to director Martin Campbell. All I could do now was wait.'[40]

Alas, in the end, it wasn't to be:

> I was disappointed. I'd wiped out my savings and inheritance and spent over £200,000 in my quest to become 007. But I've no regrets. I don't

regret a minute, or a single penny. I felt happier broke than I ever did when I had money. I'd taken a chance and chased a dream. How many people can say that they got short listed for Bond, played all the parts, met the girls, had the gadgets, rather than sitting in a boring old office.[41]

Whether or not Smith's name was ever mentioned in the upper echelons of Bondom, one will never know, but in November 2004 the numerous players involved in casting the new Bond held their first meeting in London. This included Amy Pascal, chairperson of Sony Pictures, which had recently purchased MGM. They were unable to reach an agreement, with no clear candidate. It's always the way, of course, bringing a new actor into the role you invariably have to cast against the previous incumbent, as Bond screenwriter Neil Purvis knew. 'Pierce Brosnan is a very hard act to follow, so you need something very different. You don't want to have Pierce-lite.'[42]

A new year, 2005, and a new favourite. Hugh Jackman was now both Ladbrokes' and William Hill's sure bet to become 007. All this came amidst an apparent rift between the Broccoli family and Sony. Which actor takes on the role, so said these reports, could well depend on who emerges victorious in the power struggle behind the scenes. If the Broccoli family won, audiences could well see a relatively unknown actor, while if the studio had their way it would be a top star in the role. The planned release of the next Bond film had already been postponed from 2005 to 2006, and Sony's recent takeover of MGM only added to the uncertainty.

Being the bookies' favourite generally wasn't the best barometer of the truth. William Hill admitted that it wasn't unknown for celebrities and their agents to bet significant sums to either put them in contention for major roles or simply to raise their profile.

Punters' money was now being wasted on Dominic West, whose lead role as an American homicide detective in the HBO series *The Wire* had raised his profile considerably.

West did express an interest in the role. 'I've always liked Bond and I thought I would do it better than anyone else. He's pretty much a superhero, and I think he should be more of a soldier.'[43] The actor later ruled himself out after revealing that he did go up for the role:

'Apparently all of the other candidates were turning up in a tux – as if dressed in full-on James Bond garb. So I went to my audition in an old pair of jeans and a tatty T-shirt. I thought I'd try to be different and go for the nonchalant look.'[44]

Like West, James Purefoy had the rugged looks and suave sophistication for Bond, looking equally good in a suit or combat fatigues. As a young actor, with experience in the Royal Shakespeare Company and a few roles on television, he was interviewed for *GoldenEye* but lost out to Brosnan. Gaining more experience and with roles in big movies like *A Knight's Tale* (2001) and *Resident Evil* (2002) he found himself back at the offices of Eon. 'The room is very Bond-esque – wood-panelling, big table. You sit there trying to be as serious and panther-like as you can, just letting them look at you.'[45] Lots of questions were asked, one in particular was how Purefoy would go about improving the 007 franchise, what changes would he make. 'I was eight minutes into my soliloquy when I noticed they were all staring at my legs. Being a ludicrous, overexcited boy of 42, I was kicking them like a child. I realised there was no hope.'[46]

Purefoy faced something of a quandary when it came to maybe getting the role. He had an enormous fondness and affection for Bond movies. The first film he ever saw at the cinema was *Live and Let Die* with his dad. They sat through three performances of it one after the other. Maybe it was the history and the sheer enormity of the franchise and not wanting to be the one that maybe screws it up. There was also the unwelcome media attention. Yes, it was something he would love to do, but can you be James Bond and still live the kind of life you lived before? It's too life-changing. Years later Purefoy had had time to mull over in his mind his two close encounters with Bond, this spectre that hung over his career. 'There have been jobs, Bond being one of them, where you get very close to getting something and then you start pulling away because the ramifications of what would happen if you got it become a little troubling. The closer I got to Bond, the more I wasn't really sure.'[47]

Julian McMahon also revealed that he was on a short list to appear in *Casino Royale* and met with the producers. The Australian was then best known for the American TV medical drama *Nip/Tuck* and for playing Doctor Doom in the *Fantastic Four* franchise. Young British actors were being sought too, which made sense if this film was going back to Bond's

inaugural mission. Scottish actor Sam Heughan only had a few television credits to his name when he was asked to see the casting director at Eon's office:

> Afterwards, I was invited to head up to the next floor, where producer Barbara Broccoli was waiting for me, like M, sitting in a leather chair across a large table. A replica gold revolver served as a centrepiece in front of her. The director of *Casino Royale*, Martin Campbell, was also there.[48]

It was a very casual meeting. They spoke a little about Scotland and about Bond, then Heughan was asked to read a scene. It was all over very fast, just as he sensed wet patches of sweat beginning to form under his leather jacket. Heughan knew it was a long shot getting Bond, and that at his age, just 25, he was too young and probably not ready for it:

> When I learned the role had gone elsewhere, however, the feedback I received boiled down to the fact that I wasn't edgy enough by nature. I'm always keen to take on criticism so I can improve as an actor, but the suggestion seemed to be that I lacked this quality in my real character. I could not see what bearing that would have on playing the role.[49]

It is strange that the makers should see this as an issue, that just because an actor doesn't possess a certain characteristic that he would be unable to realise it on the screen. Heughan later found fame in the role of Jamie Fraser in the historical fantasy series *Outlander*.

When the Welsh actor Matthew Rhys was asked to see the producers, he was a few years older than Heughan, and with more experience, but still to establish himself. When he was asked to show up at the Mayfair headquarters of Eon in a dark suit he discovered he was not alone. Far from it, he recognised several familiar faces in the antechamber waiting for their turn. 'We all sat there sweating and making terrible small talk.'[50]

When it was Rhys' turn, he walked in and found himself in what he described as an intimidating office. There sat the kingmakers, behind a desk, with all the power to change your life in a second. Rhys tried to stay calm and collected, while at the same time channelling a bit of James Bond. He was asked questions like if he had read *Casino Royale*.

He had. Then they threw a curve ball at him, a question he hadn't anticipated – 'What would you do differently with Bond?' That stumped him. Was it a trick question? Were they expecting someone to come out with a totally radical new approach? 'As a terrible joke I said, limp? It went very quiet. So, then I thought I would double down and said, eyepatch? It lasted about 30 seconds after that. There was a quick, terse, thank you so much for coming in, and you're like, oh, that was my Bond moment.'[51]

One interesting thing Rhys remembered being told was the proposition that in the new film Bond was basically coming straight out of college. Another young actor was also told this at his interview. Rupert Friend was 22, and just out of acting college, when he did three high-profile pictures back-to-back: *The Libertine* (2004), *Pride & Prejudice* (2005) and *Mrs. Palfrey at the Claremont* (2005). Word arrived at his agents that the Bond people wanted to talk to him about their plans to reboot the series. 'Obviously I've watched them growing up and just love all the actors and all the movies,' said Friend.[52] The conversation went along the lines of if the screen test was to go well, they would sign him up for three pictures. That's when Friend stepped back a little bit and told them:

> 'I just feel at this point in my life and career, I'm too young, I don't have the experience, I don't have the acting chops and I don't have any of the hard knocks – emotionally, psychologically, physically – that a great Bond should have. So, I'm gonna politely decline.' That was probably a bit of an eyebrow raise for them.[53]

Eon casting director Debbie McWilliams has spoken about Rupert Friend, that he did an excellent reading and that in her opinion he was a strong contender. But looking back years later, Friend thinks he made the right decision:

> Because back then, not only could the part have sort of eclipsed me, I felt like the part was bigger than me as an actor or even as a person. That it would sort of swallow me up and I might sink the franchise, or at least be the worst Bond that ever lived. And that was just not an option, because I love the franchise.[54]

Besides looking at the new crop of up-and-coming British actors, the producers, as they had done before, thought outside the box and began a search for people who were not necessarily an actor first, but could bring off what was a very physical role. Ex-boxer Gary Stretch followed in that line of hard men. After all, Connery was a boxer in the navy and bodybuilder, Lazenby was in the Australian Army, in the early 1970s Eon reportedly looked at recruiting from the army, Bond candidate Sir Ranulph Fiennes was in the SAS, and more recently they had interviewed boxer Glenn McCrory. 'I think Bond is a bit of a man's man role,' says Gary. 'Or it should have been. Fleming wrote it that way.'[55]

Born in 1965 in St Helens in Lancashire, Gary was a former British and WBC International Super Welterweight Champion, known for his good looks and powerful punching power. During his boxing career, which included a head-to-head clash with Chris Eubank, Gary's official pro record was twenty-five fights, twenty-three wins. Those good looks quickly got him noticed and he was asked to participate in advertising campaigns, mostly in America, for Versace, Hugo Boss and Calvin Klein. 'They earnt me more money than I was earning from boxing.'[56]

In the early 1990s Gary quit the boxing game. He was in his mid-twenties and facing an uncertain future. He had a friend out in Los Angeles who was an actor and was asked to come over and visit. Picked up at the airport, his friend had to go to an audition on the way home so Gary waited for him in the car:

> And I saw an elderly lady getting into a confrontation with a couple of guys regarding a parking space. And I helped her out. We ended up talking and she thanked me and asked to have lunch before I left town. She gave me her name and number. I got back in the car and when my friend returned from the audition, he noticed the card and said, 'Where the hell did you get that number?'[57]

The lady turned out to be Janet Alhanti, one of the most respected acting coaches in the business who had worked with everyone from Brando to Burton. Janet was semi-retired and didn't take on many new students, but Gary managed to wrangle his friend an interview with her.

Gary went along with his friend for the interview but saw that it didn't go well. At the end Janet asked a question, one that had no right or wrong answer. 'What's the difference between love and lust? Tell me in one sentence.' Gary's friend proceeded to talk for nearly twenty minutes on the subject before Janet shut him up. Looking at Gary, she asked him the same question. Gary shook his head. 'I don't have an answer. I don't want to be an actor.' She pressed him, so Gary answered. 'With love you give, and with lust you take.'

That night Janet called Gary to say she wasn't taking his friend on as a student. 'But you're very interesting. And you can't learn to be interesting, Gary. You either are or you're not.'

Gary still had no intention of being an actor but a few days later picked Janet up at a small studio in Hollywood for their lunch date. Sidney Poitier happened to be taking a class with Janet; they were reading a poem, so Gary sat down at the back. 'It was the most beautiful thing I've ever seen. And I sat for an hour and I laughed, and I cried.'[58] Deeply moved, Gary told Janet over lunch that he wanted to be an actor. 'Start Monday,' she said. And he worked with her for twenty years.[59]

Gary got an agent and started to pick up work. His breakthrough came when he played a gangster in Shane Meadows' cult thriller *Dead Man's Shoes* (2004), and when Oliver Stone cast him alongside Anthony Hopkins, Colin Farrell and Angelina Jolie in *Alexander* (2004). Then the call to meet with the Bond producers in Los Angeles arrived through his agent and he went to the MGM offices in Santa Monica:

> There were a hundred Bonds in a room, then it went down to 20, and then down again. They kept bringing us back, and then when I finally went in I was pretty much on my own in a couple of the meetings. It was an interesting and fun process. Some of the meetings were readings from the script, which was filmed, some were just interviewing you, getting a sense of who you are and what you're about.[60]

In that regard, Gary made sure to be himself, and came dressed in casual gear, stuff that he would normally wear:

I remember, when I went to the first audition everyone was in black suits and rollnecks, they looked like a hundred penguins. I just went as myself. I think what you wear and the way in which you approach it, they get an essence of who you are. You can wear a uniform; it doesn't mean you're a soldier.[61]

To prepare, Gary read a bunch of the Fleming books and got a take on the way he wanted to approach the role. Growing up Gary had been a big fan of a series of paperback pulp novels by Don Pendleton called *The Executioner*, which features a tough, American version of Bond who fights organised crime and terrorism. 'He was a dirty Bond. Bond drinks Martinis shaken not stirred, the Executioner smokes a bit of weed.'[62] Gary wanted to bring a bit of that realism and toughness to his portrayal:

Bond, if you read the novels, he's dangerous, it's if all else fails they bring him in. I think he has to have an edge and I think there's a sense of humour about it. What's interesting about the Bond films is the comedic element. There's some violent stuff in Bond but you never look upon it as a violent film. He'll shoot a baddie with a speargun and say, 'I think he got the point.' That kind of humour takes away from the violence. It makes an audience a little more comfortable and takes away from the nature of what he's doing. It's about getting the job done and he does it in style. There's a real style to Bond.[63]

That's something that Gary found slightly missing in the Daniel Craig movies:

Daniel is a great actor, but for me he was never Bond. As much as I really like what he did as an actor, I just see Bond different physically. And also the way it was written. I don't know why people want to change something. If it works, why fix it. And Bond had certain qualities that were necessary. If you read the books it was very specific what Fleming wanted, so why change it, you become more important than the writer as a producer, you want to do your thing. Connery, Roger Moore, and Pierce Brosnan all brought a different element to

the character, but they all had a very similar something, and I thought that Daniel jumped out of that.[64]

Gary was genuinely surprised that he was even on the Bond producers' radar, having only recently begun his film acting career:

> I think maybe they wanted to take a look at me because I had an edge, and that comes naturally from the fight game. I have a certain confidence. And I think the look was the right look. I had a few qualities that were probably interesting for them. Looking back, did I have the levels of an actor, I don't know. I was pretty new and inexperienced to a degree. I was just flabbergasted that I got an opportunity to go through the process.[65]

The press back in the UK got wind of Gary's audition, reporting that he was under serious consideration and had been called back several times. In the end, though, he wasn't selected.

> Apparently, and this is what I heard back from my agent, the reason being was that I was too similar to Pierce Brosnan and they were trying to go different. That was the feedback I got. Barbara had her own vision. I never felt in my heart that I would get James Bond. I felt at the time I was a bit young. I think Bond should be in his forties. An experienced man who's been around. Seen it, done it. But I would have loved the opportunity. It was fun to be involved. The producers were lovely people. They made the process really enjoyable. They were very pleasant and very kind. And I learnt a lot just from the experience. When you do that and then you go for an audition for a little movie then it gives you a lot more confidence.[66]

It was now that Daniel Craig was linked with Bond in the press for the first time, his candidacy taking most people by surprise. The *Sun* newspaper revealed that the actor had been asked to take over from Brosnan in the next three films. Not unnaturally Eon refused to comment on the reports. When word filtered back to Craig that he was under heavy consideration it gave him pause. Bond was no ordinary film role; he was an icon and how do you play an icon? And yet he was fully aware that

to dismiss Bond out of hand could be a decision that haunts you for the rest of your life.

Meanwhile other names were jockeying for space. Australian Alex O'Loughlin was another young candidate, having only made his first film in 2004, the drama *Oyster Farmer*. In Los Angeles he met with Martin Campbell at his office at Sony Pictures and was asked to fly to London for a screen test. He was put up at a plush West End hotel, looked after regally, fitted out at Hugo Boss for a tuxedo and had his hair cut. The test itself at Pinewood was very comprehensive. O'Loughlin thought he handled it all professionally and did a good job. He didn't hear anything for a couple of months. It was while making a film in Vancouver and having breakfast in a cafe that he spotted a fellow customer reading a newspaper with a large photograph of Daniel Craig and the headline: 'Bond Revealed'. Disappointed, O'Loughlin nursed a bruised ego for a few weeks but was content that the experience was a great journey. He later found fame on television as the star of the revamped *Hawaii Five-O*.

New Zealander Karl Urban was best known for playing Éomer in the *Lord of the Rings* franchise when he had a meeting with Barbara Broccoli that went well enough for him to be asked to do a test. Unfortunately, he couldn't do it due to prior filming commitments. 'I'm actually pretty grateful I didn't because I think Daniel Craig did such an extraordinary job and I couldn't have imagined a better Bond.'[67]

It was around this time that, according to reports, Rikki Lee Travolta was ushered from the Chicago set of a television series and flown to London for a closed-door screen test. 'It was not, to my belief, for James Bond,' he says. 'Unless the producers were doing their tests with a fake name for the project. Since that is not unheard of, of course, there is always that chance. But I was told it was a different role entirely. The dialogue was very close to a traditional James Bond scene.'[68]

As a follow-up to this story, Travolta's publicist announced that there had been a massive groundswell of grassroots support for their client becoming Bond as evidenced by a report that his fans sent him over 135,000 copies of the *Casino Royale* novel. When a few sceptical journalists asked for proof, Travolta's PR people announced that all those books had been donated to charity. The truth of the matter, as always, was very different. 'The grassroots campaign of sending copies of *Casino Royale* to me is a bizarre mix of fact and fiction,' says Rikki:

The original report was completely fiction. I wasn't even represented by the agency that was reported to have received all those books when the rumour started. However, after the report hit the newswires it seemed to inspire a whole legion of fans to action. As a bizarre twist – after that rumour was first reported we did, in fact, start receiving a few thousand Xerox copies of the cover of *Casino Royale* with letters urging me to play James Bond. If only all those thousands of fans had sent their pleas to the producers and not to us, who knows?[69]

Who knows indeed and Rikki admits that, not unnaturally with all those rumours flying around, it did cross his mind at one point what he would do if he ever were entrusted with carrying on the James Bond legacy:

I think to do the role justice you have to really go back to the original novels and bring the characteristics in the books into the character. The scripts as they are today, to stay viable and create a profitable picture, have to ignore certain aspects of the legacy of the origins of Bond and concentrate on what the modern audience wants. The job of the actor, then, is to create the story and character beyond the script. That's where Shakespearean study can be so amazingly advantageous. In Shakespeare you have to make the audience understand the meaning of what you are saying, even if they don't understand the words. The same is true with playing a classic character under the restraints of a modern script – as an actor you have to convincingly convey what isn't in the script. Who is this man – James Bond? Why is he like this? What does it feel like to kill a man and then go about business like nothing has happened? How does this man's past sins prevent him from obtaining true romantic intimacy with a woman beyond the physical? Does he hide the portions of him that are damaged or does he wear them with a badge of honour?[70]

With so many names in the frame, Daniel Craig gave an interview to *GQ* magazine in October 2005 (in which, ironically, he shared the cover with a certain Pierce Brosnan), that threw more light upon the possibility of his casting. 'I'd love to play him,' he said. 'But I'm not sure it's possible.' The problem, as he saw it, was that much had changed since Brosnan revitalised the franchise in the mid-1990s; the world had become a much more cynical place. 'Spies are fucking nasty cunts, and I feel that that's

the way they have to go. And I don't know how you would do that. I don't know how you make it so you fear for that man's life. Because why worry? It's James Bond! He's Superman, for fuck's sake!' In the same interview Craig confessed to play-acting as James Bond in the school playground; 'every fucking kid I know played James Bond'.

Martin Campbell shared Craig's misgivings that the Bond films had 'gone off the rails', and he had been brought back on board to revitalise the franchise once again. He told the producers it made sense to return to the character's literary origins and the books. 'We settled on a more fucked up character with a dark streak in him.'[71]

Campbell confirmed, too, that Craig was on the final short list that consisted of three other actors: Henry Cavill, Goran Višnjić and Sam Worthington. All of them were to undertake screen tests and the new 007 would be named soon.

Višnjić was Campbell's own suggestion, after the actor impressed him with his audition for the *Zorro* movie he directed. Višnjić was born in 1972. A trained paratrooper, Višnjić enlisted in the Croatian Army when war erupted in the Balkans. Once hostilities were over, he dedicated himself to his chosen profession, acting, and in 1997 director Michael Winterbottom cast him in the highly acclaimed movie drama *Welcome to Sarajevo*. Voted as one of *People* magazine's 50 Most Beautiful in 2000, Višnjić's popularity grew yet further after landing a role in the American medical drama series *ER*.

Višnjić was soon ruled out as the new James Bond; now only three remained to battle it out to win the fated role: Daniel Craig, Sam Worthington and Henry Cavill.

Sam Worthington was born in 1976 in Godalming, Surrey, and moved with his parents to Australia when he was young. Seen very much as a rising star, he made his film debut in 2000's Australian dance movie *Bootmen*, and followed that with a role in the Bruce Willis drama *Hart's War* (2002).

At first Worthington wasn't interested in doing the Bond audition. They had seen tapes of his work and been impressed but repeated phone calls met with a blank refusal from the actor. He didn't think he had anything to offer and he thought that it made no sense why they wanted to see him. Finally, he relented and flew to London. To prepare for the test he read all of Fleming's novels and saw every 007 film he could. He

recalled Barbara Broccoli coming into his room as he was getting ready, to personally supervise how his hair should look.

The test involved wearing the obligatory tuxedo and acting out a scene from *From Russia with Love*. 'You walk in, there's the girl in the bed, you charm her. I could get the killer of Bond down; I just couldn't get the charm. I couldn't charm her. The suit didn't fit, man.'[72]

Another concern was the accent. 'If I do an Australian, I'm gonna be the next George Lazenby,' he said. So, he tried British. 'It was awful. I sounded like Dick Van Dyke from *Mary Poppins*. I remember Martin Campbell going, "Just do your normal voice. It's all cool man." I had no idea what I was doing.'[73]

After the test Worthington was invited to dinner with the Bond producers and, even though he lost out on the role, just being around Barbara and Michael G. Wilson, watching them in action, gave him an insight into the making of a successful franchise that was to prove invaluable when he came to star in *Avatar* (2009):

> They are so detailed and meticulous. They are protective and passionate about this series. And what I learned is that you listen to these people. It's the same thing with James Cameron. He's done all the research and there's nothing you can't ask him that he doesn't have an answer for.[74]

With Worthington out of the running only two remained. It was now between Daniel Craig and Henry Cavill. Born in 1983 in Jersey, Cavill, despite his youth, had already come extremely close to playing another iconic fictional character – Batman. Prior to the Bond test Cavill auditioned for the lead role in *Batman Begins*. For a while it looked like he may have won the cape, but then lost out to Christian Bale.

Cavill had appeared in the 2002 remake of *The Count of Monte Cristo* and done some TV work but had no profile at all. According to Martin Campbell, Cavill excelled at his Bond test. 'If Daniel didn't exist Henry would have made an excellent Bond,' said the director. 'He looked terrific, he was in great physical shape, very handsome, very chiselled. He just looked a little young at that time back then.'[75] Cavill was 22.

In interviews Cavill has been philosophical about losing out on Bond, realising that he probably wasn't ready at the time. In the end he didn't

need Bond: after landing the role of Superman, he has since carved out a highly successful career – in part thanks to that Bond audition: 'It definitely gave me a boost to my career. That was the key element of it.'[76] After going to audition after audition without much luck, when word got out about how close he came to playing Bond, doors suddenly began to open for him.

In the final reckoning, it came very close between these final three candidates. Maybe the age factor played an important part in the decision-making. Worthington would have been 30 years old in his debut James Bond film, Cavill 23 when *Casino Royale* opened. Craig was 37. If anyone realistically fitted the 'younger' Bond brief without being too young or too old it was Worthington. When Craig eventually got the nod the disparity in age between himself and the other two finalists suggested that there may have been a difference of opinion on how far to go with the young Bond angle.

Or was Craig chosen simply because he was the best of the lot – and the more experienced? According to Bond composer David Arnold, it was Craig's audition that stood out from the other two. 'That was the one who really made you sit up. But I think Barbara had her eye on Daniel for a long time.'[77]

Barbara Broccoli indeed had her eye on Craig for quite some time, and his work in things like the BBC's *Our Friends in the North* and especially his star turn in the British thriller *Layer Cake* (2004). To her he had an incredible presence and was a fascinating combination of character actor and leading man. Her impression of him was only bolstered after he came in for a meeting and she became his number one advocate. 'He's an actor who defines his generation of British actors. He is charismatic, versatile and sexy.'[78]

Craig tested brilliantly and watching that footage today it's easy to identify what was so appealing about him. He was his own man. There was nothing that harked back to any of the other Bond actors. He didn't fit the mould of the classic Bond persona.

With Barbara and now Wilson pushing for Craig, there was only one small problem: Craig himself had severe misgivings. It wasn't just the role itself. It was being caught up in the huge corporate machine of Eon and Sony, spending more time publicising the product than actually making it, wearing the right watch and suit, dealing with stuff

that wasn't really anything to do with him as an actor. Importantly, too, the script wasn't finished.

Craig sounded out friends and colleagues about whether he should accept or not.

One of those was Roger Michell, who directed Craig in two films. 'He was very ambivalent about taking it on. It's a life sentence, after all. I think he was initially excited by the work but also daunted by the attendant tap-dancing – the constant attention. He found that all pretty oppressive.'[79]

Making *Munich* for Steven Spielberg, Craig asked the director for advice. Craig saw himself as an actor who generally focused on small independent movies, not big studio blockbusters. Spielberg told him that if the script and the deal was right, to take it. Then Craig asked straight out, 'Should I do it?' Spielberg didn't hesitate with his reply. 'Of course you fucking should.' Or words to that effect. 'I knew he'd give me a straight answer,' said Craig, 'because he's a straight guy.'[80]

When Craig finally had a script to read it impressed him. Had he disliked the script the decision not to do it would have been an easy one to make. Now he couldn't say no; it would be too much of a missed opportunity. 'You can't really turn something like this down. You can, but you shouldn't.'[81]

Craig was on location in Baltimore for the film *The Invasion*, starring opposite Nicole Kidman, when his phone rang. It was Barbara. 'Over to you, kiddo,' she said.

On 14 October 2005, Daniel Craig was confirmed as the new James Bond. An official Eon press release ran: 'We are thrilled Daniel Craig will play the character of 007. Daniel is a superb actor who has all the qualities needed to bring a contemporary edge to the role.' In another statement Amy Pascal of Sony Pictures said, 'We believe that in Daniel Craig we have found the ideal 21st century Bond.'

The press conference was unlike anything the Bond producers had held before. It took place in London at HMS *President*, a Royal Navy Reserve station at St Katherine Docks on the banks of the Thames, downstream of Tower Bridge. Craig arrived in suitable Bond-style via speedboat with wind-blown hair and modelling a Brioni suit. The image was slightly offset by the fact that the new 007 was forced to wear a life jacket due to health and safety regulations. 'It's a huge challenge,' he

said to the waiting press. 'Life is about challenges and this is one of the big ones as an actor.'

At the press call Michael G. Wilson revealed that the filmmakers considered more than 200 actors from around the world over the course of two years before settling on Craig. While reports emerged that the producers often didn't agree with each other on casting possibilities, Eon insisted that Craig had always been their top choice and no other actor was offered the role.

Daniel Craig was born in 1968 in Chester; his mother was an art teacher, his father first a midshipman in the merchant navy, then a steel erector and later a pub landlord. When his parents divorced in 1972, Craig and his sister moved to the Wirral with their mother, where he attended primary school in Hoylake.

The young Craig was inspired to pursue acting after regular visits to the Everyman Theatre in Liverpool with his mother. It was his father who first introduced him to Bond, when he took the 6-year-old Daniel to the pictures to see *Live and Let Die*. In 1984 the 16-year-old Craig moved to London and joined the National Youth Theatre and then attended the Guildhall School of Music & Drama. Soon after graduating Craig made his film debut in the 1992 drama *The Power of One*. Roles on television followed, and he performed on stage with the National Theatre.

His breakthrough role came in 1996 when he starred in the BBC drama serial *Our Friends in the North*, along with other rising British actors Christopher Eccleston and Mark Strong. This led to roles in a series of mainstream films like the historical drama *Elizabeth* (1998), *Lara Croft: Tomb Raider* (2001) and *Road to Perdition* (2002), when he first worked with future Bond director Sam Mendes. But the actor seemed more at home in smaller British independent pictures, playing opposite Derek Jacobi in *Love Is the Devil* (1998), about the painter Francis Bacon; the drama *Some Voices* (2000); and the psychological thriller *Enduring Love* (2004). And it was a British independent picture, *Layer Cake*, that brought him to the attention of Barbara Broccoli and his shot at Bond.

Before taking over, Craig spoke about his admiration for the original 007. 'Sean Connery set and defined the character. He did something extraordinary with that role. He was bad, sexy, animalistic, and stylish, and it is because of him I am here today.'[82]

After he was cast, Craig contacted Connery. 'I wanted Sean Connery's approval and he sent me messages of support, which meant a lot to me.'[83]

Craig entered the world of Bond under a cloud of doubt the like of which no previous Bond actor has ever endured. When Craig was first announced there was a massive and largely irrational backlash against the actor from certain sections of the press and from some of the public and fans. 'I think that backlash stems from the internet age,' says Rikki Lee Travolta:

> And, of course, all the rumours of other potential Bond candidates. A whole website was created by anti-fans that touted actors like myself and many others as a preferable choice. While I am of course flattered by those who have expressed admiration for me, I would never say anything negative about Daniel. I think he is an amazing actor and he does great justice to the James Bond legacy in a way very few actors could.[84]

As for some of those other candidates, Rikki has his own views regarding their suitability or otherwise for the role:

> Clive Owen has a classical background much like Timothy Dalton. I suspect he would have brought much of the same brooding element to the character. At the same time, Clive isn't as much of a physical actor as others. Daniel Craig beefed up tremendously to give Bond an authentic edge. Clive would have done a splendid job as Bond, but it would be far different than how Daniel handled the role. Adrian Paul has years of combat and martial arts experience. Adrian has a wonderful understated comic talent that flies right beneath the radar. He probably would have been able to infuse the character with many elements that haven't been seen since Sean Connery. Hugh Jackman is so incredibly diverse. He has strength and elegance and balances them so well. He, too, would have brought his own special touch to the role. Could I see Eric Bana as Bond? Not really. I mean no disrespect to Eric, he's a fine actor. However, he was a stand-up comic who broke through in dramatic films to his own surprise. I don't know if his heart would be in it and James Bond is a coat of honour that you have to wear – you can't shrug it off at the end of the day. Julian McMahon would have been completely different as Bond. I think

he is amazing. But you play to your strengths. Julian isn't physically imposing; instead, his forte is on the smooth side. I suspect Julian's Bond would have had a sexual charge that would have made Roger Moore's Bond look like a boy scout.[85]

Most of the criticism levelled at Craig seemed to revolve around the fact that he was blonde and too short, rather than whether he had the acting chops to do the job. Roger Moore was quick to leap to Craig's defence, insisting criticism of the decision to cast him was harsh: 'I am a great defender of Daniel Craig. He's a good actor. People have been so beastly; he's not even had a chance.'[86] Pierce Brosnan also came to his defence, sending Craig a good luck message.

Craig himself tried to shrug off the negativity, indeed used some of it to spur him on, fuel to prove his doubters wrong. To prepare for the role he not only had a personal trainer to bulk him up, but he went back and watched all the Bond films three or four times each, taking it all in and then throwing it away and starting from scratch. Along with those actors who came before him, Craig was to find inspiration and the key to playing the role in the words of Ian Fleming. One description caught his imagination, when Fleming described Bond as a 'blunt instrument'. That simple description underpinned a lot of what Craig brought to his debut movie.

Casino Royale opened in November 2006 and was a critical and commercial smash hit. Having endured the unfair criticism that swirled around his casting, it must have been rewarding for the actor to receive almost unanimously positive critical praise. As Kim Newman in *Empire* noted, 'Contrary to pre-release nay-sayers, Daniel Craig has done more with James Bond in one film than some previous stars have in multiple reprises. This is terrific stuff, again positioning 007 as the action franchise to beat.' *Variety* wrote, 'For once, there is truth in advertising: The credits proclaim Daniel Craig as "Ian Fleming's James Bond 007," and Craig comes closer to the author's original conception of this exceptionally long-lived male fantasy figure than anyone since early Sean Connery.' And while the critic of the *Telegraph* found Craig to have a face like 'an Easter Island statue', he made 'a terrific debut. He manages to exude not only danger and unpredictability and wit – but also, and this is a first, some vulnerability.'

Craig's reign as James Bond was the longest of any of the previous actors' – fifteen years. This was largely due to the long gap between his films being made. His debut surely ranks amongst the best of the series, only to be followed by one of the worst, *Quantum of Solace* (2008), which must grapple with *Die Another Day* and *A View to a Kill* as the worst the franchise has to offer. Things picked up markedly with *Skyfall* (2012), which is almost if not the equal of *Casino Royale*, then slightly dipped again with *Spectre* (2015). Craig's final outing, *No Time to Die* (2021), undoubtedly ranks as the most controversial film of the entire series, due to the decision to kill off the main character, while in the closing credits reassure the audience that he will be back in the next film – whenever that is. An odd decision to put it mildly and one that divided fans.

Craig's departure as Bond left the producers in the same dilemma as when Brosnan was dispensed with. There is no obvious candidate to replace him. Again, it seemed that pretty much every British actor who could walk in a straight line was being touted for the role in the press, so many names have been mentioned: Idris Elba, Tom Hardy, Aaron Taylor-Johnson, Tom Hiddleston, Aidan Turner, James Norton, Michael Fassbender, Jamie Bell, Luke Evans are just a few. By the time this book is published we may know the answer as to who the producers have chosen. He will join an illustrious and exclusive club. More people have walked on the moon than played James Bond. As 007 contender Neil Dickson so humorously suggested earlier in the book, maybe they should all get their own badge.

This book has thrown up a myriad of alternative Bond universes, where it was Patrick McGoohan staring back at Eunice Gayson across the green baize of a casino table; where Burt Reynolds drove the underwater Lotus Esprit or indulged in banter, Smokey and the Bandit style, with Sheriff J.W. Pepper; or where Lewis Collins kicked Michael Gothard's car over a cliff. But all that was never to be, and maybe it was for the best. After all, the actors the producers finally did cast as Bond have been arguably the perfect choices for their era. Can we visualise another actor other than Moore in *The Spy Who Loved Me* or Timothy Dalton in *The Living Daylights*?

For a lot of the actors who lost out on Bond, as we have seen, very few harboured any regrets. Most of them carried on with their careers, faded back into relative obscurity or shot to stardom without the aid

of 007. For some it was the ultimate gig and seeing it slip through their fingers was a bitter pill to swallow. For others, it remained an unfulfilled dream. And some tried to chase down that dream, like Roger Barton Smith, who spent thousands in his pursuit of becoming James Bond. It didn't work out. 'I packed my 8-year acting career away,' he says today, 'and then went back to the real world and did some training courses with an ex-security services expert in London upgrading my skills as a safe technician. I now work for private clients as a security consultant/technician.'[87]

Concluding this book and the many years involved in the search for Bond, I guess an actor who exists in one of those alternative Bond worlds is Rikki Lee Travolta, and maybe he sums it all up best:

> The role of James Bond is both an honour and a sacrifice. It would be an honour to play – to not only join a fraternity of some of the greatest actors in modern history, but to play one of the true classic literary espionage characters of all time. At the same time, there is a certain burden that comes with the role. Anything you ever do will be secondary. Is that a bad trade off? Not at all. Anyone who tells you that they wouldn't want to play James Bond is lying – and not well. Every actor who has played Bond has lived the dreams of every little boy. I applaud each one of them. They all have brought their own special twist to the character. Every fan has a favourite actor – and every one of them is right. Every actor in the Bond legacy deserves their fans. Every Bond actor deserves to be proud to have worn the crown. While my name will always be an oddly famous footnote in the history of Bond lore, there will always be a sense of pride that so many thousands of fans embraced the idea of Rikki Lee Travolta as James Bond with such fever and determination. Bond fans are truly some of the best in the world and to have felt that embrace on even such a dislocated level is a feeling of incredible acceptance that words can never do justice to.[88]

Notes

1: Before Connery

1 Guy Masterson: Author interview.
2 Ibid.
3 *Daily Mirror*, 2002.
4 *Cinema Retro*, issue 6, 2006.
5 *Starlog*, October 1983.
6 *New York Daily News*, 1995.
7 Bob Holness: Author interview.
8 Ibid.
9 Ibid.
10 Ronald Payne: Author interview.
11 Ibid.
12 Ibid.
13 Ibid.
14 Ibid.
15 Ibid.
16 Ibid.
17 Ibid.
18 Ibid.
19 Christopher Lee: Author interview.
20 Sellers, Robert, *Battle for Bond* (Tomahawk Press, 2007).
21 Ibid.
22 Ibid.
23 Ibid.
24 Ibid.
25 Ibid.

2: Connery

1. John Glen: Author interview.
2. *National Catholic Register*, January 2016.
3. *Daily Telegraph*, May 2000.
4. *Starlog*, July 1986.
5. *Western Mail*, April 2004.
6. Christopher LeClaire: Author interview.
7. Ibid.
8. Ibid.
9. Ibid.
10. Ibid.
11. Ibid.
12. Ibid.
13. Michael Craig: Author interview.
14. Ibid.
15. *Boca Raton News*, June 1999.
16. *Cinema Retro*, issue 10, 2008.
17. Ibid.
18. *Little Shoppe of Horrors*, number 17, November 2005.
19. Ibid.
20. George Baker: Author interview.
21. Ibid.
22. www.ec1echo.co.uk, April 2022.
23. David Rossi: Author interview.
24. Ibid.
25. www.ec1echo.co.uk, April 2022.
26. David Rossi: Author interview.
27. Ibid.
28. Ibid.
29. Ibid.
30. *Rolling Stone*, October 1983.
31. Ibid.
32. Haining, Peter, *James Bond: A Celebration* (W.H. Allen, 1987).
33. Cyril Frankel: Author interview.
34. Ibid.
35. Ibid.
36. Ibid.
37. Ibid.
38. Broccoli, Cubby, *When the Snow Melts: The Autobiography of Cubby Broccoli* (Boxtree, 1998).
39. Ibid.
40. *Daily Telegraph*, May 2000.
41. Passingham, Kenneth, *Sean Connery, a Biography* (Sidgwick & Jackson, 1983).
42. Ibid.

43 Lane, Sheldon, *For Bond Lovers Only* (Panther Books, 1965).
44 *Saturday Evening Post*, June 1964.
45 Yule, Andrew, *Sean Connery: Neither Shaken nor Stirred* (Little, Brown, 1993).
46 Sterling, Martin and Gary Morecambe, *Martinis, Girls and Guns: Fifty Years of 007* (Robson Books, 2002).
47 *Starlog*, October 1983.
48 Picker, David, *Musts, Maybes, and Nevers: A Book about the Movies* (CreateSpace, 2013).
49 Pearson, John, *The Life of Ian Fleming* (Jonathan Cape, 1966).
50 Sterling, Martin and Gary Morecambe, *Martinis, Girls and Guns: Fifty Years of 007* (Robson Books, 2002).
51 *Playboy*, November 1965.
52 Cilento, Diane, *My Nine Lives* (Michael Joseph, 2006).
53 Ibid.
54 Callan, Michael Feeney, *Sean Connery: His Life and Films* (W.H. Allen, 1983).
55 Osborne, John, *Almost a Gentleman* (Faber & Faber, 1991).
56 *Bondage*, number 10, 1981.
57 Tom Mankiewicz: Author interview.
58 *Photoplay*, November 1962.
59 Ibid.
60 *Cinescape*, January 2001.
61 Philip Saville: Author interview.
62 Guy Hamilton: Author interview.
63 Roderick Mann, February 1965.
64 Cilento, Diane, *My Nine Lives* (Michael Joseph, 2006).
65 Cork, John and Bruce Scivally, *James Bond – The Legacy* (Boxtree, 2002).
66 *True* magazine, June 1966.
67 Ibid.
68 Lewis Gilbert: Author interview.
69 Cork, John and Bruce Scivally, *James Bond – The Legacy* (Boxtree, 2002).
70 Honor Blackman: Author interview.

3: Replacing the Irreplaceable

1 *Starlog*, March 1983.
2 Deadline.com, November 2015.
3 *Movie Collector*, vol. 2, issue 2.
4 Ibid.
5 *Daily Express*, October 1968.
6 Field, Matthew and Ajay Chowdhury, *Some Kind of Hero: The Remarkable Story of the James Bond Films* (The History Press, 2015).
7 Barnes, Alan and Marcus Hearn, *Kiss Kiss Bang Bang* (Batsford, 2001).
8 Peter Snow: Author interview.
9 Ibid.

10 Michael Billington: Author interview.
11 Ibid.
12 *Evening Standard*, May 2013.
13 Ibid.
14 Taylor, Tadhg, *Masters of the Shoot-'Em-Up* (McFarland, 2015).
15 *Daily Mail*, February 2009.
16 Ibid.
17 *Celebrity Magazine Television*, October 2020.
18 Ibid.
19 West, Adam, *Back to the Batcave* (Titan Books, 1994).
20 Ibid.
21 Ibid.
22 *Le Journal de Quebec*, June 2018.
23 Ibid.
24 *Cinema Retro*, issue 46, 2020, Mark Mawston.
25 Ibid.
26 Ibid.
27 Barnes, Alan and Marcus Hearn, *Kiss Kiss Bang Bang* (Batsford, 2001).
28 *Neon* magazine, January 1998.
29 *Daily Mail*, November 2015.
30 Dyson Lovell: Author interview.
31 Ibid.
32 *007 Magazine*, issue 27, October 1994.
33 Dyson Lovell: Author interview.
34 *Palisadian Post*, November 2008.
35 Field, Matthew and Ajay Chowdhury, *Some Kind of Hero: The Remarkable Story of the James Bond Films* (The History Press, 2015).
36 Ibid.
37 Picker, David, *Musts, Maybes, and Nevers: A Book about the Movies* (CreateSpace, 2013).
38 Field, Matthew and Ajay Chowdhury, *Some Kind of Hero: The Remarkable Story of the James Bond Films* (The History Press, 2015).
39 *Bondage*, issue 9, 1980.
40 Dyson Lovell: Author interview.
41 *Bondage*, number 6, 1978.
42 Ibid.
43 Haining, Peter, *James Bond: A Celebration* (W.H. Allen, 1987).
44 Ibid.
45 *Movie Collector*, vol. 2, issue 2.
46 *Daily Mail*, December 1969.
47 Ibid.
48 Gross, Edward and Mark A. Altman, *Nobody Does It Better* (Forge Books, 2020).
49 Dyson Lovell: Author interview.

4: Return of the King

1. *Observer*, February 2004.
2. Sir Ranulph Fiennes: Author interview.
3. Ibid.
4. Ibid.
5. Ibid.
6. Ibid.
7. Smooth Radio, October 2010.
8. Roger Green: Author interview.
9. Ibid.
10. Ibid.
11. Ibid.
12. Ibid.
13. Ibid.
14. Ibid.
15. Michael McStay: Author interview.
16. Ibid.
17. Ibid.
18. Ibid.
19. Ibid.
20. Simon Oates: Author interview.
21. Ibid.
22. Ibid.
23. Ibid.
24. John Ronane: Author interview.
25. Ibid.
26. Ibid.
27. Eric Braeden: Author interview.
28. Ibid.
29. Ibid.
30. Ibid.
31. Ibid.
32. Guy Hamilton: Author interview.
33. Cork, John and Bruce Scivally, *James Bond: The Legacy* (Boxtree, 2002).
34. Maria Gavin: Author interview.
35. Ibid.
36. Ibid.
37. Ibid.
38. Picker, David, *Musts, Maybes, and Nevers: A Book about the Movies* (CreateSpace, 2013).
39. Maria Gavin: Author interview.
40. Ibid.
41. Ibid.

42 Ibid.
43 Broccoli, Cubby, *When the Snow Melts: The Autobiography of Cubby Broccoli* (Boxtree, 1998).
44 Tom Mankiewicz: Author interview.
45 Ibid.

5: The Saintly Bond

1 Julian Glover: Author interview.
2 Ibid.
3 Ibid.
4 Ibid.
5 *The Star Phoenix*, March 1973.
6 Michael Billington: Author interview.
7 Ibid.
8 Ibid.
9 Mower, Patrick, *My Story* (John Blake, 2007).
10 *TV Times* (Melbourne), October 1978.
11 *Los Angeles Times*, September 2010.
12 Tom Mankiewicz: Author interview.
13 Robin Hawdon: Author interview.
14 Ibid.
15 Ibid.
16 Ibid.
17 Ibid.
18 Ibid.
19 Ibid.
20 Tony Bonner: Author interview.
21 Ibid.
22 Ibid.
23 Ibid.
24 Ibid.
25 Ibid.
26 Ibid.
27 Ibid.
28 Ibid.
29 Ibid.
30 Ibid.
31 Field, Matthew and Ajay Chowdhury, *Some Kind of Hero: The Remarkable Story of the James Bond Films* (The History Press, 2015).
32 Ibid.
33 Robert S. Baker: Author interview.
34 Ibid.
35 Moore, Roger, *Bond on Bond* (Globe Pequot Press, 2012).

36 Roger Moore: Author interview.
37 *Time*, January 1973.
38 Roger Moore: Author interview.
39 Tom Mankiewicz: Author interview.
40 *Photoplay*, January 1975.
41 Ibid.
42 *Time*, January 1973.
43 *Bondage*, number 9, 1980.
44 Ibid.
45 Michael Jayston: Author interview.
46 Ibid.
47 Ibid.
48 Ibid.
49 Ibid.
50 David Robb: Author interview.
51 Ibid.
52 Ibid.
53 Ibid.
54 Ibid.
55 Slater, Jason and Harvey Fenton, *David Warbeck: The Man and His Movies* (Fab Press, 1996).
56 Ibid.
57 Paul Hough: Author interview.
58 Slater, Jason and Harvey Fenton, *David Warbeck: The Man and His Movies* (Fab Press, 1996).
59 Glen, John, *For My Eyes Only* (Signum Books, 2015).
60 Oliver Tobias: Author interview.
61 Ibid.
62 Ibid.
63 Ibid.
64 Ibid.
65 Ibid.
66 Ibid.
67 *Daily Star*, August 1982.
68 Ibid.
69 *Cinema Retro*, issue 4, 2006.
70 *Daily Star*, August 1982.
71 *Daily Telegraph*, September 2010.
72 *This Morning*, ITV, May 2019.
73 Ibid.
74 Michael Billington: Author interview.
75 Duncan, Paul, *The James Bond Archives* (Taschen, 2012).
76 Ibid.
77 Roger Moore: Author interview.

6: The Shakespearean Bond

1 Mark Greenstreet: Author interview.
2 Ibid.
3 Ibid.
4 Ibid.
5 Ibid.
6 Ibid.
7 Ibid.
8 Ibid.
9 Ibid.
10 Ibid.
11 James Watt, BBC Radio Stoke, July 2015.
12 Ibid.
13 Ibid.
14 *TV Week*, September 1998.
15 The Venetian Vase blog, July 2023.
16 Ibid.
17 Ibid.
18 Ibid.
19 John James: Author interview.
20 Ibid.
21 Ibid.
22 Ibid.
23 Ibid.
24 Ibid.
25 *Daily Mail*, 1989.
26 *Financial Times*, September 2020.
27 Ibid.
28 Ian Ogilvy: Author interview.
29 Ibid.
30 Ibid.
31 Marcus Gilbert: Author interview.
32 Ibid.
33 Ibid.
34 Ibid.
35 Ibid.
36 Cork, John and Bruce Scivally, *James Bond: The Legacy* (Boxtree, 2002).
37 Glen, John, *For My Eyes Only* (Signum Books, 2015).
38 Sam Neill: Author interview.
39 KVIFF TV, July 2017.
40 Giammarco, David, *For Your Eyes Only: Behind the Scenes of the James Bond Films* (ECW Press, 2003).
41 Pfeiffer, Lee and Philip Lisa, *The Incredible World of 007* (Boxtree, 1992).
42 Neil Dickson: Author interview.

43 Ibid.
44 Ibid.
45 Ibid.
46 Ibid.
47 Ibid.
48 Ibid.
49 Ibid.
50 Haining, Peter, *James Bond: A Celebration* (W.H. Allen, 1987).
51 *007 Magazine*, number 21, Winter 1989.
52 *Bondage*, number 15, May 1987.
53 *007 Magazine*, number 21, Winter 1989.
54 *Bondage*, number 17, Summer 1989.
55 *Independent*, October 1992.
56 Ibid.
57 *GoldenEye* magazine, Summer 1997.
58 Ibid.
59 JoBlo celebrity interviews blog, June 2021.
60 Field, Matthew and Ajay Chowdhury, *Some Kind of Hero: The Remarkable Story of the James Bond Films* (The History Press, 2015).
61 *Metro*, February 2007.

7: Born to Be Bond

1 Guy Hamilton: Author interview.
2 Giles Watling: Author interview.
3 Ibid.
4 Ibid.
5 Ibid.
6 Glenn McCrory: Author interview.
7 Ibid.
8 Ibid.
9 Ibid.
10 Ibid.
11 Ibid.
12 Ibid.
13 Ibid.
14 Ibid.
15 Ibid.
16 Ibid.
17 *Guardian*, March 2019.
18 *Rolling Stone*, February 2023.
19 Ibid.
20 Fabien Frankel: Author interview.
21 Caroline Besson: Author interview.

22 Ibid.
23 Ibid.
24 Fabien Frankel: Author interview.
25 Field, Matthew and Ajay Chowdhury, *Some Kind of Hero: The Remarkable Story of the James Bond Films* (The History Press, 2015).
26 Ibid.
27 Rubin, Steven Jay, *The Complete James Bond Movie Encyclopedia* (McGraw-Hill, 1990).
28 *GoldenEye* souvenir brochure.
29 American Film Institute, Sean Connery tribute, 2006.
30 *Daily Record*, November 2000.
31 *Independent*, November 2003.
32 *Guardian*, April 2001.
33 Colin Wells: Author interview.
34 BBC, May 2000.
35 Digitalspy.com, June 2011.
36 Netfm.com, April 2001.
37 *Guardian*, April 2001.
38 Vic Armstrong: Author interview.
39 Ibid.
40 *Bridget Jones: The Edge of Reason*: DVD extras, 2004.
41 *Independent*, January 2015.
42 *Hello!* magazine, April 2002.
43 *Guardian*, August 2002.
44 BBC, November 2002.

8: The Blonde Bond Bombshell

1 *Scotsman*, September 2003.
2 *Irish Examiner*, December 2003.
3 BBC, May 2017.
4 BBC, 2002.
5 Adrian Paul: Author interview.
6 Ibid.
7 Ibid.
8 Rikki Lee Travolta: Author interview.
9 Ibid.
10 Ibid.
11 *Independent*, March 2022.
12 Ibid.
13 Blackfilm.com, November 2004.
14 Ibid.
15 Ewan Stewart: Author interview.
16 Ibid.
17 *Loose Women*, ITV, 2017.

18 *Guardian*, November 2004.
19 *Guardian*, September 2004.
20 Roger Barton Smith: Author interview.
21 Ibid.
22 Ibid.
23 Ibid.
24 Ibid.
25 Ibid.
26 Ibid.
27 Ibid.
28 Ibid.
29 Ibid.
30 Ibid.
31 Ibid.
32 Ibid.
33 Ibid.
34 Ibid.
35 Ibid.
36 Ibid.
37 Ibid.
38 Ibid.
39 Ibid.
40 Ibid.
41 Ibid.
42 *Screen International*, March 2005.
43 *Scotsman*, February 2005.
44 *Daily Telegraph*, July 2005.
45 Contactmusic.com, June 2006.
46 Ibid.
47 *Daily Telegraph*, December 2020.
48 Heughan, Sam, *Waypoints: My Scottish Journey* (Radar, 2022).
49 Ibid.
50 *Conan O'Brien Needs a Friend* (podcast), May 2023.
51 Ibid.
52 *Variety*, May 2023.
53 Ibid.
54 Ibid.
55 Gary Stretch: Author interview.
56 Ibid.
57 Ibid.
58 Ibid.
59 Ibid.
60 Ibid.
61 Ibid.
62 Ibid.

63 Ibid.
64 Ibid.
65 Ibid.
66 Ibid.
67 *Daily Mail*, May 2016.
68 Rikki Lee Travolta: Author interview.
69 Ibid.
70 Ibid.
71 *007 Magazine*, July 2011.
72 Comicbook.com, January 2023.
73 *Daily Mail*, January 2023.
74 *Variety*, December 2022.
75 *Daily Express*, June 2023.
76 *Happy Sad Confused* (Josh Horowitz's podcast), October 2022.
77 *The London Paper*, March 2007.
78 *Sunday Times*, October 2006.
79 *Guardian*, December 2011.
80 Premiere.com, November 2006.
81 *GQ*, December 2007.
82 *Daily Telegraph*, November 2006.
83 Ibid.
84 Rikki Lee Travolta: Author interview.
85 Ibid.
86 *The Times*, November 2006.
87 Roger Barton Smith: Author interview, 2024.
88 Rikki Lee Travolta: Author interview.

Bibliography

Barnes, Alan and Marcus Hearn, *Kiss Kiss Bang Bang* (Batsford, 2001).
Broccoli, Cubby, *When the Snow Melts: The Autobiography of Cubby Broccoli* (Boxtree, 1998).
Callan, Michael Feeney, *Sean Connery: His Life and Films* (W.H. Allen, 1983).
Cilento, Diane, *My Nine Lives* (Michael Joseph, 2006).
Cork, John and Bruce Scivally, *James Bond: The Legacy* (Boxtree, 2002).
Duncan, Paul, *The James Bond Archives* (Taschen, 2012).
Field, Matthew and Ajay Chowdhury, *Some Kind of Hero: The Remarkable Story of the James Bond Films* (The History Press, 2015).
Giammarco, David, *For Your Eyes Only: Behind the Scenes of the James Bond Films* (ECW Press, 2003).
Glen, John, *For My Eyes Only* (Signum Books, 2015).
Gross, Edward and Mark A. Altman, *Nobody Does It Better* (Forge Books, 2020).
Haining, Peter, *James Bond: A Celebration* (W.H. Allen, 1987).
Heughan, Sam, *Waypoints: My Scottish Journey* (Radar, 2022).
Lane, Sheldon, *For Bond Lovers Only* (Panther Books, 1965).
Moore, Roger, *Bond on Bond* (Globe Pequot Press, 2012).
Mower, Patrick, *My Story* (John Blake, 2007).
Osborne, John, *Almost a Gentleman* (Faber & Faber, 1991).
Passingham, Kenneth, *Sean Connery, a Biography* (Sidgwick & Jackson, 1983).
Pearson, John, *The Life of Ian Fleming* (Jonathan Cape, 1966).
Pfeiffer, Lee and Philip Lisa, *The Incredible World of 007* (Boxtree, 1992).
Picker, David, *Musts, Maybes, and Nevers: A Book about the Movies* (CreateSpace, 2013).
Rubin, Steven Jay, *The Complete James Bond Movie Encyclopedia* (McGraw-Hill, 1990).
Sellers, Robert, *Battle for Bond* (Tomahawk Press, 2007).
Slater, Jason and Harvey Fenton, *David Warbeck: The Man and His Movies* (Fab Press, 1996).
Sterling, Martin and Gary Morecambe, *Martinis, Girls and Guns: Fifty Years of 007* (Robson Books, 2002).
Taylor, Tadhg, *Masters of the Shoot-'Em-Up* (McFarland, 2015).
West, Adam, *Back to the Batcave* (Titan Books, 1994).
Yule, Andrew, *Sean Connery: Neither Shaken nor Stirred* (Little, Brown, 1993).

Index

Abbott, Maggie 61–2, 63
Adams, Tom 56–7
Alhanti, Janet 189–90
Allen, Irving 27, 37, 98
Allen, Patrick 30
Aman, Leigh 16
Anderson, Sylvia 92
Andress, Ursula 60, 85
Anthony, Peter 32–4
Archer, Jeffrey 105–6
Armstrong, Vic 166
Arnold, David 197

Baker, George 18, 30–1
Baker, Robert S. 101
Baker, Stanley 18, 23, 52
Bale, Christian 167, 171, 196
Bana, Eric 176, 177, 200
Bardot, Brigitte 31
Barry, Gene 51
Bell, Jamie 202
Beswick, Martine 60
Biehn, Michael 124
Billington, Michael 54, 92–3, 109, 116, 117–18
Blackman, Honor 48
Bloom, Orlando 173
Bogarde, Dirk 16, 26–7
Bonner, Tony 97–100
Boorman, John 41, 108

Borienko, Yuri 64
Boyd, Stephen 18
Braeden, Eric 81–2
Brett, Jeremy 90–1
Broccoli, Albert R. ('Cubby') 18–19, 22–3, 27, 29, 46, 106, 146
 and George Lazenby 63, 64, 65, 66, 67–8, 69, 97
 health and death 147, 153, 162
 idea of Bond 31, 38, 44, 62, 65, 82–3, 121, 128, 131
 and Patrick Mower 55, 93, 108–9
 and Pierce Brosnan 152, 159–60
 and Roger Moore 101, 102, 107, 111–12, 118, 119, 168
 and Sean Connery 36–40, 42, 44, 47, 49, 65, 87
 search for Connery's replacement 47, 49, 52–5, 58–60, 92–6, 98–9, 101
 search for *Dr. No*'s Bond 21–3, 26–7, 29, 31–4, 36–40, 42, 44
 search for Lazenby's replacement 71–7, 80–5
 search for Moore's replacement 107–15, 125–31, 134, 136–9, 141
 and Timothy Dalton 131, 137, 141, 145, 146, 147, 148, 149
Broccoli, Barbara 147, 158, 159, 174
 and Daniel Craig 197, 198, 199
 and Neil Dickson 139, 140, 141

search for Brosnan's replacement 163, 164, 165, 166, 167, 183, 184, 187, 192, 193, 195–6
search for Connery's replacement 90, 93
search for Dalton's replacement 154, 155–6, 157
search for Moore's replacement 109, 113, 114, 115, 116, 122, 127, 128, 129, 134, 139–40
and Timothy Dalton 147, 148
Broccoli, Dana 23, 37, 71, 100, 114, 137
Brolin, James 117
Brosnan, Pierce 44, 100, 136, 146, 148, 151–69, 179, 185, 194
 endorses future Bonds 175–6, 178, 201
 misses out on Bond 86, 109–10, 138–9, 152, 160
 plays Bond 16, 110, 135, 161–3, 167–9, 171, 172–4, 176, 191–2
 television career 79, 86, 109–10, 138–9
Brown, Bryan 127
Bryce, Ivar 9, 15, 17, 39
Burton, Richard 9–10, 45, 46, 140
Butler, Gerard 163–4

Caine, Michael 37, 41, 52, 55, 59, 81, 91, 116, 151
Calley, John 146
Campbell, Martin 160, 162, 172, 178, 184, 187, 193, 195, 196
Campbell, Robert 60
Casino Royale (1967 spoof) 31, 45, 51
Casino Royale (2006) 115, 123, 131, 169, 178, 184, 186, 197, 201
Casino Royale (CBS television adaptation) 10, 11, 12
Casino Royale (novel) 10, 143, 187–8, 193–4
Cavill, Henry 195, 196–7
Cilento, Diane 40, 44, 46, 67
Clark, Duncan 140
Clark, Robert 30–1
Clarke, Andrew 127–8
Clay, Nicholas 108
Clift, Montgomery 18

Coburn, James 52, 131
Collins, Lewis 115–16
Connery, Jason 125, 131–2
Connery, Neil 51
Connery, Sean 23, 26, 29, 35–48, 71, 77, 78, 79–80, 84–7, 103, 109, 145
 Bond's persona 28, 43–4, 66, 102, 103, 104–5, 111, 122, 123, 144, 156, 173, 191–2
 endorses other Bonds 70, 142–3, 161, 179, 200
 and Fleming's concept of Bond 38, 39, 41, 43, 116
 iconic Bond 11, 27, 30, 48, 54, 58, 69, 82, 90, 94, 97, 156, 161, 163, 199
 Never Say Never Again 112, 118
 non-Bond films 21–2, 28, 35–7, 40, 42, 60, 64, 84, 85, 136
Conrad, Jess 57–8
Cooper, Terence 51
Corbett, Harry H. 52
Craig, Daniel 12, 125, 177, 179, 191–202
 Bond's character 141, 156, 173, 175, 191–2, 201
 Casino Royale 123, 131
 pre-Bond work 100, 125, 157, 167, 177, 194, 197, 198, 199
Craig, Michael 18, 26–7
Crawley, Tony 18, 93–4
Crowe, Russell 165–6
Cruise, Tom 176
Curtis, Tony 98, 101
Cushing, Peter 18, 94

d'Abo, Maryam 136, 158
Dalton, Timothy 16, 62, 117–18, 131, 134, 135, 137, 139, 140–9, 156, 161, 165, 179, 202
Damon, Matt 172, 173
Dance, Charles 132
De Sica, Vittorio 53
Dehn, Paul 9
Dench, Judi 28
Diamonds Are Forever (1971) 34–5, 65, 71, 77, 78, 84–7, 101, 103

Index

Dickson, Neil 139–41, 202
Die Another Day (2002) 14, 167, 168, 171, 173, 202
Donner, Richard 147
Dr. No (1962) 21–3, 25, 33, 36, 45, 50, 100, 121
 in the audience 48, 142
 budget 28
 Connery's fee 40
 reception 43
Dutton, Simon 154

Eastwood, Clint 51–2, 94
Elba, Idris 202
Eton College 32, 53, 72, 90, 132
Evans, Lawrence 17
Evans, Luke 202

Farrell, Colin 178, 179, 190
Fassbender, Michael 202
Fiennes, Ralph 146, 157, 172
Fiennes, Sir Ranulph 72–4, 189
Finch, Jon 91
Finch, Peter 16, 18
Finney, Albert 27, 41
Firth, Colin 166–7
Fisz, Benjamin 36
Fleming, Ian 9–10, 12–13, 15–19, 72
 approves actors 9–10, 15–16, 18, 30–2, 33, 39, 43, 102, 103, 144
 concept of Bond 38, 39, 40, 41, 45, 66, 80, 102, 103, 143, 157, 161, 189, 191, 201
 and Sean Connery 38, 39, 41, 43, 102
For Your Eyes Only (1981) 90, 106–7, 109, 111, 112, 118, 132, 151–2
France, Michael 147
Frankel, Cyril 36
Frankel, Fabien 158, 159
Frankel, Mark 158–9
Franklyn, William 29–30
French, Philip 172
Friend, Rupert 188
From Russia with Love (1963) 23, 44, 123, 136, 196

From Russia with Love (planned TV drama) 16
Fullerton, Fiona 124

Gambon, Michael 71–2
Garner, James 18
Gavin, John 83–4, 85–6, 95
Gemmill, Tristan 179
Gibson, Mel 127, 139, 146–7, 164, 176
Gilbert, Lewis 47–8, 93, 153, 154
Gilbert, Marcus 134–5
Glen, Iain 167, 171–2
Glen, John 22, 93, 107, 110, 112, 118, 122, 128, 129, 138, 139, 144, 146, 165–6
 oversees auditions 110, 112, 113, 123–4, 126, 135, 138
Glover, Julian 89–90
GoldenEye (1995) 118, 147, 160, 161–2, 186
Goldfinger (1964) 44, 45–6, 130, 161
Grant, Cary 22–3, 43
Grant, Hugh 146, 174
Green, Roger 75–7
Greenstreet, Mark 121–5, 126, 127
Gruffudd, Ioan 164–5, 179

Hamilton, Anthony 128
Hamilton, Guy 31, 34, 45–6, 76–7, 82, 92, 95, 96–7, 103–4, 151
Hammond, Louis 122
Hardy, Robert 51
Hardy, Tom 202
Harlin, Renny 147–8
Harper, Gerald 51
Harris, Cassandra 100, 151–2
Harris, Richard 16–17
Harvey, Laurence 44–5
Hassall, Imogen 76
Hatton, Richard 80
Hawdon, Robin 95–7
Hendry, Ian 27–8, 51
Heughan, Sam 187
Hiddleston, Tom 202
Hitchcock, Alfred 9, 15, 84
Holden, William 18
Holness, Bob 11–12

221

Hough, John 98, 110–11
Howard, Trevor 16
Hudson, Rock 83–4
Humperdinck, Engelbert 74
Hunt, Peter 36, 50, 54, 56, 60, 64, 65, 66, 67
Hurt, John 91
Huyck, Gloria and Willard 146

Jackman, Hugh 166, 175, 179, 185, 200
Jackson, Michael 106
James, John 129–31
Jayston, Michael 107–8
Jenkins, Chard 61
Johansson, Ingemar 17
Johnson, Boris 179
Johnson, Richard 29, 51
Jones, Tom 74–5
Juroe, Charles 'Jerry' 133, 141

Kennedy, John F. 21
Kerkorian, Kirk 112
Kleeman, Jeff 148, 159
Kotcheff, Ted 146
Krim, Arthur 39
Kristel, Sylvia 93, 108
Kubrick, Stanley 84

Landis, John 146
Law, Jude 167, 171, 174, 179
Lawford, Peter 21–2
Lazenby, George 50, 54, 58, 61–70, 73, 79, 97, 103, 145, 189
LeClaire, Christopher 24–6
Lee, Christopher 16, 54
Leech, George 64
Lewis, Patricia 32, 35
Licence to Kill (1989) 145–6, 147, 162
Light, Finlay 128
Live and Let Die (1973) 87, 92, 103–5, 186, 199
The Living Daylights (1987) 136, 138, 143–5, 173, 202
Lloyd, Euan 115, 116
Lorre, Peter 11, 14

Lovell, Dyson 62, 63, 65, 70, 95
Lucan, Lord 53–4

McCallum, David 51
McClory, Kevin 9, 15, 16–17, 18, 44–5, 46, 152
McCrory, Glenn 154–7, 189
McGoohan, Patrick 22, 39, 51
McGregor, Ewan 171, 174, 179
McMahon, Julian 186, 200–1
Macnee, Patrick 28, 51, 105
McQueen, Steve 29, 44
McStay, Michael 77–9
McWilliams, Debbie 122, 135, 154, 157, 165, 188
Maibaum, Richard 38, 49–50, 121, 146
Majors, Lee 51–2
Malmgren, Yat 44
The Man with the Golden Gun (1974) 103, 145
Mancuso, Frank 146
Mankiewicz, Tom 43, 95, 103
Mann, Delbert 13, 14–15
Marshall, Scott and Denise 155
Mason, James 16, 41, 43
Masterson, Guy 9–10
Maxwell, Lois 93, 102, 119
Mendes, Sam 50, 199
Meyer, Ron 106
Michell, Roger 198
Moonraker (1979) 16, 92, 93, 106, 107
Moonraker (film rights) 12–15
Moonraker (novel) 12
Moonraker (radio adaptation) 12
Moore, Geoffrey 168
Moore, Roger 79, 82, 92–4, 97–112, 117–19, 122, 131, 133, 143–5, 156
 Bond persona 28, 102–5, 143–5, 162, 173, 191–2
 candidate to play Bond 22, 52, 62, 71, 90, 98, 100–1
 endorses other actors 161, 168, 201
 salary negotiations 107, 111–12, 117, 118, 169
 synonymous with Bond 106, 127, 137, 202

television career 22, 28, 51, 52, 71, 90,
 98, 100–1, 102
Morgan, Sir John 32, 39
Mower, Patrick 54–5, 93, 107, 108–9
Myers, Gary 62–3

Neeson, Liam 122, 130, 146, 157–8
Neill, Sam 135–6
Nelson, Barry 10–11
Never Say Never Again (1983) 112, 118, 132
Newman, Paul 52, 94
Niven, David 9, 13, 18, 31, 41, 43, 103
No Time to Die (2021) 202
Norton, James 202

Oates, Simon 79–80
Octopussy (1983) 112, 117, 118, 146
Ogilvy, Ian 56, 75, 132–4
O'Hara, Maureen 14
Olivier, Laurence 27, 69, 108
O'Loughlin, Alex 193
On Her Majesty's Secret Service (1969) 31,
 47, 49, 54, 66–9, 100, 107, 122, 137,
 166
O'Rahilly, Ronan 68
Ornstein, Bud 54
Osborne, John 27, 41
O'Toole, Peter 18, 41, 45, 137, 142
Ovitz, Michael 106
Owen, Clive 167, 168, 172, 175, 179, 200

Paluzzi, Luciana 84
Parker, Sue 100
Pascal, Amy 185, 198
Pastrie, Katherine 35
Paul, Adrian 174–5, 200
Payne, John 12–15
Picker, David 39, 47, 64, 84, 85
Pilon, Daniel 59
Plummer, Christopher 28
Poitier, Sidney 190
Polanski, Roman 28, 91
Powell, Dick 13
Power, Tyrone 14
Praed, Michael 121, 125–7, 131

Previn, Steve 78
Purefoy, James 186
Purves, Peter 57
Purvis, Neil 185

Quantum of Solace (2008) 202

Rathbone, Basil 14
Redford, Robert 94
Reed, Oliver 51, 52, 91
Reeves, Michael 132–3
Reeves, Steve 23, 24–6
Reynolds, Burt 81, 82–3, 95
Rhys, Matthew 187–8
Richardson, Ian 56
Richardson, John 60–1
Richardson, Tony 27
Rigg, Diana 65
Robb, David 109
Rogers, Anthony 60
Romero, Cesar 14
Ronane, John 80–1
Rossi, David 33–4, 35
Royal Academy of Dramatic Art (RADA)
 29, 44, 54, 62, 95, 101–2, 108, 132,
 142, 172
Royal Shakespeare Company 80, 89, 108,
 155, 186
Rubin, Steven Jay 67

St John, Jill 23, 65
Salmon, Colin 175–6
Saltzman, Harry 18–19, 27, 36, 38, 41, 46,
 56, 81, 92, 106
 and George Lazenby 64, 66, 67–8, 69,
 97
 and Roger Moore 100, 101, 102
 and Sean Connery 36–41, 42, 49, 87
 search for Connery's replacement 49,
 50–2, 54–6, 59, 60, 64, 92–5, 98–9,
 100
 search for *Dr. No*'s Bond 21–2, 26, 27,
 29, 31–4, 36–41, 51
 search for Lazenby's replacement 71,
 76–7, 80–1, 83

Savalas, Telly 65
Saville, Philip 44
Scott, Dougray 163, 178, 179
Scottish International Educational Trust 85
Selleck, Tom 129
Sellers, Peter 45
Seymour, Jane 92
Shaw, Martin 115, 116
Shaw, Robert 39
Silver, Joel 147
Simmons, Bob 33, 64, 65, 76
Sinden, Donald 18
Skyfall (2012) 50, 202
Smith, Roger Barton 179–84
Snow, Peter 52–3
Sopel, Stanley 37, 83, 84–5
Spectre (2015) 50, 202
Spielberg, Steven 48, 198
The Spy Who Loved Me (1977) 31, 92, 103, 106, 202
Stack, Robert 51
Stamp, Terence 55–6
Stewart, Ewan 178–9
Stewart, James 15
Stretch, Gary 189–92

Tarantino, Quentin 169
Taylor, Elizabeth 10, 21, 70, 102, 140
Taylor-Johnson, Aaron 202
Taylor, Rod 23, 44, 45
Thunderball (1965) 32, 60, 75, 84, 165
Thunderball (novel) 18, 44
Thunderball (screenplay) 18, 44–6
Tobias, Oliver 113–15
Todd, Richard 18, 31–2
Tomorrow Never Dies (1997) 162, 163
Travolta, Rikki Lee 176–7, 193–4, 200, 202–3
Trevarthen, Noel 94
Turner, Aidan 202
Turner, Lana 21, 37, 42, 84

Underdown, Edward 32
Urban, Karl 193

Valentine, Anthony 56
Van Dyke, Dick 59
Vaughan, Frankie 52
A View to a Kill (1985) 28, 118, 119, 124, 202
Višnjić, Goran 195
Vries, Hans De 60

Wagner, Robert 94–5
Walker, Alexander 69, 105, 145
Warbeck, David 93–4, 110–11
Wasserman, Lew 81, 82
Watling, Giles 153–4
Wayne, John 14, 44–5, 60
Weintraub, Jerry 127
Wells, Colin 164
West, Adam 58–9
West, Dominic 185–6
Whicker, Alan 47
Whitehall, Michael 105
Whittingham, Jack 18
Williams, Robbie 165
Wilson, Lambert 136–7
Wilson, Michael G. 109, 113, 122, 134, 135, 139, 147, 152–3, 155–6, 174, 196
 and Daniel Craig 197, 199
 and Pierce Brosnan 184
 and Timothy Dalton 141, 148
 young Bond 121
Wise, Greg 164
The World Is Not Enough (1999) 161, 162
Worthington, Sam 195–6, 197

You Only Live Twice (1967) 47, 49, 60, 165
You Only Live Twice (BBC radio adaptation) 108
Young, Terence 23, 25, 29, 35–6, 37, 40, 42, 46, 80